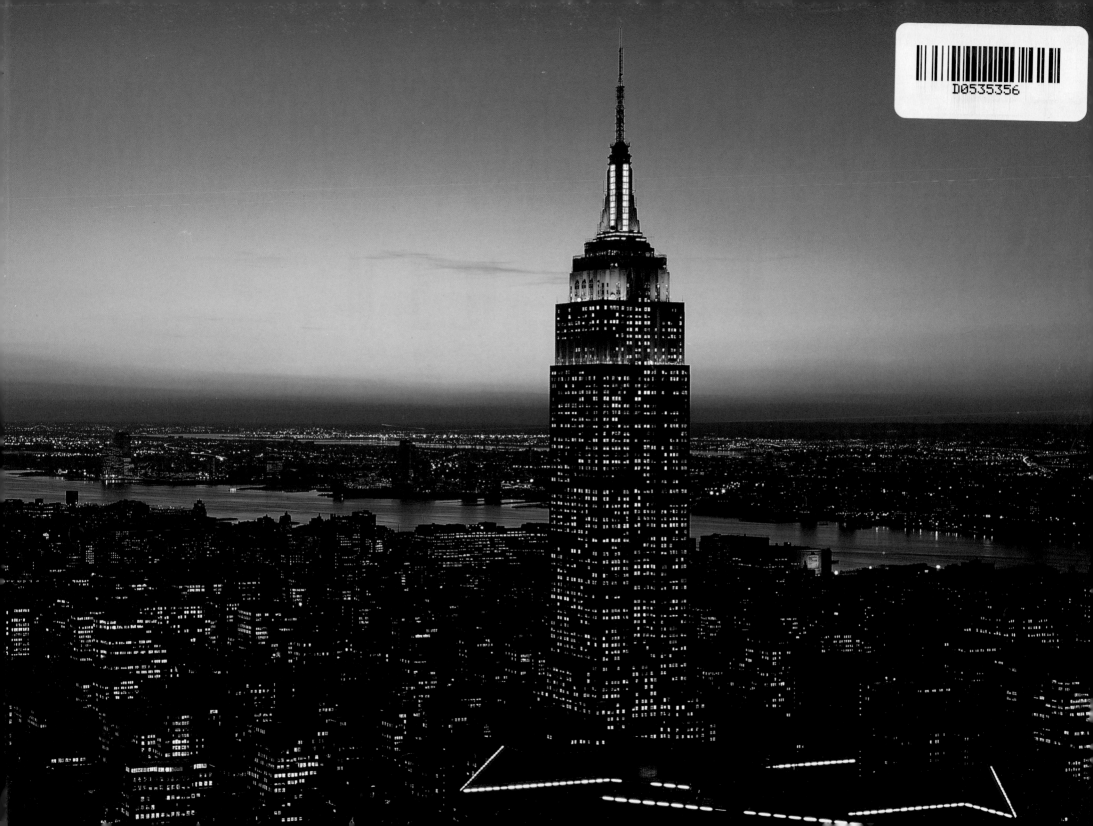

PANORAMIC

NEW YORK

RICHARD BERENHOLTZ

Foreword by Paul Goldberger

THE VENDOME PRESS
NEW YORK CITY

For Pamela

Graphic design by Harry Chester.

Text copyright © 1993 The Vendome Press, New York City.
Photographs copyright © 1993 Richard Berenholtz.

First published in the United States of America by
The Vendome Press, 515 Madison Avenue, New York, NY 10022.
Distributed in the United States of America and Canada by
Rizzoli International Publications, 300 Park Avenue South, New York, NY 10010.

Library of Congress Cataloging-in-Publication Data
Berenholtz, Richard, 1949—
 Panoramic New York / photographs by Richard Berenholtz;
 introduction by Paul Goldberger.
 p. cm.
 ISBN 0-86565-146-9
 1. New York (NY)—Pictorial works. 2. Architecture—New York
 (NY)—Pictorial works. 3. New York (NY)—Buildings, structures,
 etc.—Pictorial works. I. Title.
 F128.37.B53 1993
 974.7'1—dc20 93-11114
 CIP

Photolithography by Colourscan, Singapore.
Printed and bound by Artegrafica, Verona, Italy.

Contents

Foreword by Paul Goldberger 7

A City of Rivers 22

The Capital of Finance: Downtown Manhattan 30

The Capital of Merchants and Media: Midtown Manhattan 38

A City of Churches 58

Iron-Front Bohemia: SoHo/NoHo 68

The Hub of Entertainment: Times Square and Coney Island 82

An Island City and Its Bridges 90

The Garden City 100

A Skyscraper Xanadu 118

Picture Descriptions 129

Foreword by Paul Goldberger

What is it about New York that will not go away? What Richard Berenholtz has found is a kind of perpetual New York, a classic New York, a set of images that seem to transcend the moment and join the city we see today with the New York we remember from long ago. The pictures in this book are not cute or, heaven forfend, nostalgic; they are sharp-edged, just as this time is sharp-edged; yet they seem suffused with warmth and possibility. The city they show us is not the city that overwhelms us with dirt and danger; it is the city that beckons and glows.

To go through Richard Berenholtz's New York is to go through a city that seems, above all, crisp. It is alive with color, and it leaps out at us, and when it is finished leaping out at us it sprawls across the landscape. Not for nothing are these photographs all wide, for they portray a sense of a city that seems to have more space than the frontier. It is impossible to

feel confined in the New York Richard Berenholtz shows us. Space seems to rush out in all directions, including up, but most of all *across*. Those streets that run river to river, with walls of buildings stretching out like endless landscapes, were made for Berenholtz. In his New York, we never feel confined. It is all there before us, under the wide open sky.

Is this the vision of New York as Montana, then? I recall a whimsical essay by Kurt Vonnegut some years ago called "Skyscraper National Park" in which Vonnegut, logically enough, called for the protection of the New York skyline as a national park. If the mountains of Yosemite and the geysers of Yellowstone could merit preservation as national treasures, he reasoned, why not the New York skyline? Why not, indeed. Berenholtz sees it as Vonnegut did—as a thing of great, majestic sweep, as a whole that must be appreciated as a whole, as a glorious thing unto itself. He knows that the reality of the city is not a matter of saving a building here and a building there, any more than Yosemite would work if one mountain were saved and the adjacent one built upon. He thinks in terms of the *tout ensemble*, and he is right.

That this is a romantic vision of the city is painfully obvious, and it is not altogether in accord with the view of New York that is most common today. The homeless are absent from these images, as is almost any sense of urban deprivation. What we see here is not really a social

pages 10-11

Lower Manhattan viewed at dusk from Brooklyn across the East River. The segment stretches from the Staten Island ferry slip at the left (note the streak of light lingering in the wake of a departing ferry) to the South Street Seaport at the right. From this vantage point, one looks straight up Wall Street, here recorded as a river of fire flowing along a zigzag course through the narrow valley formed by some of the tallest buildings in Manhattan.

document at all; it is the city as a physical object, and as a maker of moods. This is not the city that it is so fashionable these days to hate. It is more the city that it is so unfashionable these days to love.

I have been trying to grapple with why, for all of this, Richard Berenholz's images of New York do not seem like a triumph of retro photography. They are not old-fashioned, or tired, and, most important of all, they are not a victim of easy sentimentality. They show us something more than New York as artifact; in their rather glistening sharpness they show us the city of enticement, the city where everything seems so bracing, so invigorating, that it becomes seductive despite itself.

It is not, of course, a real city. Never mind the fact that there are not any people visible in these photographs; there are not even any streets, and in the real New York it is the street, more than the edifice, that is the true building block of urban architecture. When Berenholtz does not bring his lens down to the sidewalk he cuts off not only people, but also the essential truth of urban design, which is that from the life of the street comes the entire meaning of the city.

Perhaps that doesn't matter; this is not a book to tell us all things about New York, just one man's vision of it. And in his sense of the great ensemble, his sense of the sweeping totality, Berenholtz is onto another truth about the city, equally important. He knows that the urban

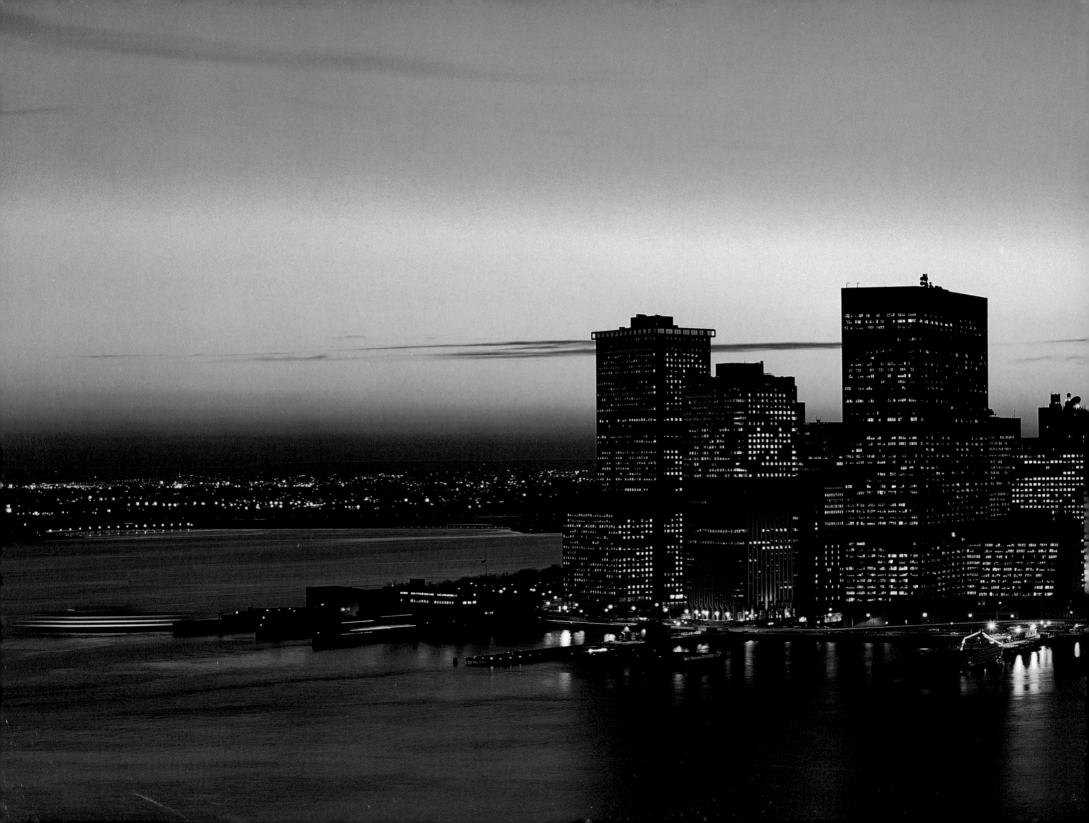

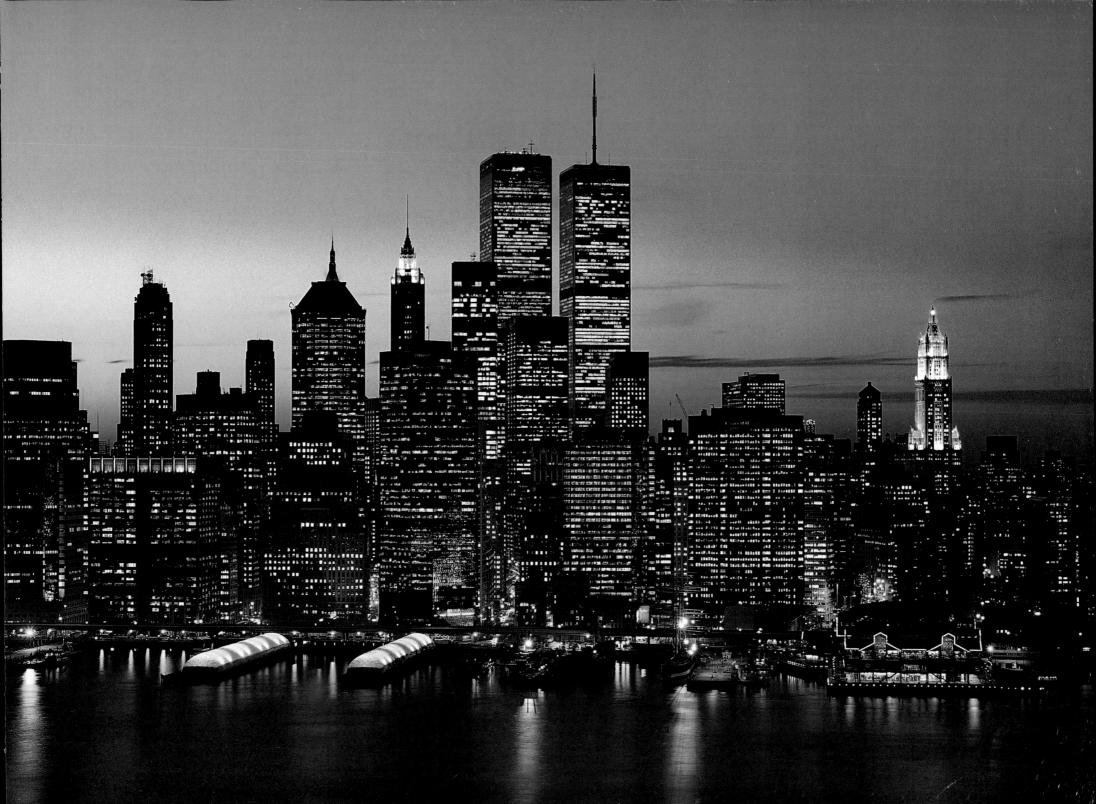

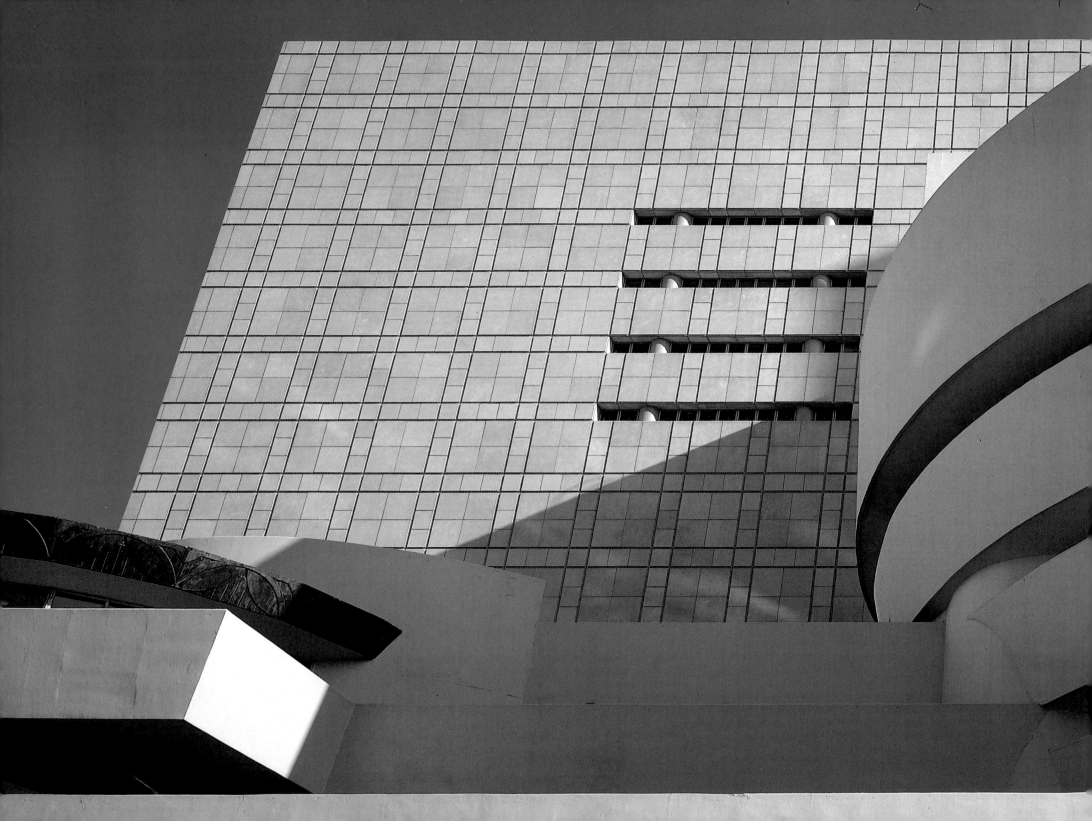

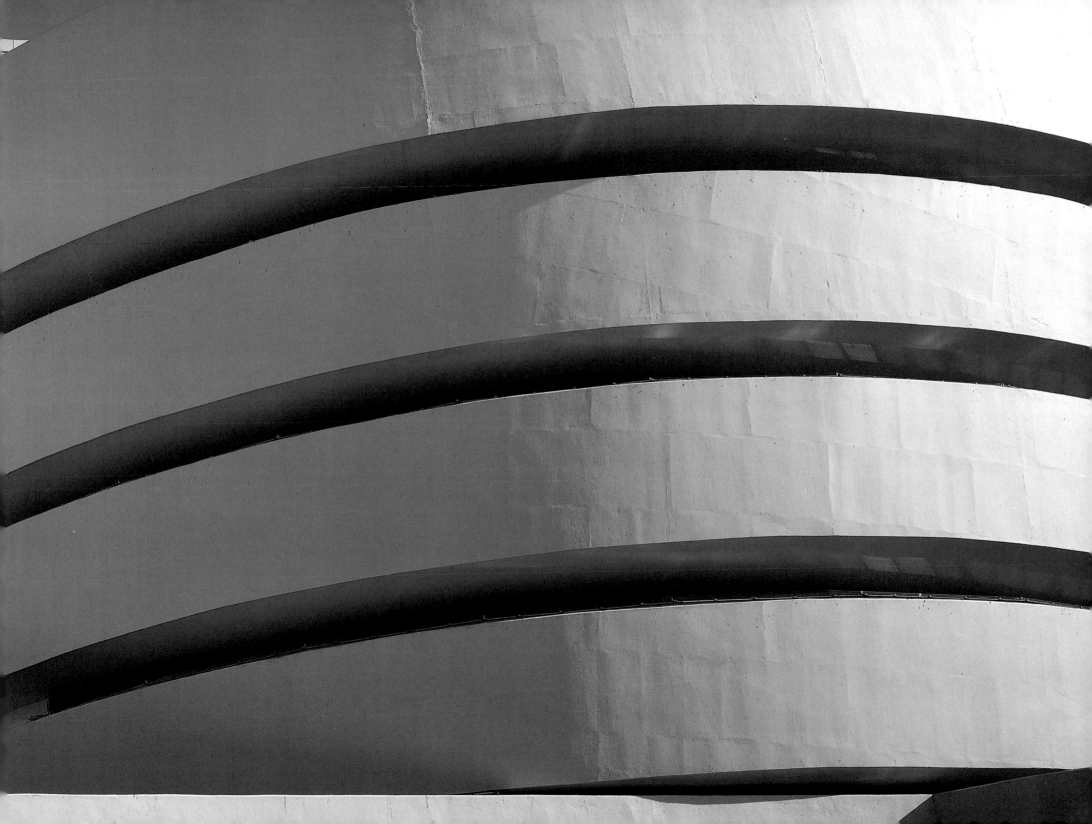

whole is more than the sum of its parts, and he is committed to making us feel that truth, to making sure we understand it.

Buildings come off as sensual objects in these photographs; we want to touch them and feel them. The metal and glass cage of I.M. Pei's Javits Center is tensile and cool, almost brittle, and I am not sure any photographer has brought us into that space the way Berenholtz has, making us feel both the space itself and the way in which the city is visible right through it. The swooping curves of Frank Lloyd Wright's original Guggenheim Museum and the addition by Charles Gwathmey and Robert Siegel play off against each other in this image as they do on Fifth Avenue, with Wright as self-assured and a bit rough-hewn, and Gwathmey and Siegel as deferential but more hard-edged.

The glib thinness of Cesar Pelli's façades for the World Financial Center in lower Manhattan; the Mozartian richness and delicacy of the incomparable façade of Louis Sullivan's Bayard-Condict Building on Bleecker Street, complete with terra-cotta angels; the newly brightened neon of Times Square, now more a landmark than a vulgarity; the sumptuous space of Grand Central Terminal, at once magnificent and comforting; the Beaux-Arts order of Rockefeller Center, where stone and gardens join in a warm ensemble. Berenholtz says as much as any architecture critic could about these places, and about others as well: the

pages 16-17

Bow Bridge in Central Park, the great nature preserve designed by Frederick Law Olmsted and Calvert Vaux (1858-76). This lyrical cast-iron structure spans the lake and leads to the Ramble, a bosky dell with a network of paths meandering among the cascades of Gill Brook. The view here is particularly rare for being free of both the wall of high-rise apartment buildings facing Central Park West and the lovers normally found rowing their way across the lake's secluded body of still water.

Cloisters, the lilting form of Bow Bridge in Central Park, the great bridges spanning the East and Hudson rivers, the still-growing stone of the Cathedral of St. John the Divine, the towers of Sixth Avenue.

We see in this book not the details of New York architectural history, but its tremendous range and scope. This is a 19th-century city, and a 20th-century city, at once. It is a finished city intent on preserving its past and an unfinished city that pushes relentlessly ahead. It is all of these things, all at the same time, and it is essential to embrace these contradictions to understand New York. The remarkable cast-iron façades of SoHo are here, but almost as an abstraction, an escapade in pure form. The crisp neoclassical grids play off against the boxy towers of postwar modernism, just as they do in the real-life experience of the city. So, too, the funky signs, the bakery storefront in SoHo, the Woolworth and Park Row Building tower tops against the sky. Each is here less to document a moment of architectural history than to be an element in a much larger composition.

This is not the New York of tourists; rather, it is the New York of New Yorkers who no longer bother to look. Perhaps that is Berenholtz's greatest contribution—not that he shows us new parts of the city, but that he encourages us to look at the ones we know, and to think about them anew. One evinces a growing awareness throughout these images that the

pages 18-19

Lincoln Center (1959-69), a 14-acre complex of architecture, gardens, and plazas devoted to the performing arts. Here, photographed at curtain time, are the three principal theaters: the Metropolitan Opera House with its celebrated ten-story arcade opening into the grand staircase and a pair of monumental murals painted by Marc Chagall; the New York State Theater, the home of the New York City Ballet and Opera companies, on the left; and Avery Fisher Hall, the seat of the New York Philharmonic Orchestra, on the right.

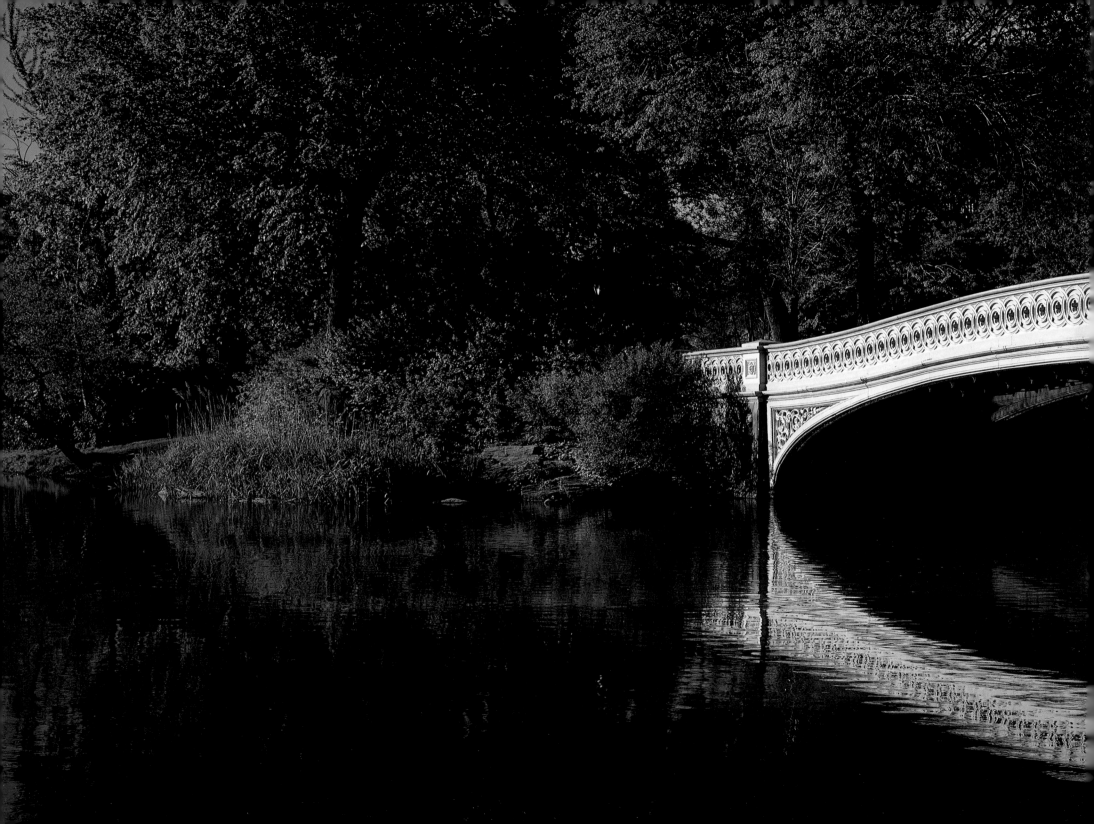

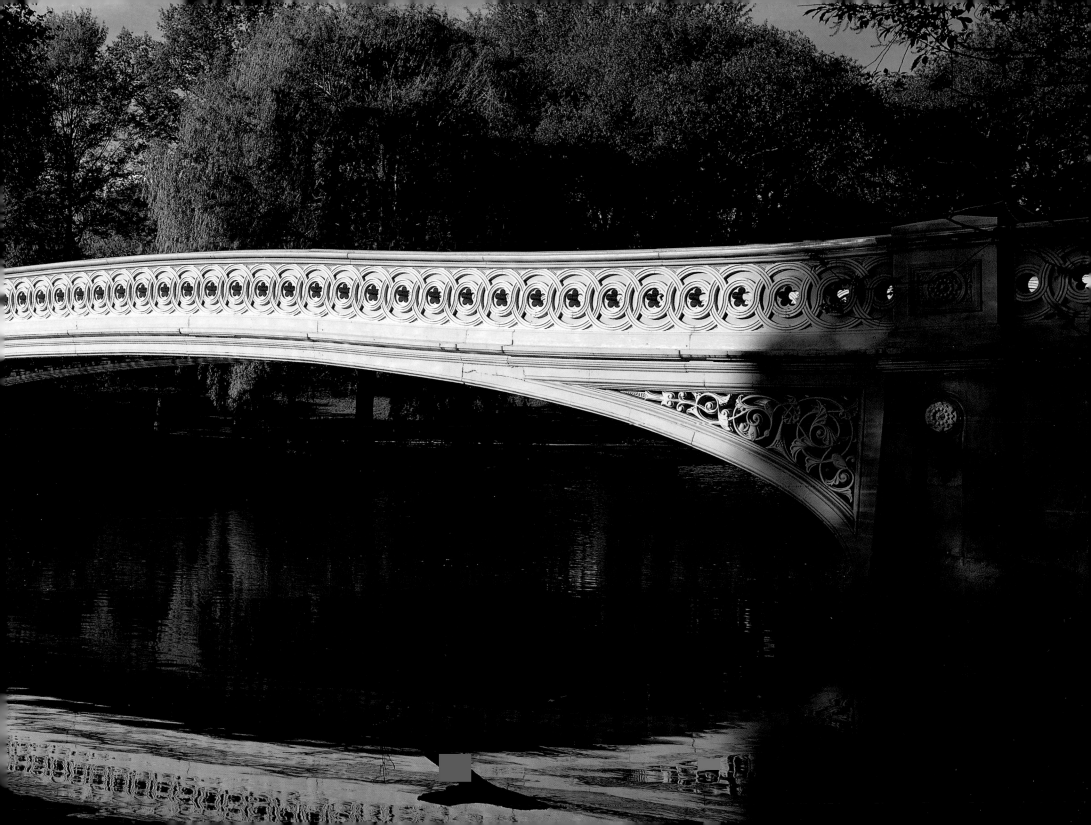

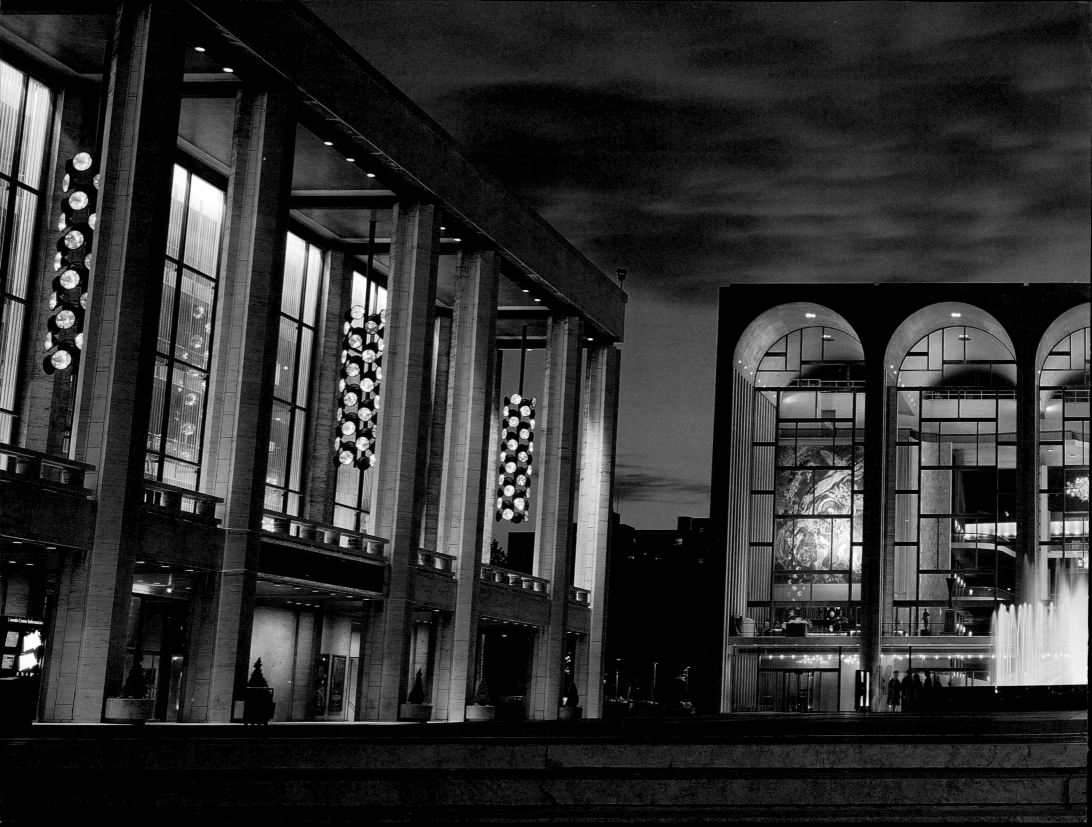

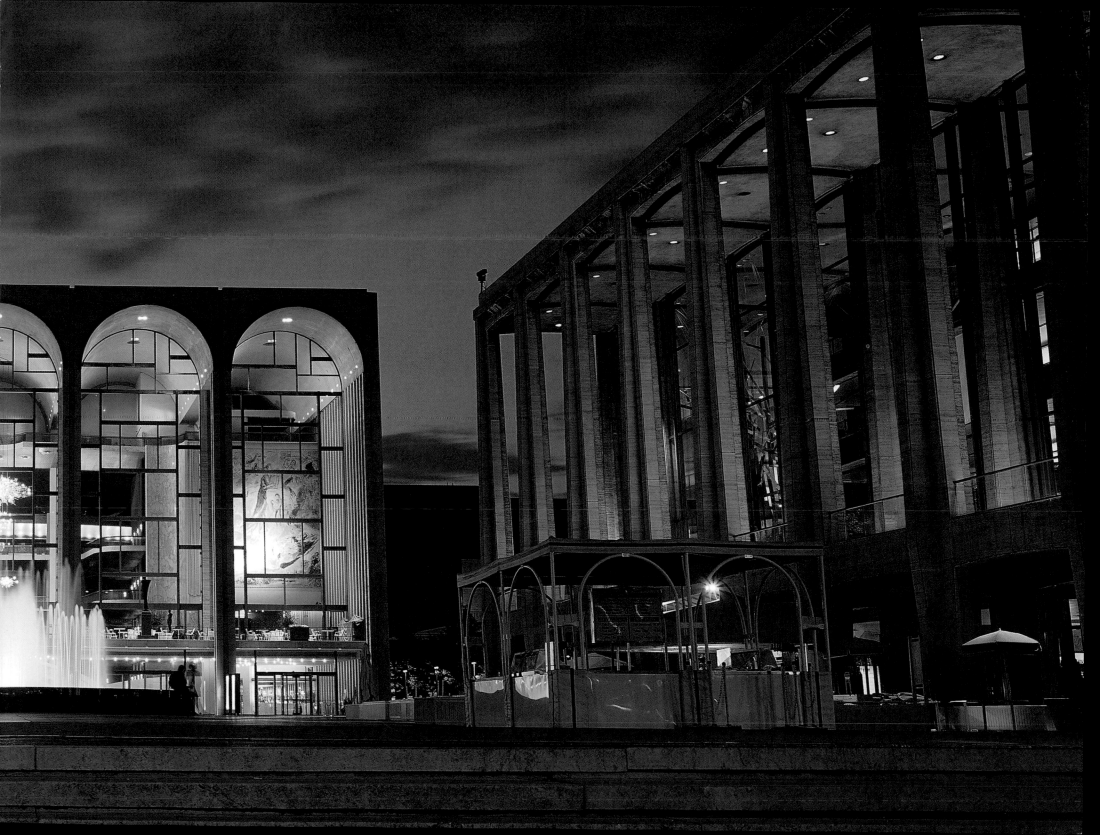

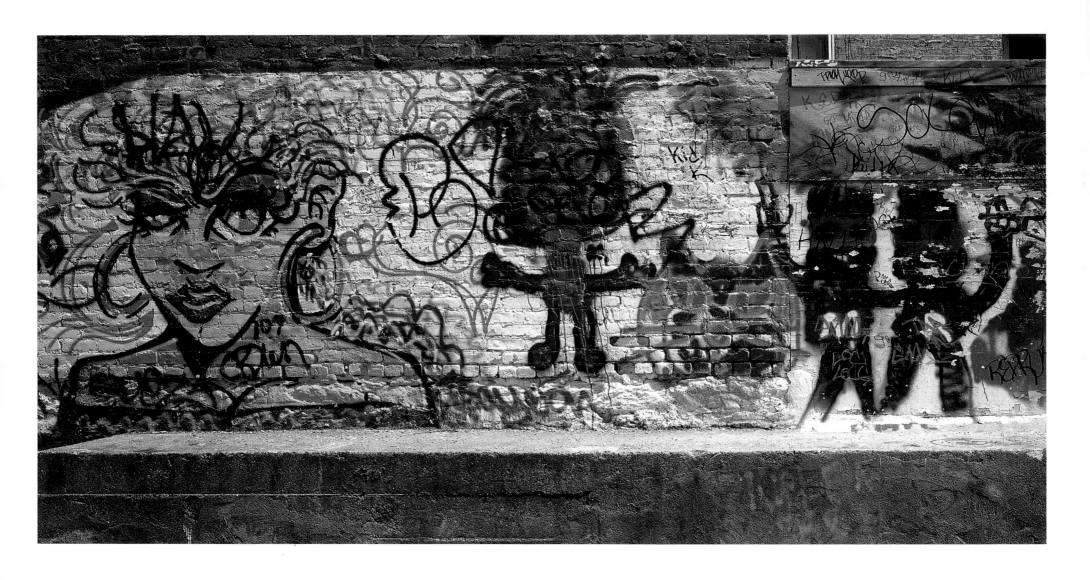

city has always been there for the looking, and it makes us feel that we have been turning away.

But what of the skyline shots, almost self-conscious in their romantic grandeur? Manhattan skyline views are to architectural photography what cheesecake is to fashion photography: quick to excite the eye, always easy to look at, yet somehow not as satisfying as more unusual images. We turn away from most of them the way we move on from any cliché. Yet Richard Berenholtz's versions are so glorious that they can be looked at again and again, for they seem to imbue the whole sweep of the city with that intensely sensual quality the photographer brings to his images of individual buildings. His skyline panoramas are of a city that floats between water and sky, and connects intimately to both. We want to *touch* these skylines; we want to reach out and caress these buildings, and take pleasure in the way their shapes and their lights dance across the evening sky.

We already know that New York is an impossible place, harsh, dirty, and dangerous. It does not hurt to be reminded, once in a while, that it is also a place of the possible—a place where, even amid the horrors, the heart can still stir.

opposite

According to Kirk Varnedoe and Adam Gopnik, writing in High and Low (Museum of Modern Art, 1991), "the graffiti artists (of New York) saw in their work the same spirit of modern optimism that Léger had found in the billboard: a summons out of the cramped tenement and away from the addiction of indoor overlord culture, into the free world of common public spectacle."

pages 22-23

In this vast panorama, taken from the New Jersey side of the Hudson River, the spiky skyline of Midtown Manhattan—the famous stone jungle—spreads wide along its flat, water-edge horizon as if the city were Venice re-created in a purely 20th-century vocabulary of forms. And the comparison with la Serenissima is not so far-fetched, given that everything made by human hands must ultimately spring from organic impulse or nature, best seen here in the magical unexpectedness of the silhouettes, intervals, sequences, rhythms, colors, textures, and patterns that march across the visual field.

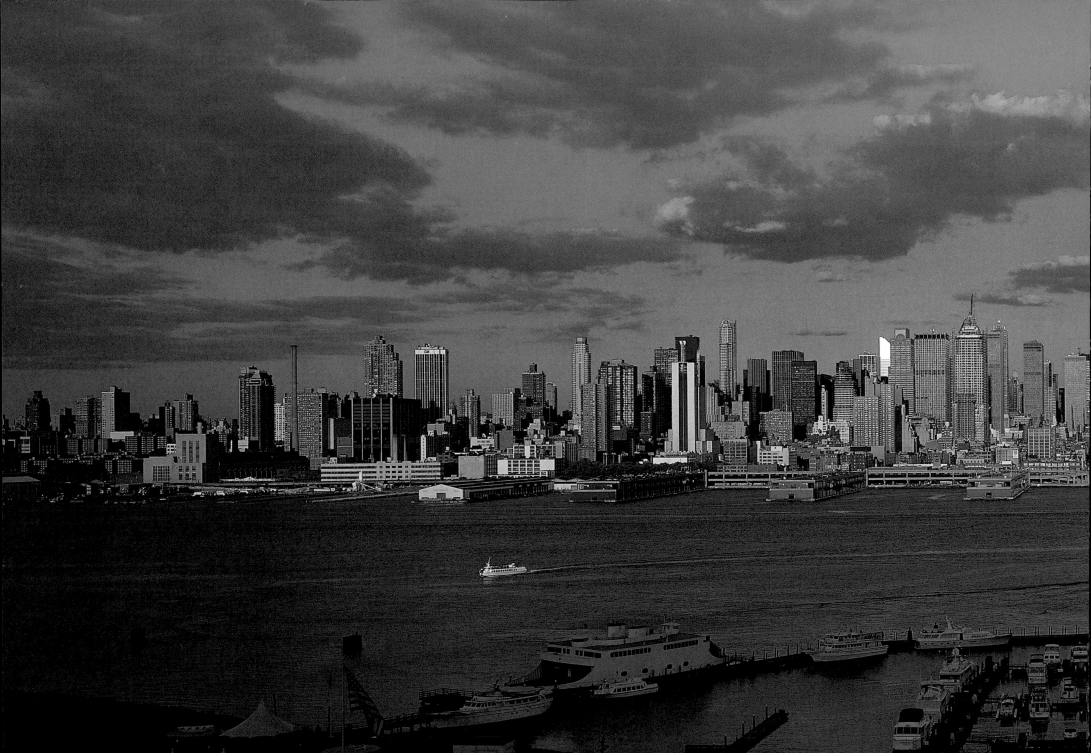

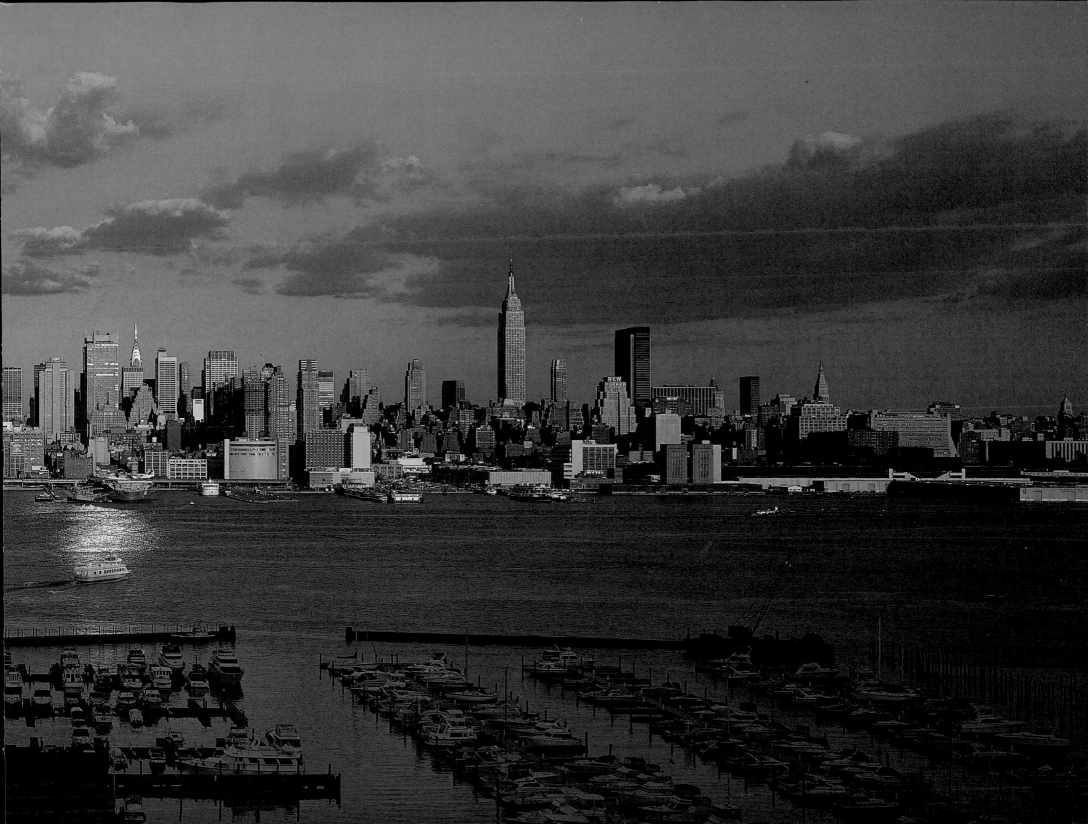

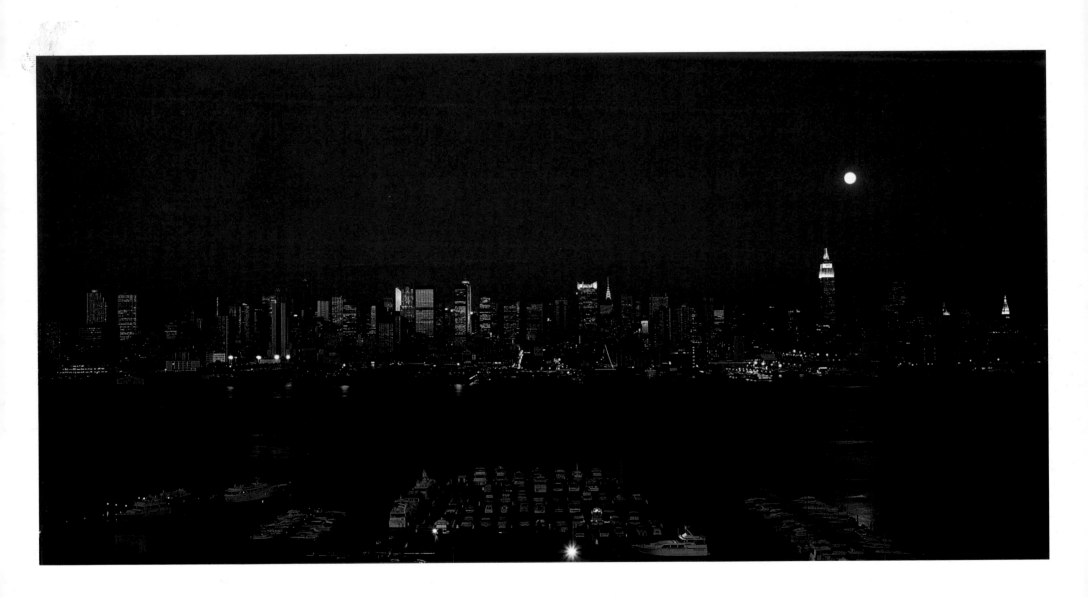

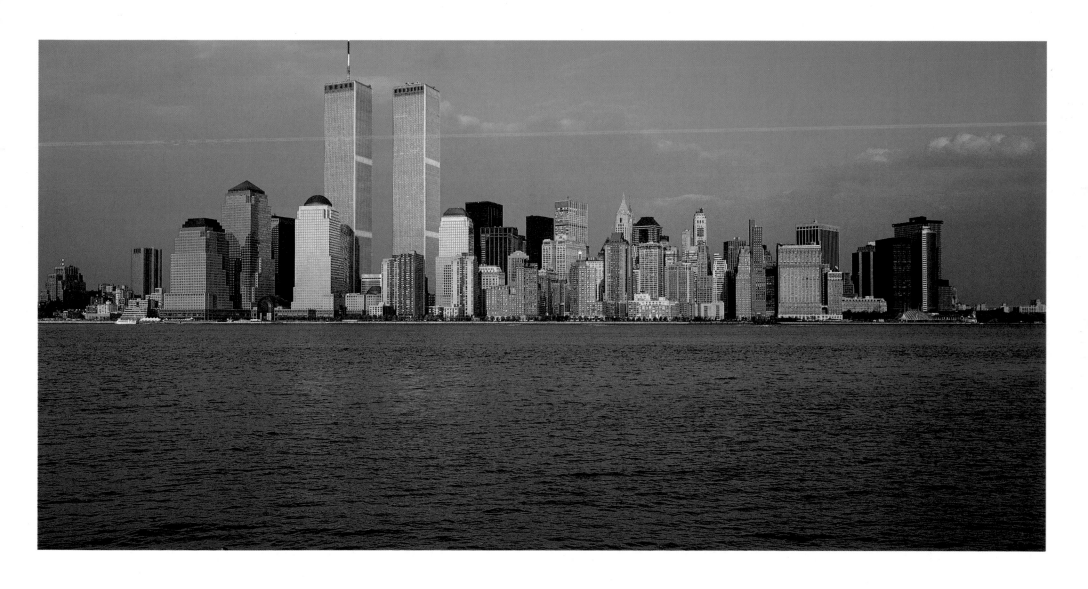

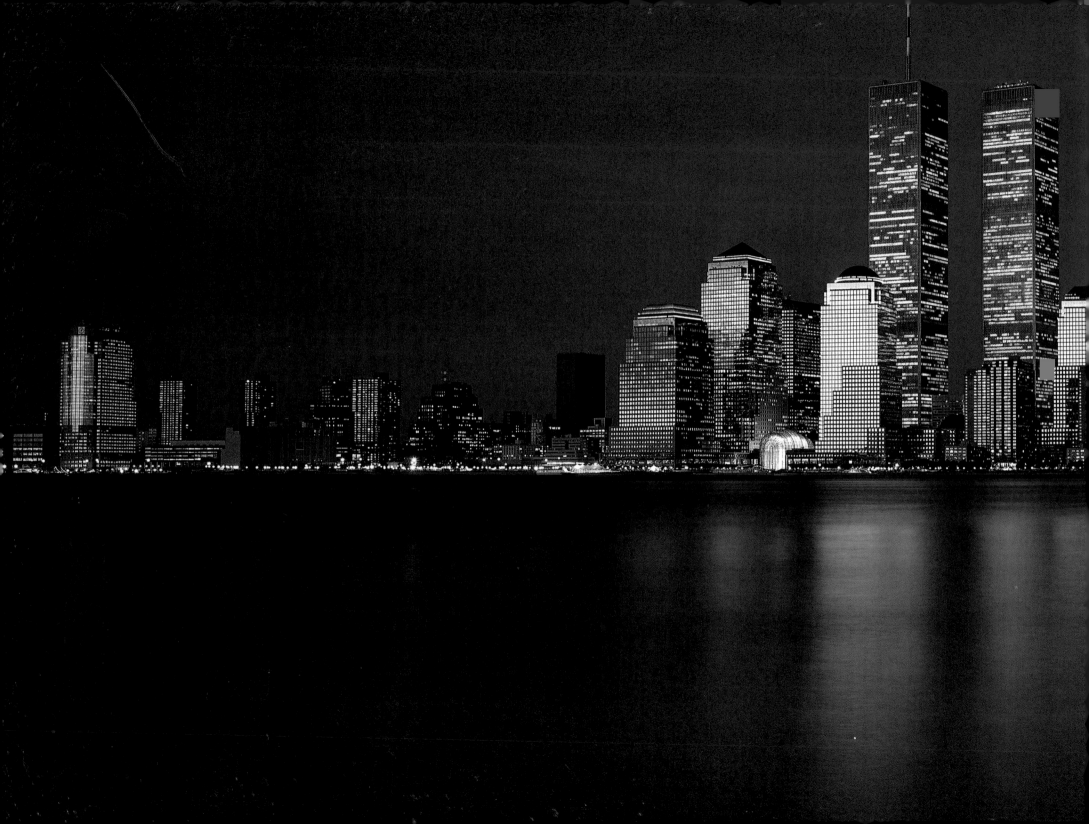

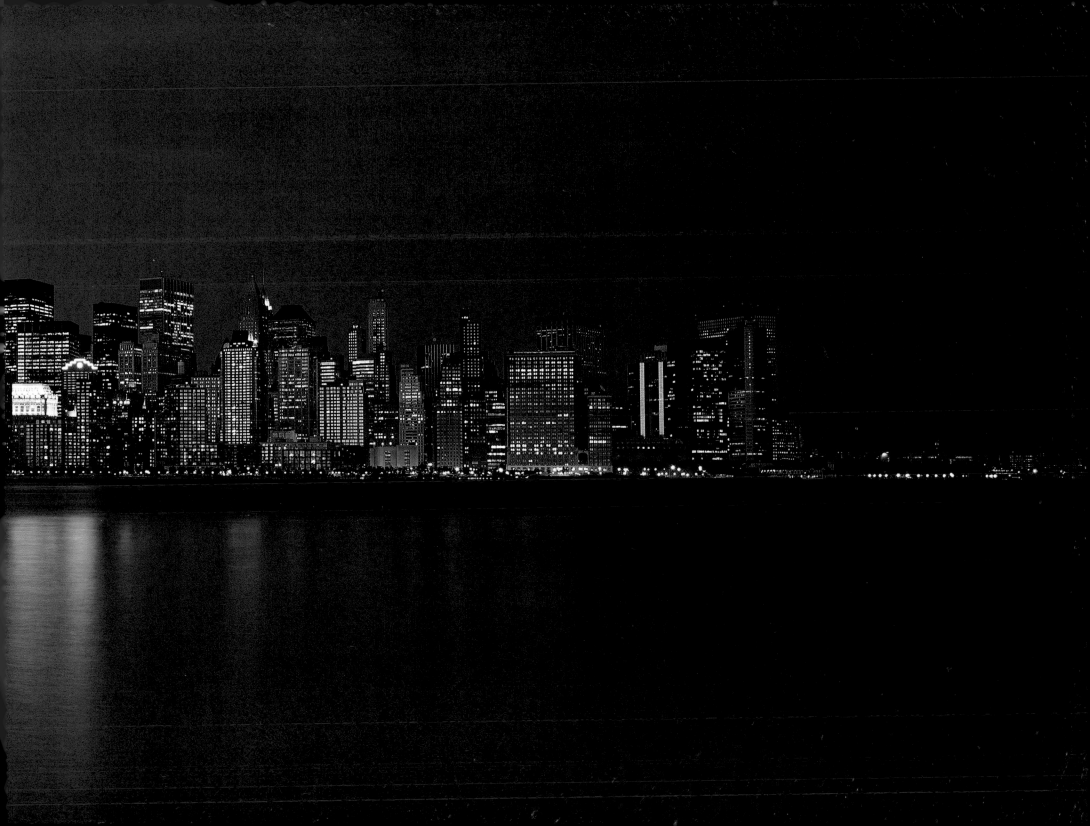

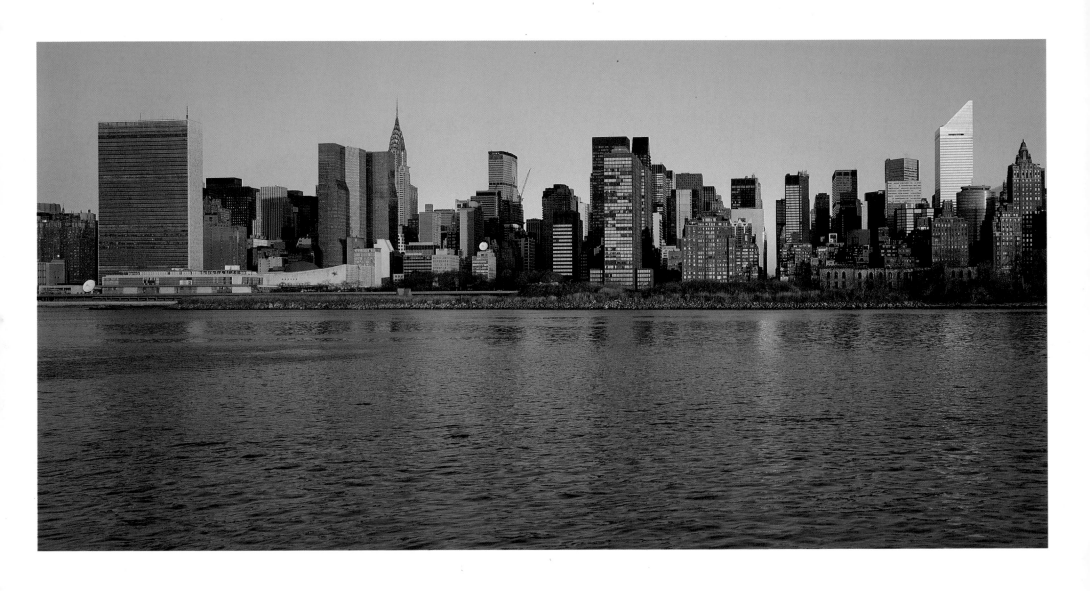

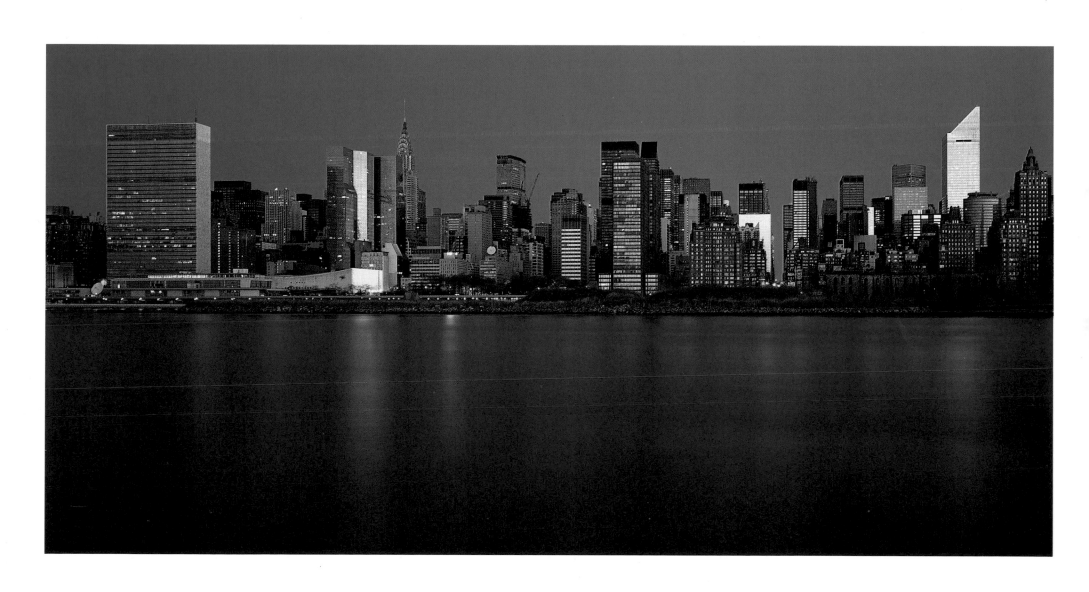

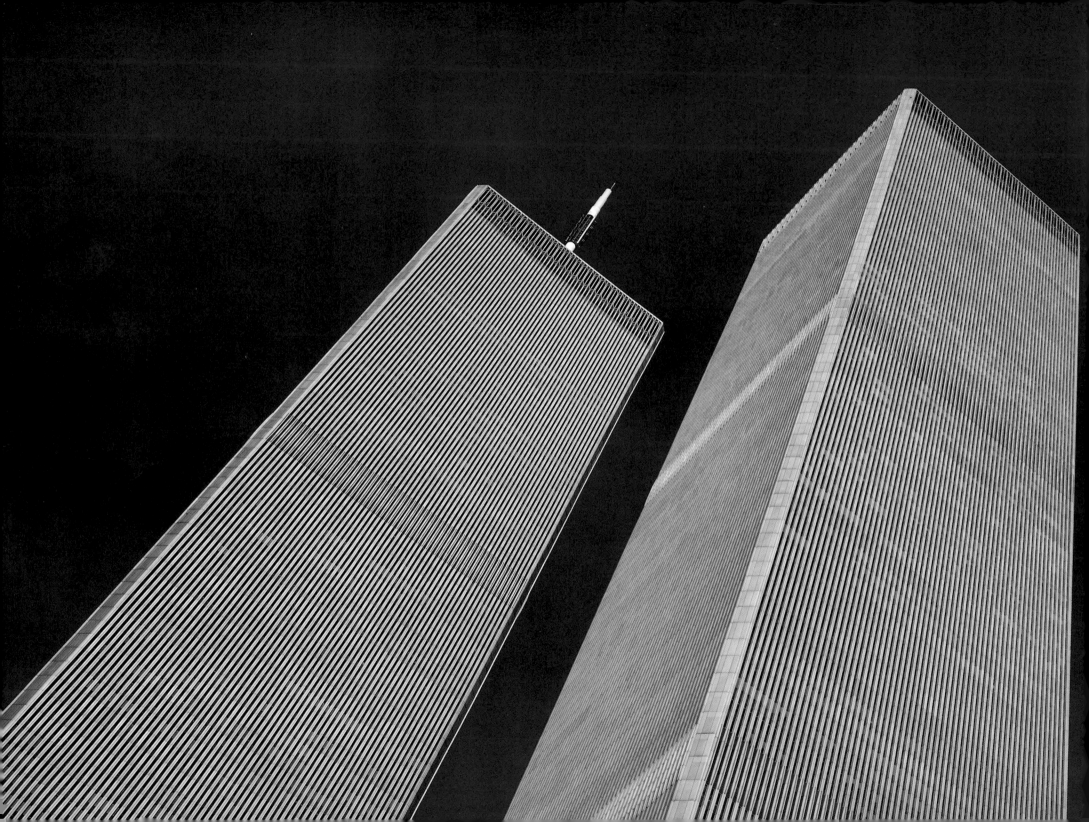

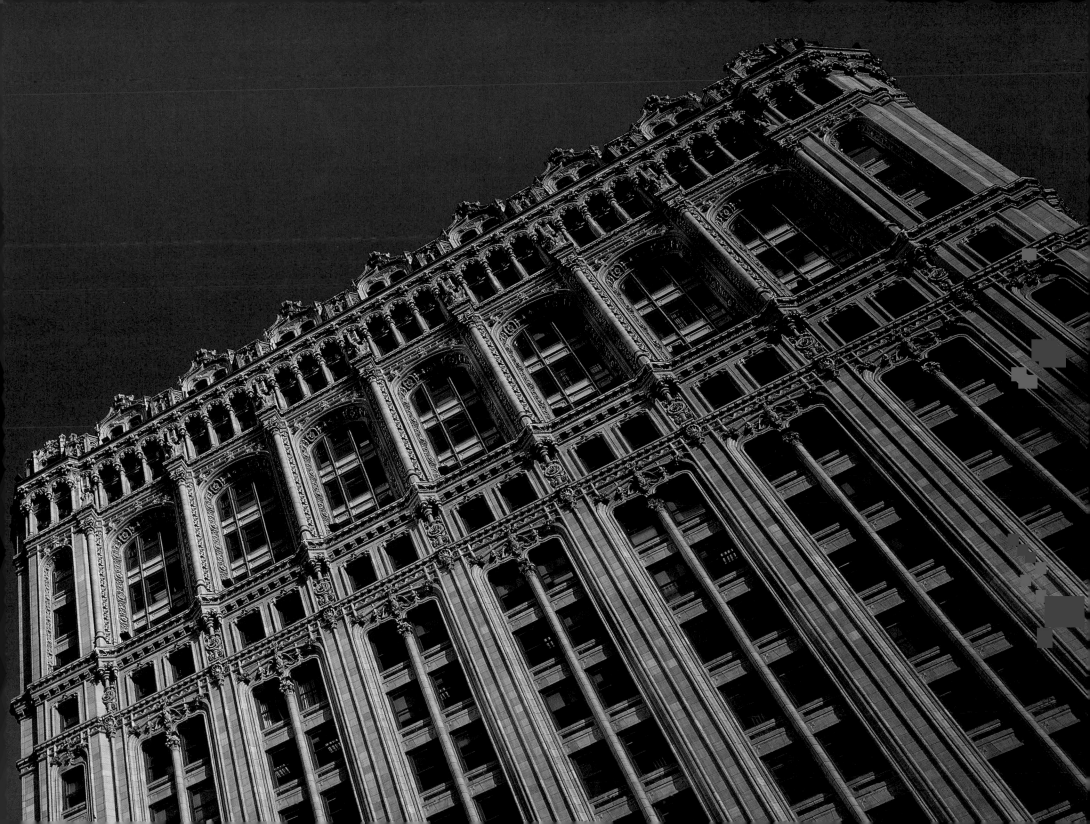

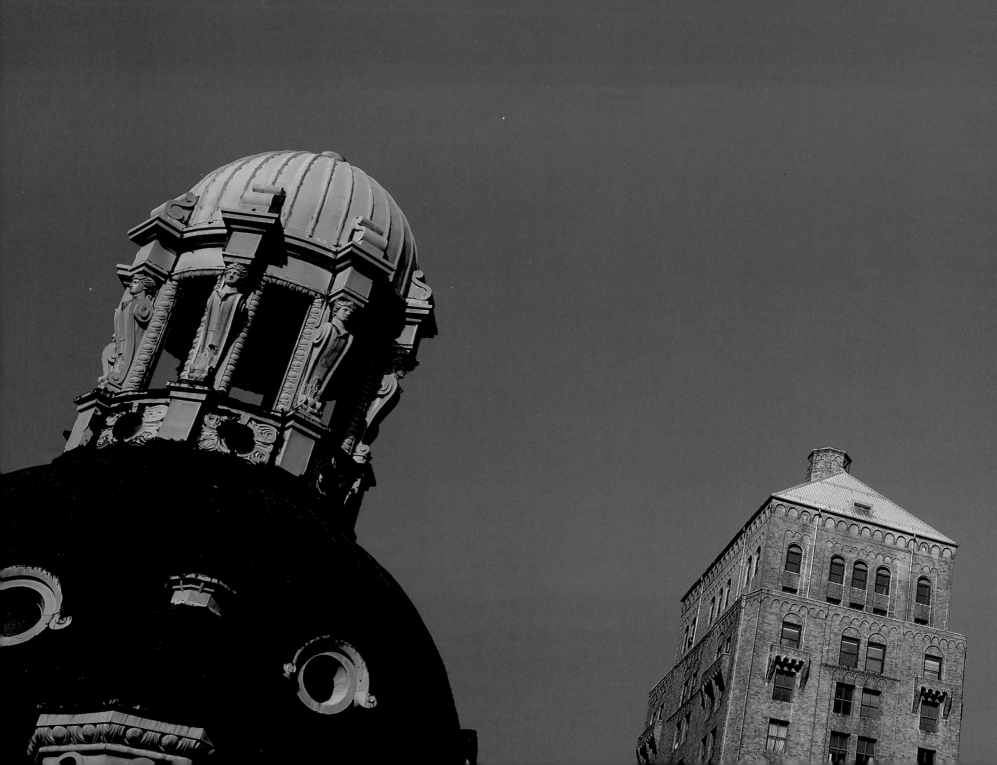

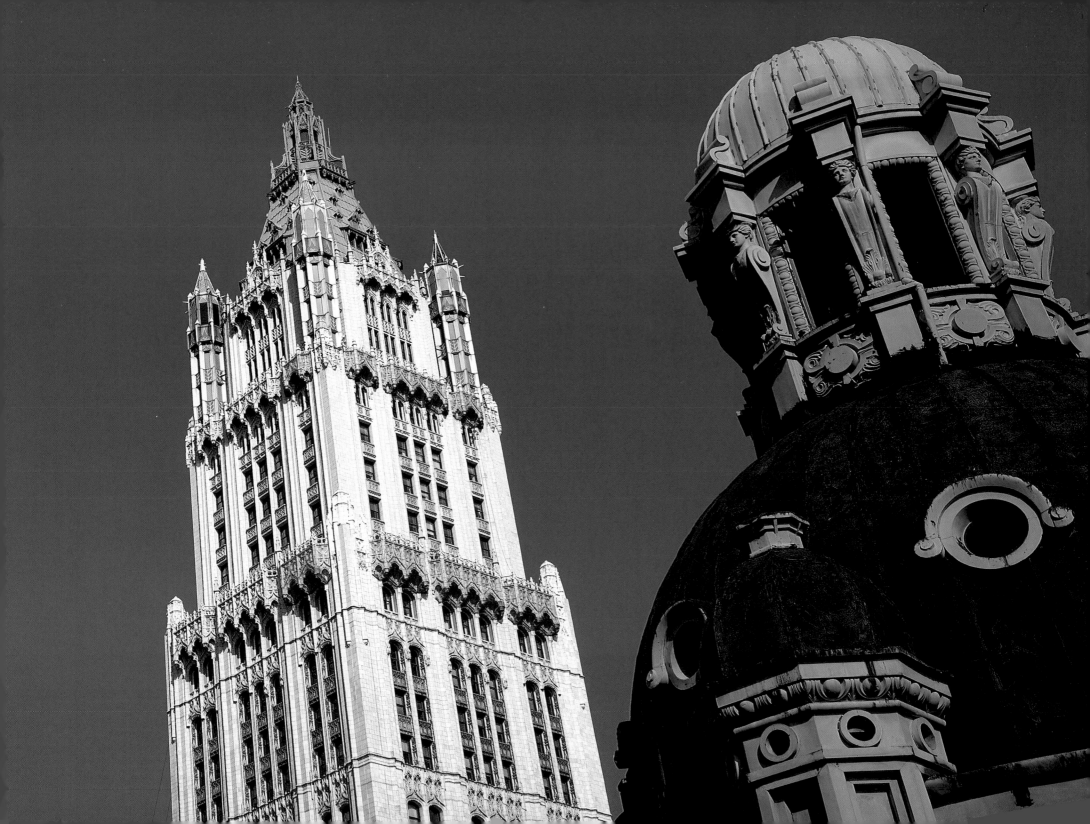

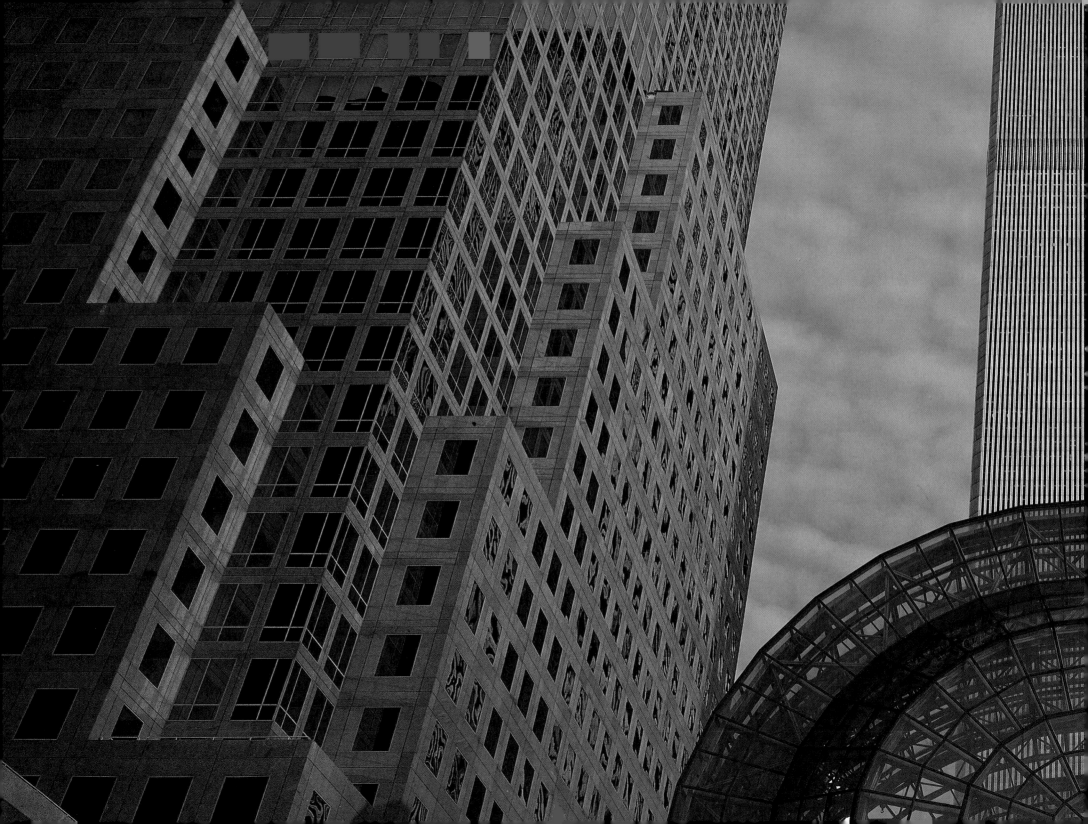

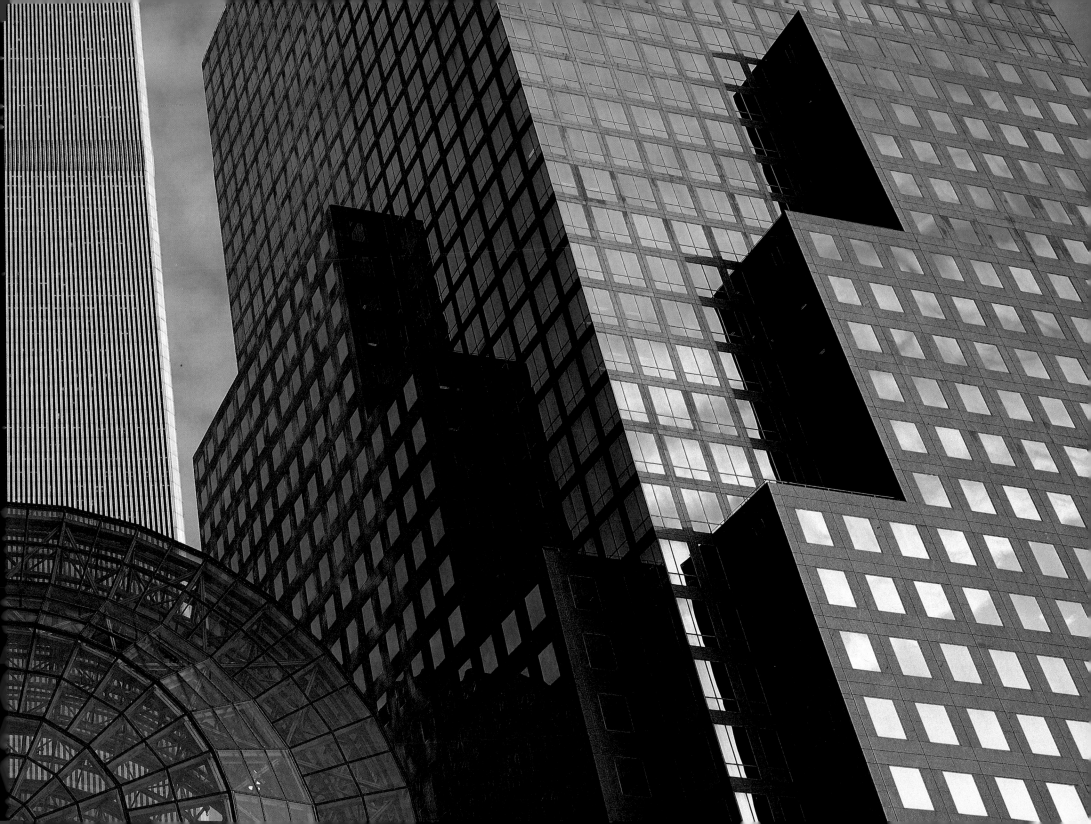

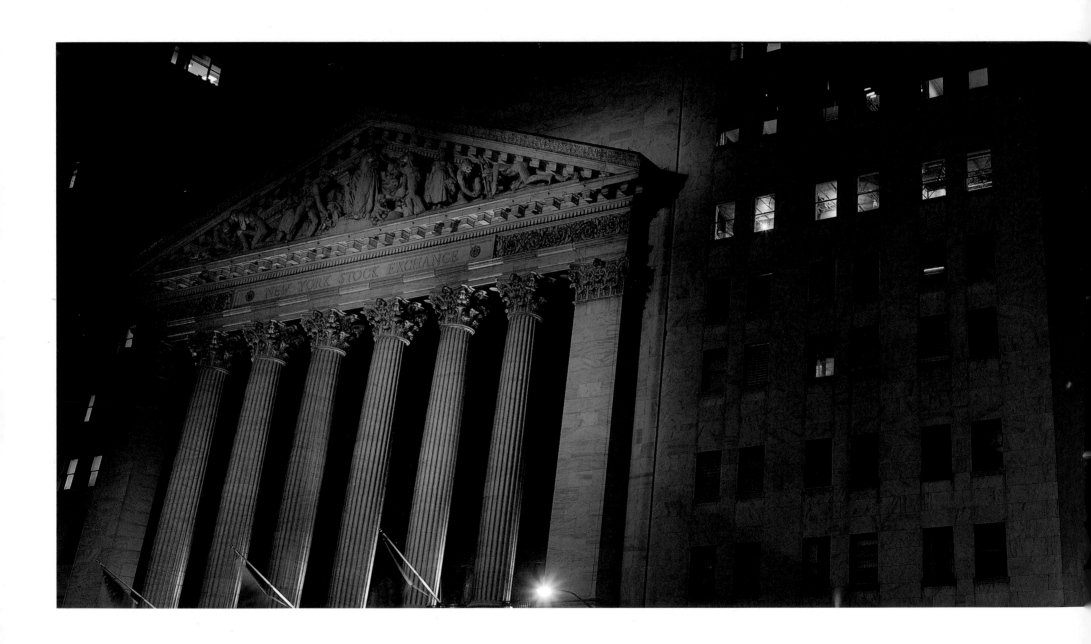

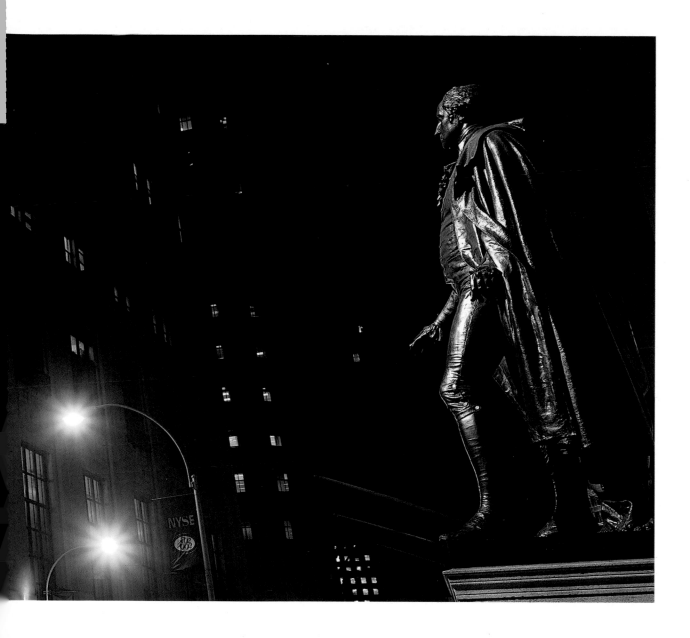

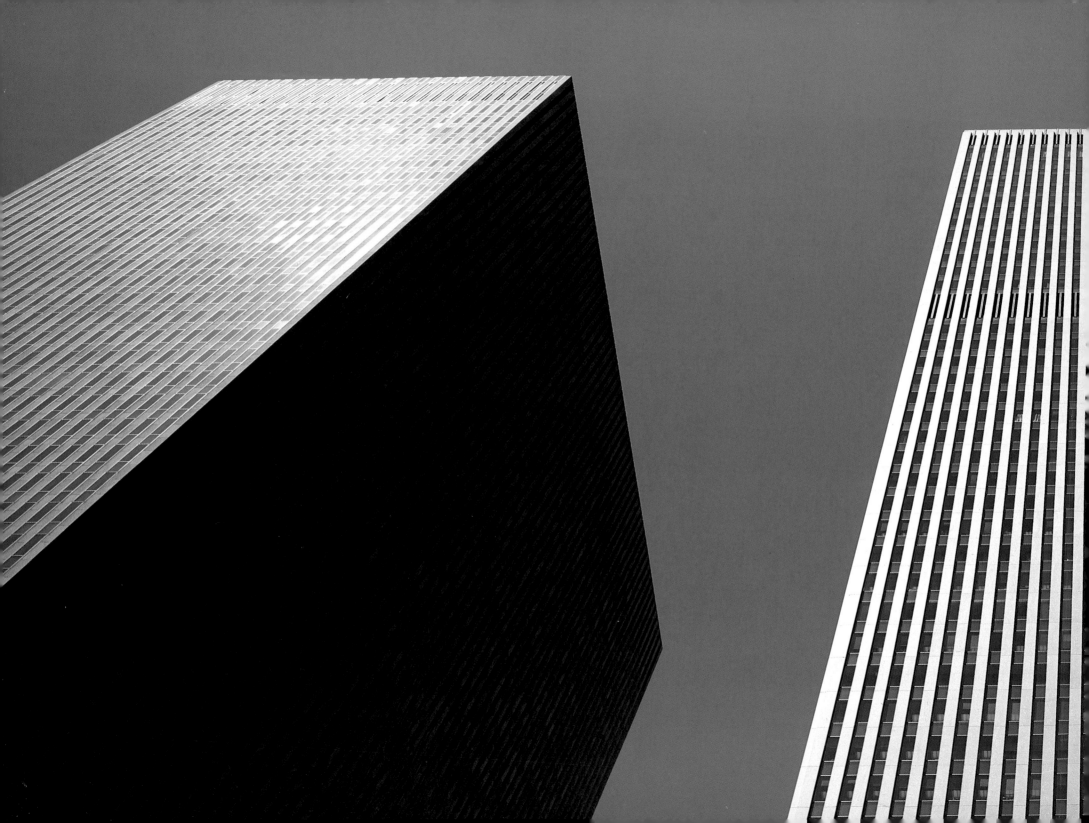

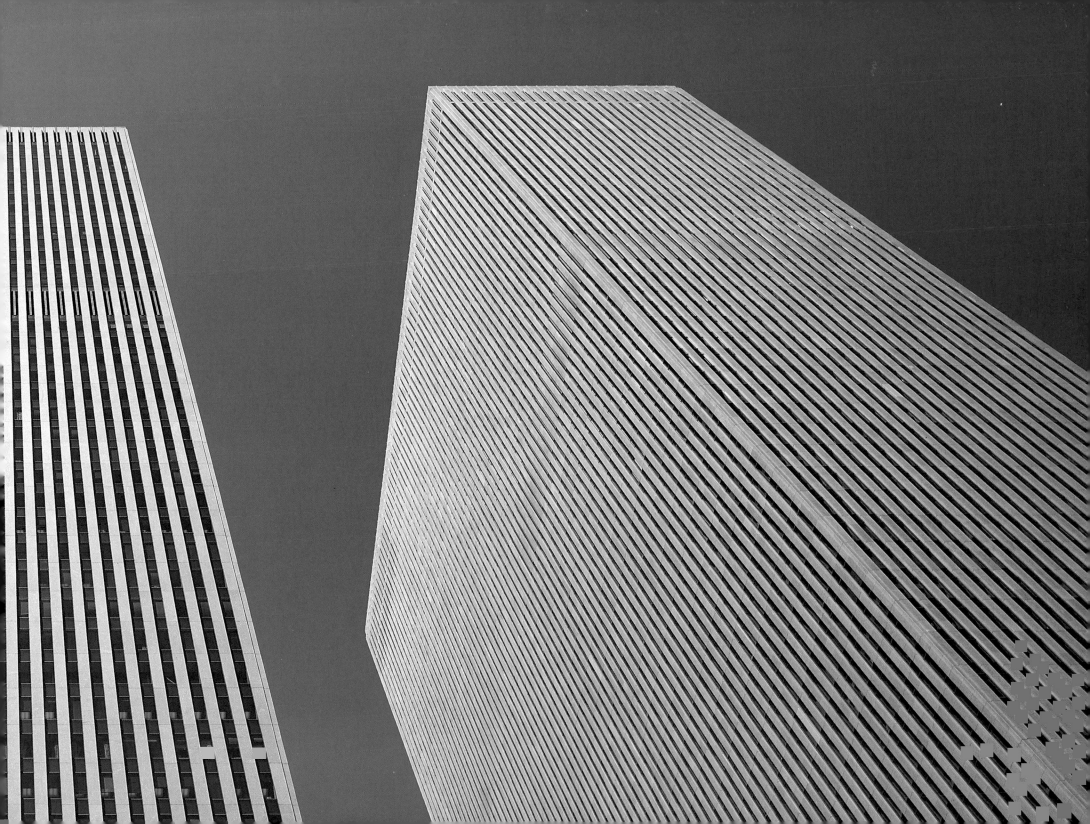

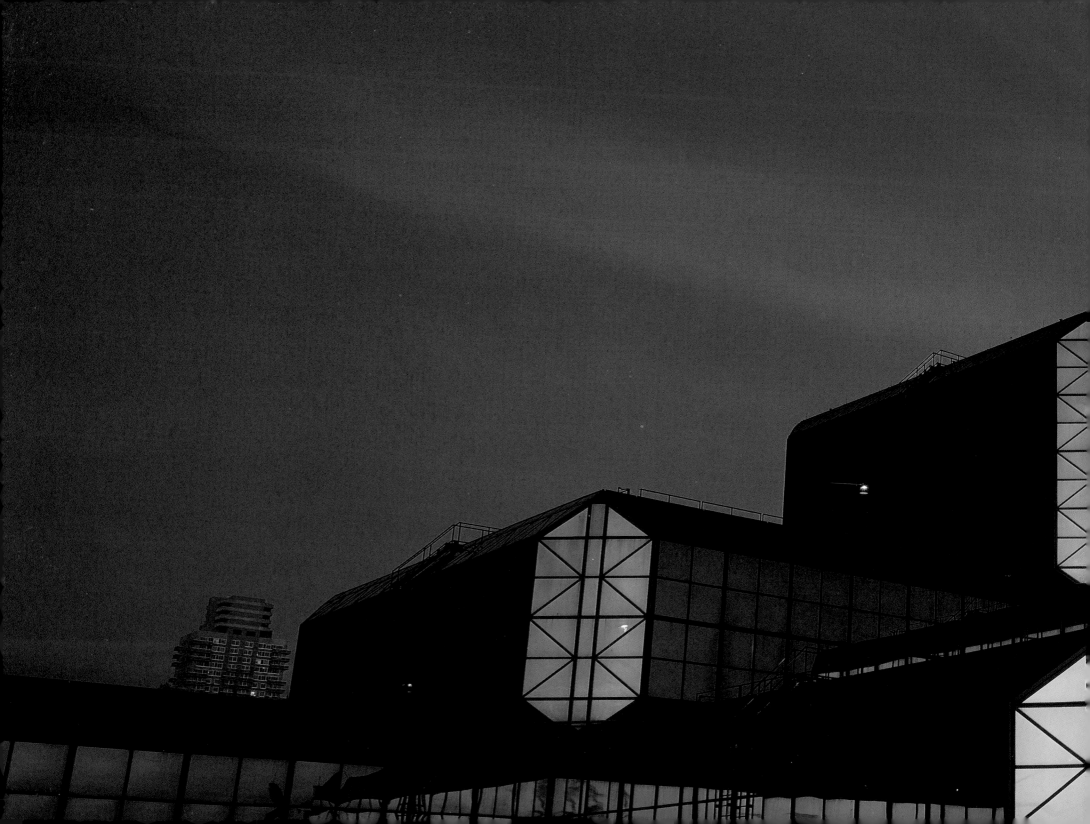

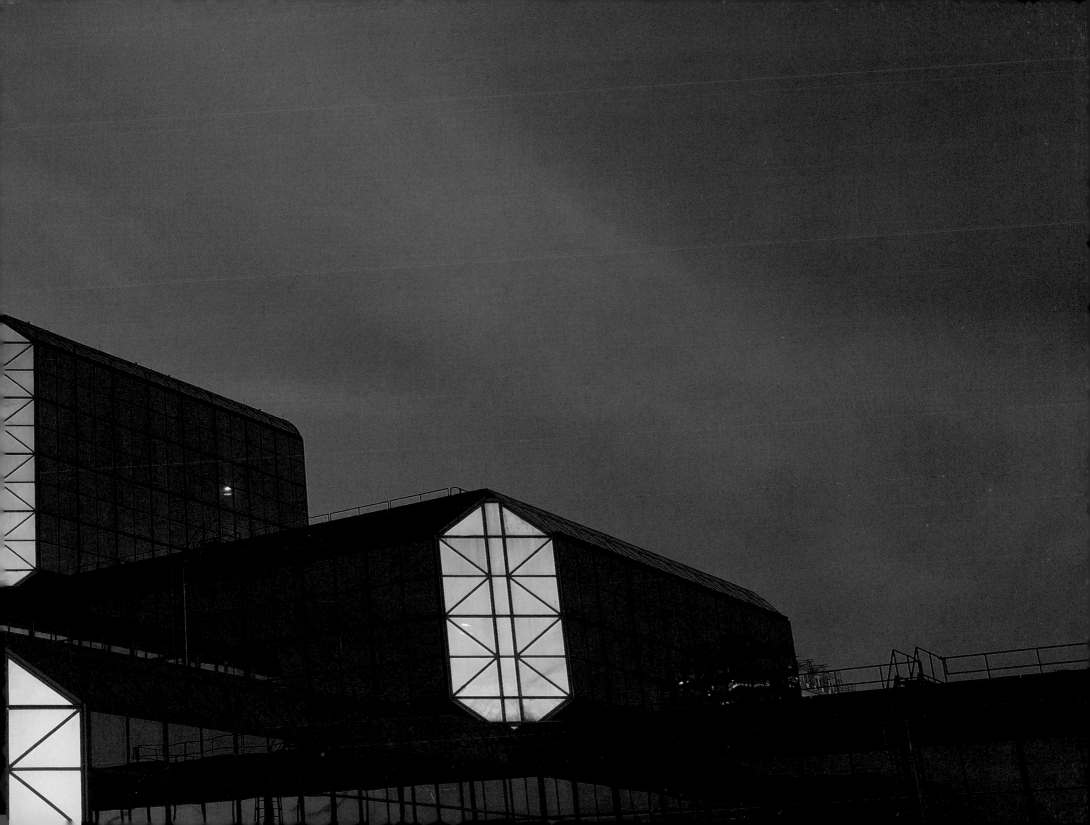

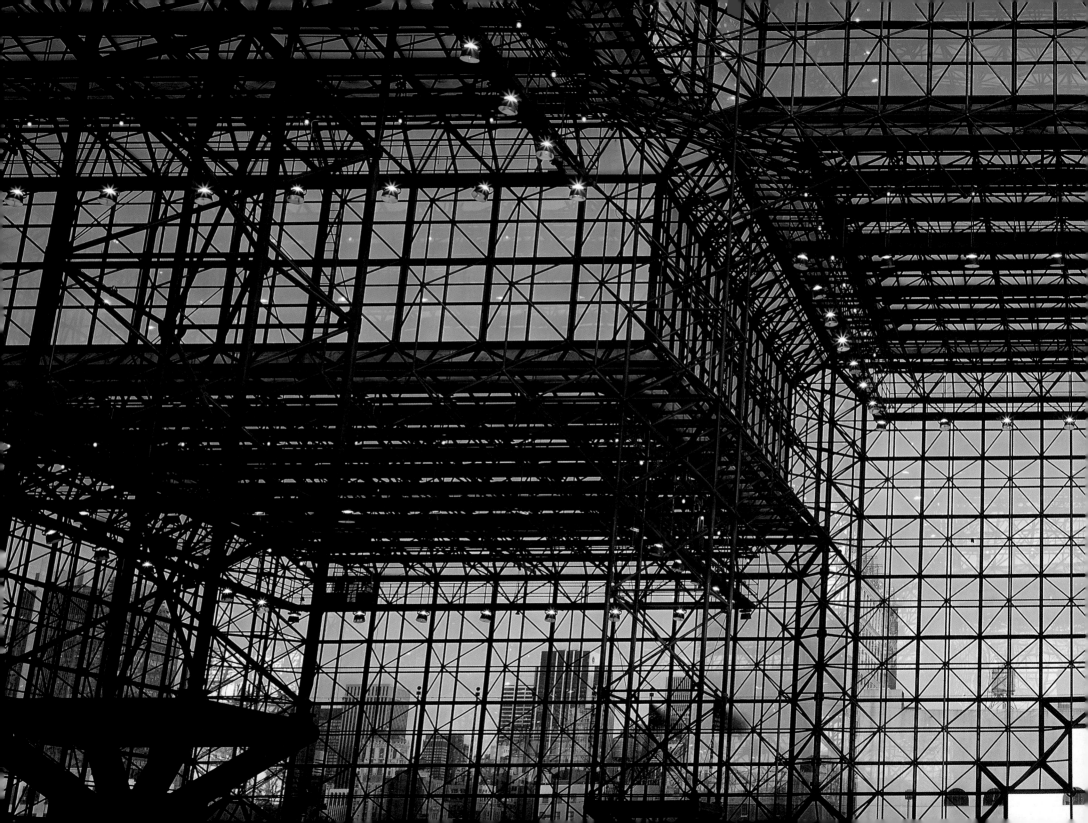

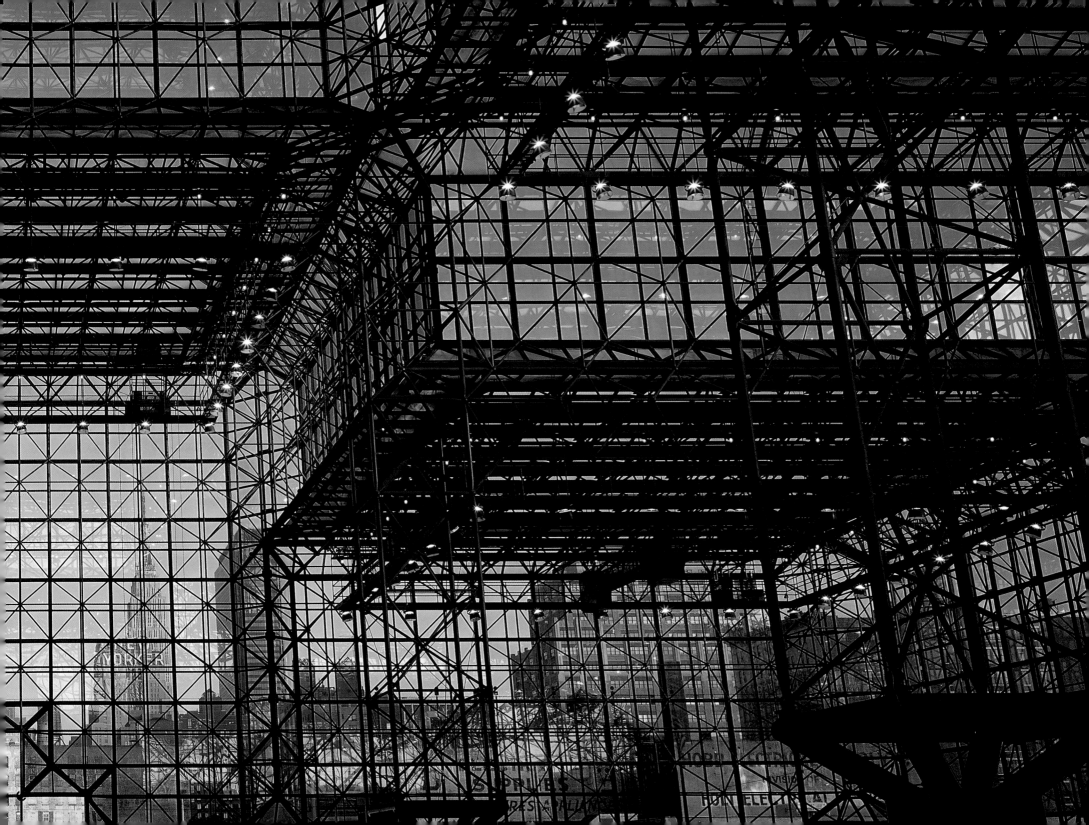

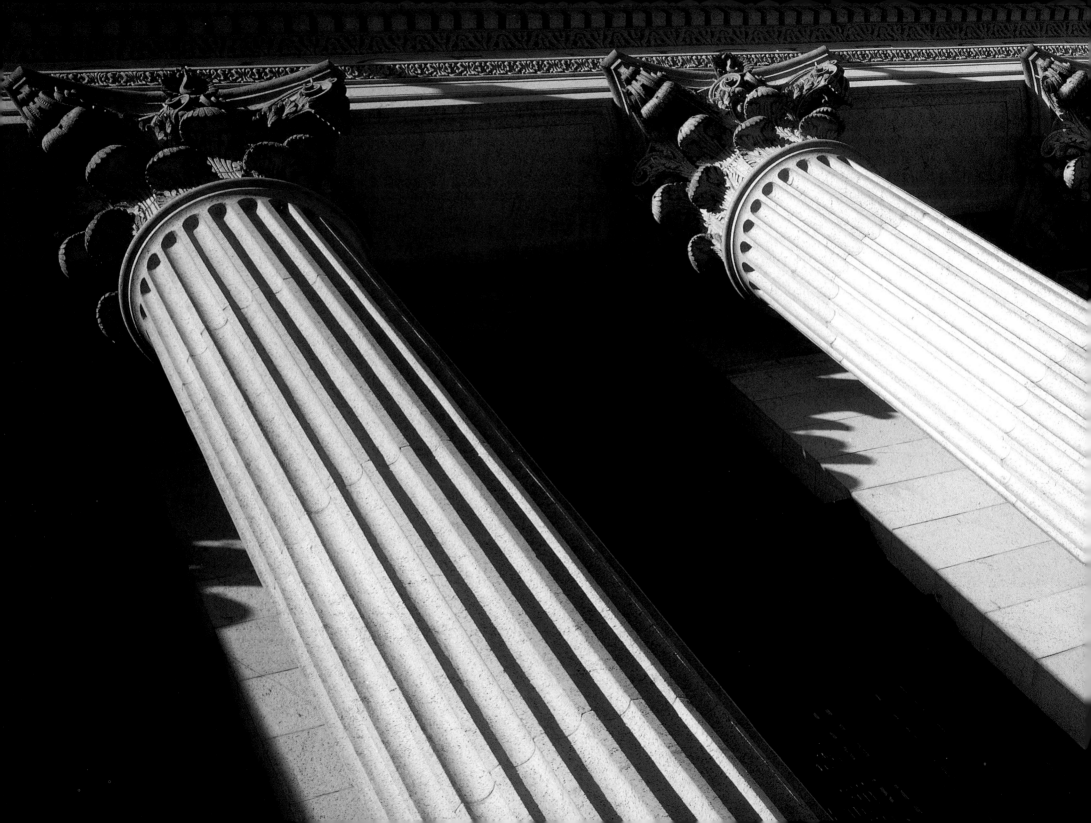

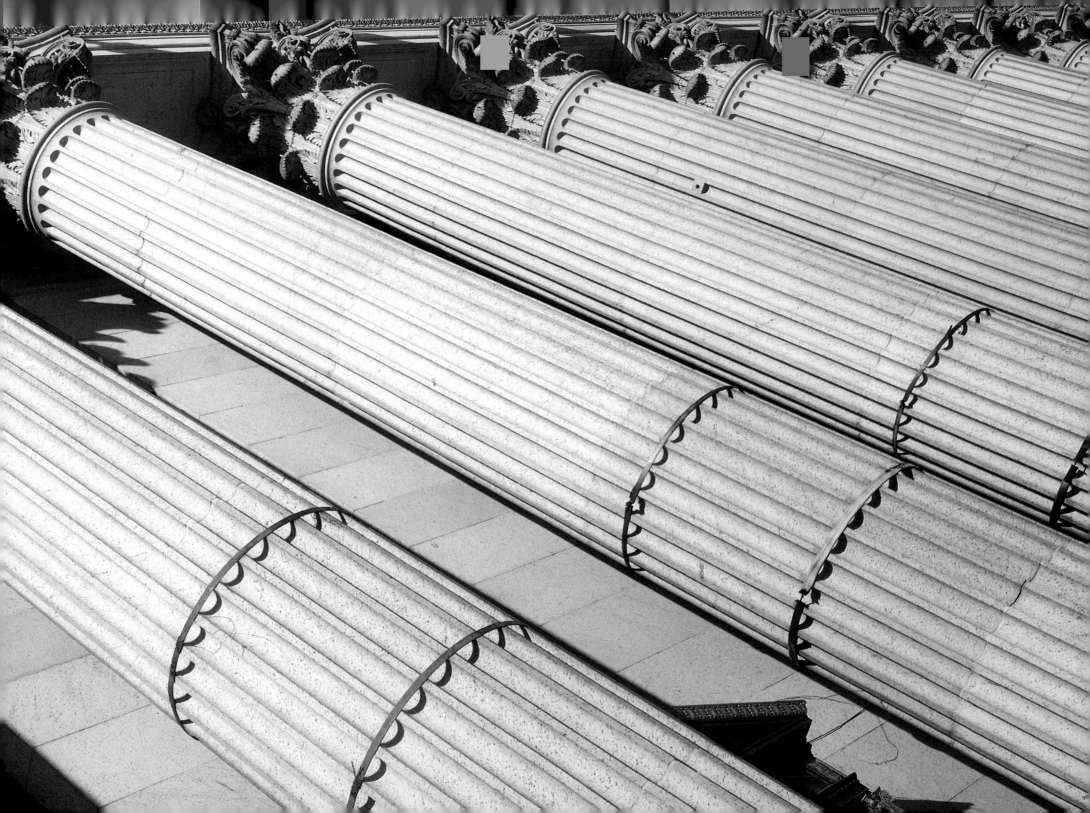

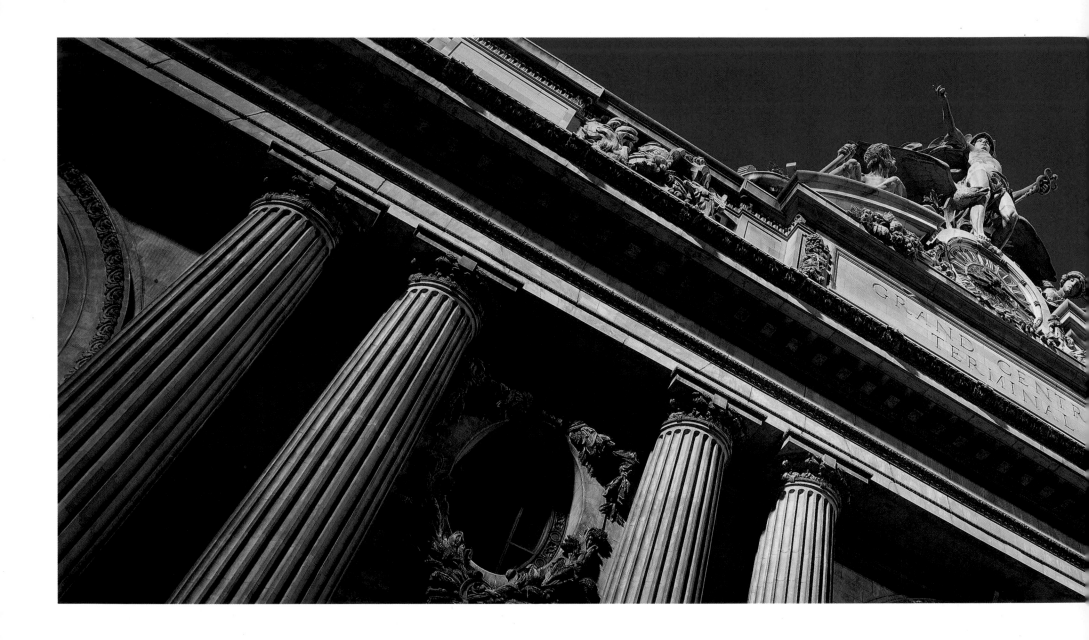

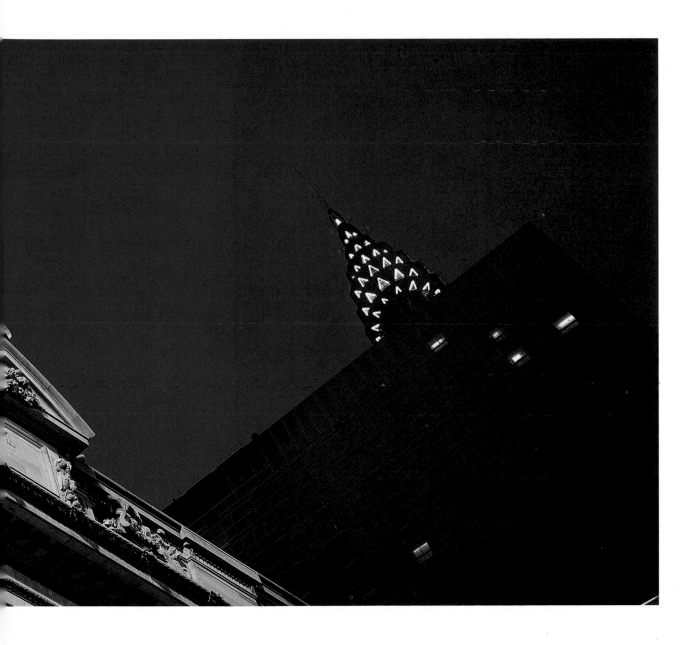

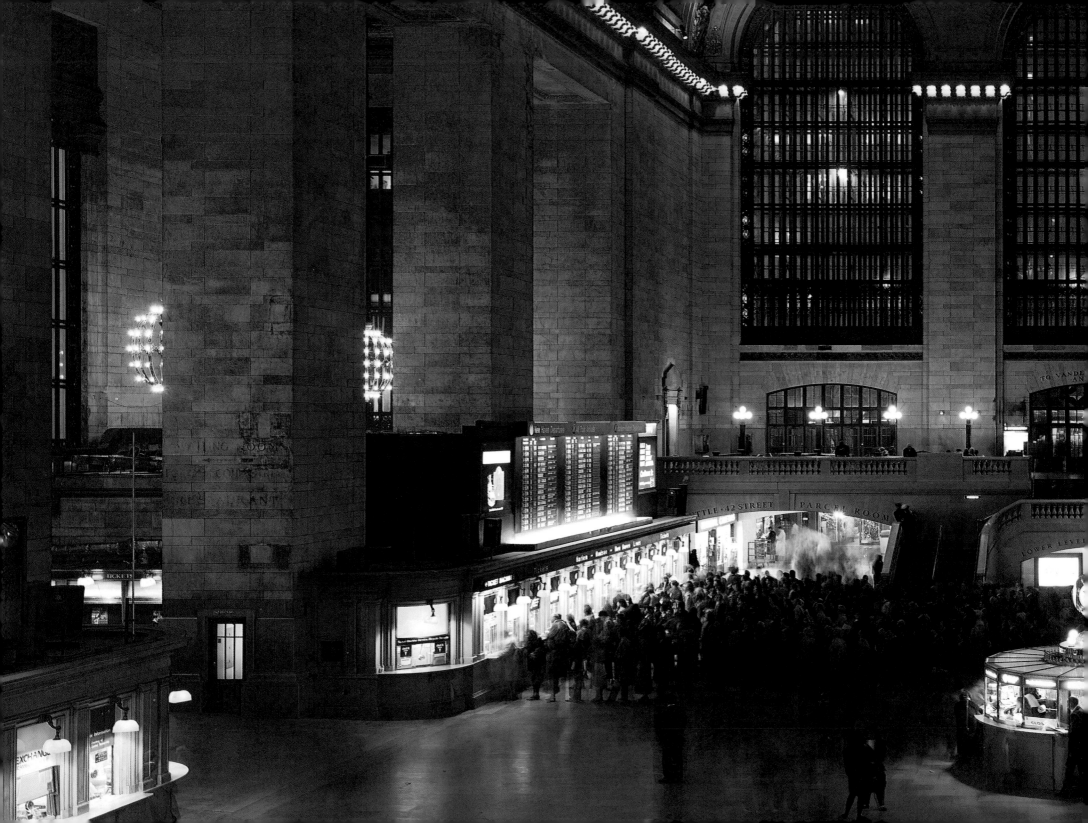

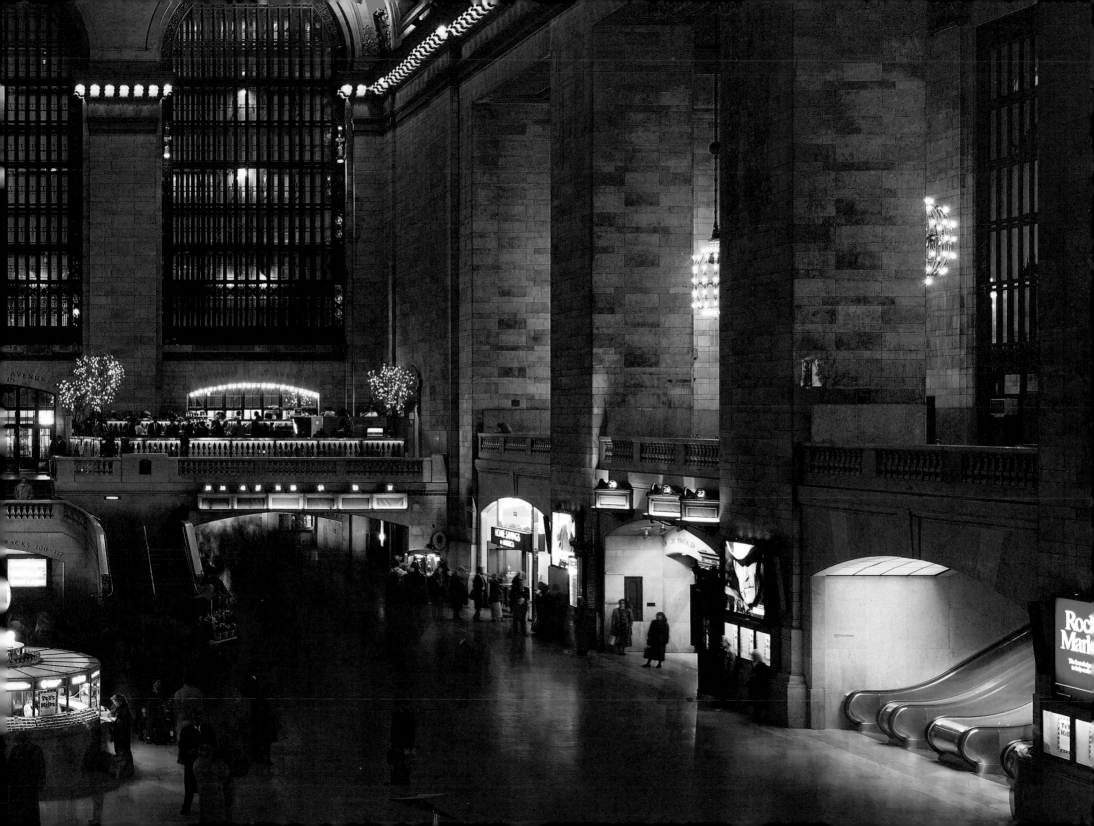

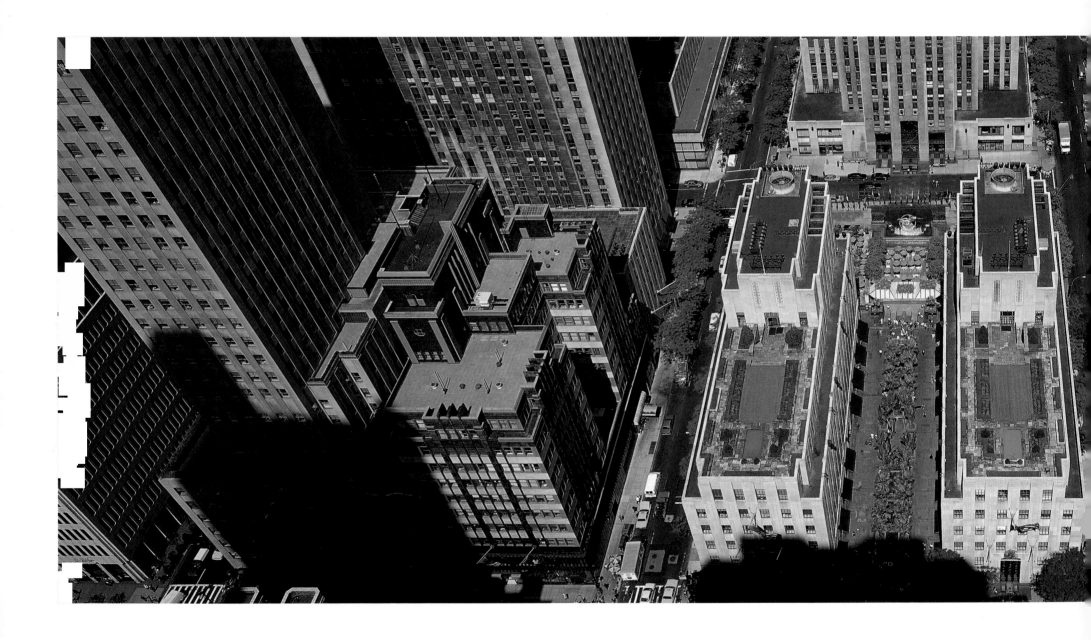

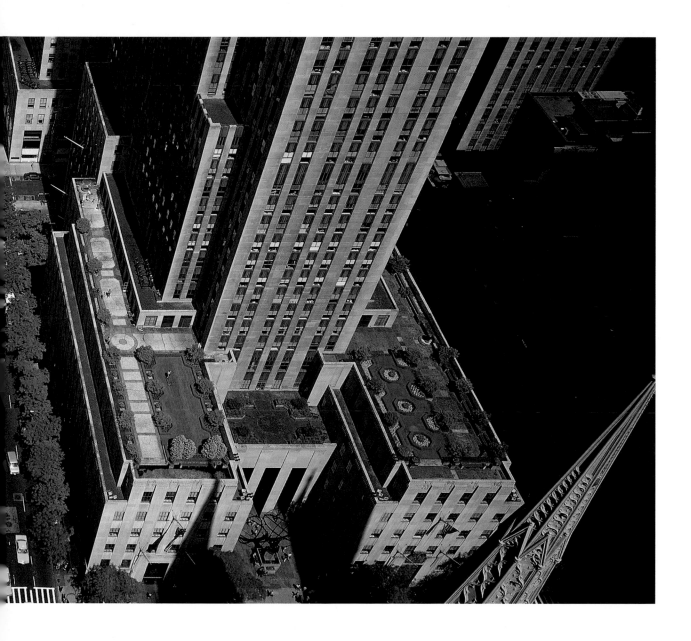

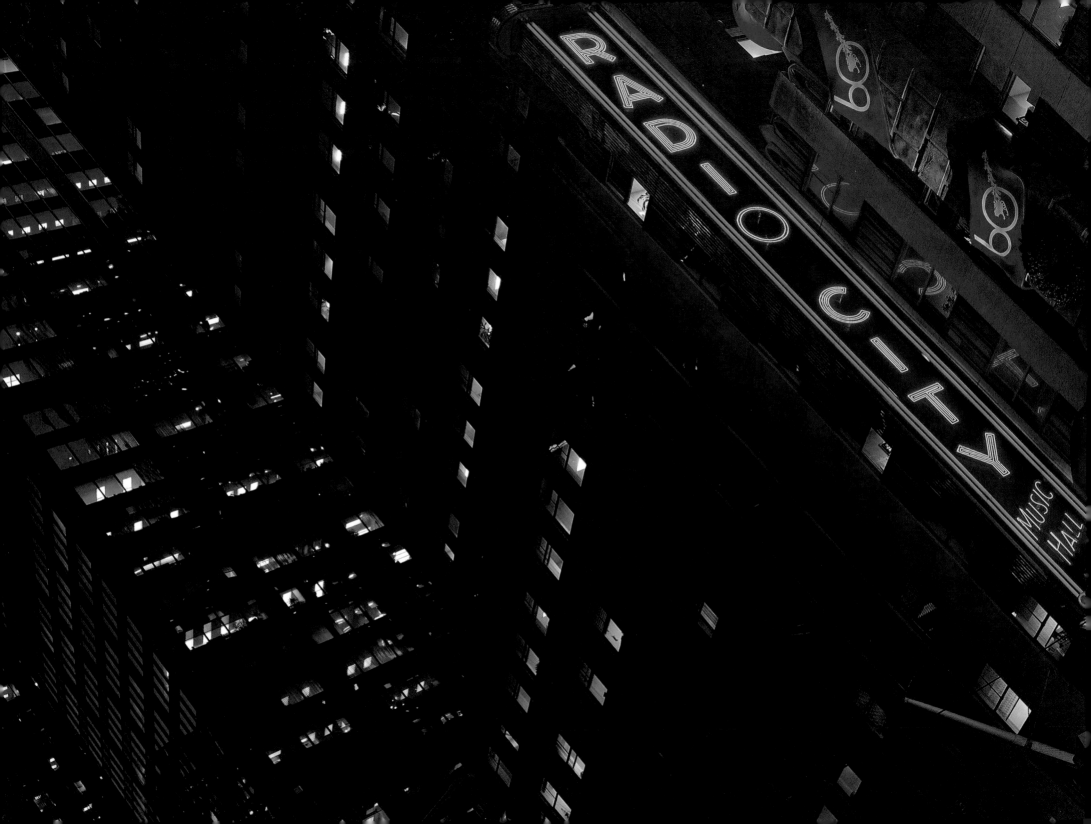

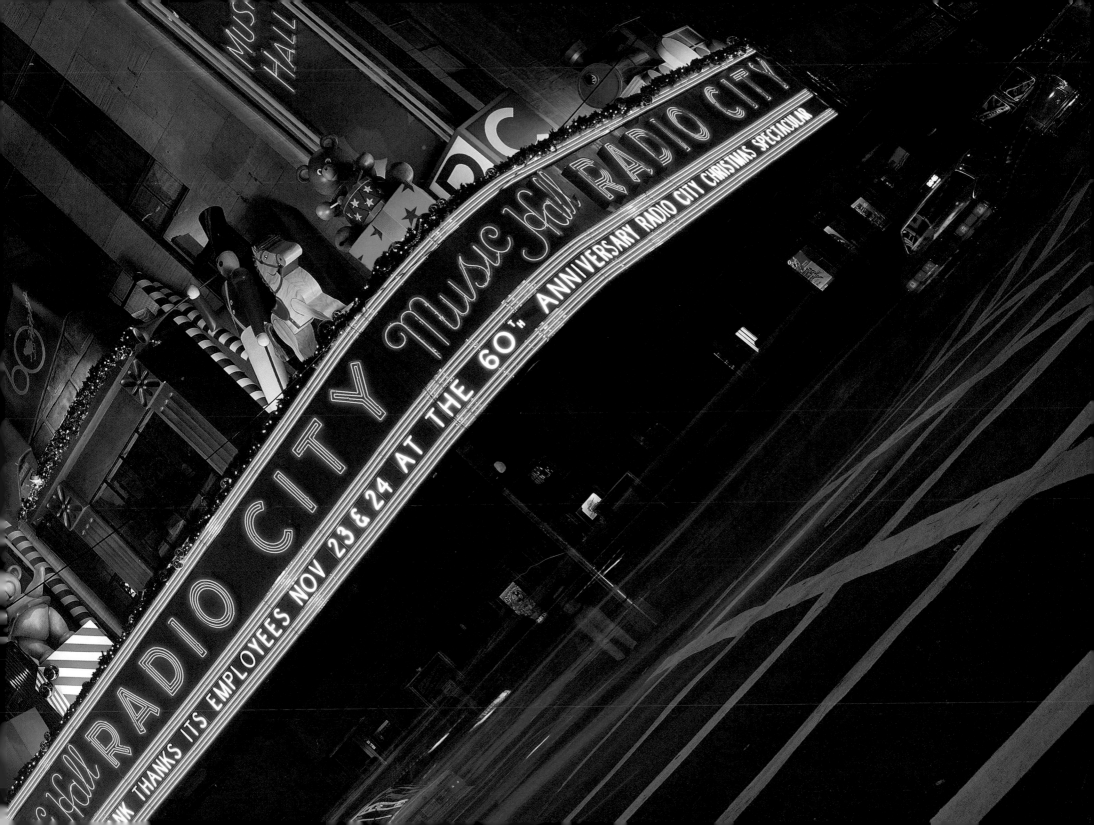

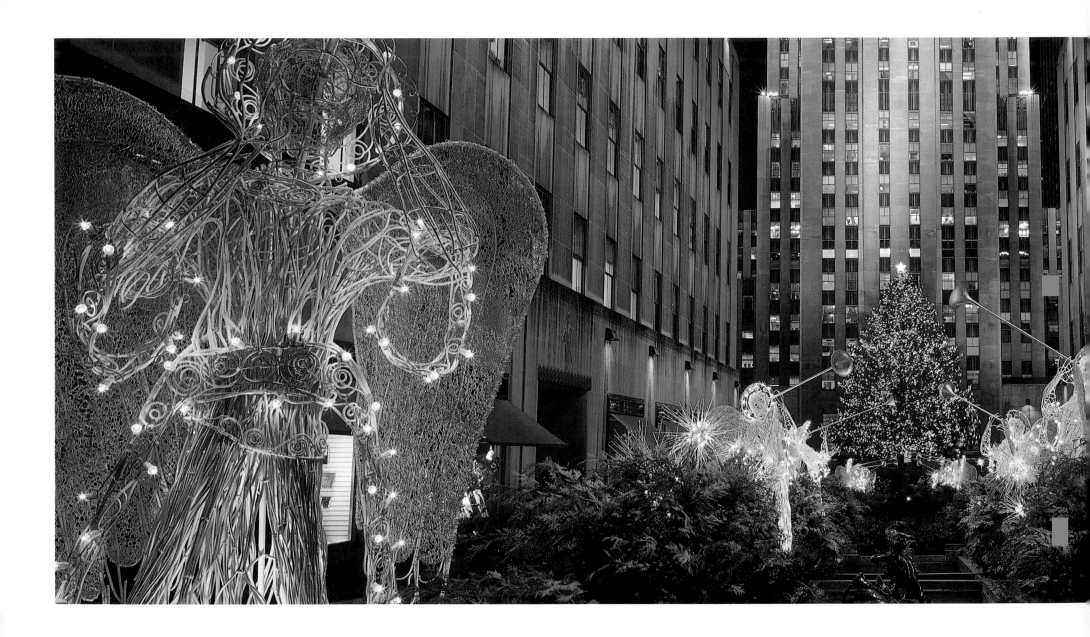

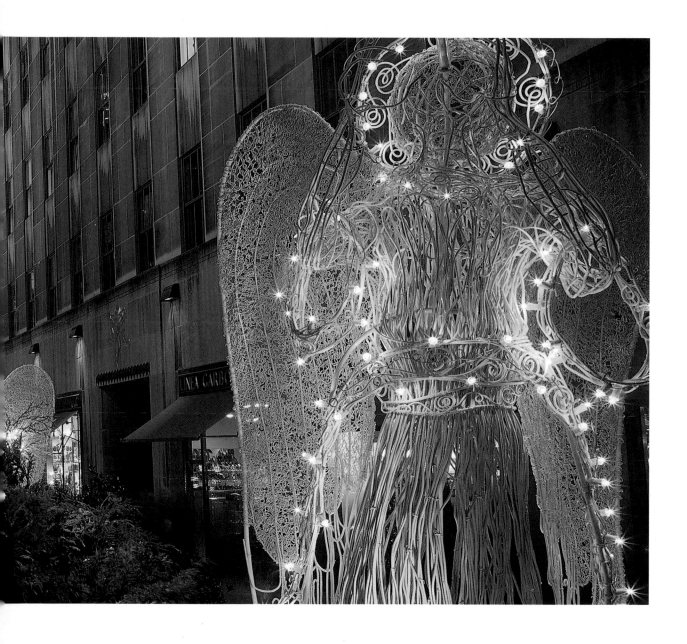

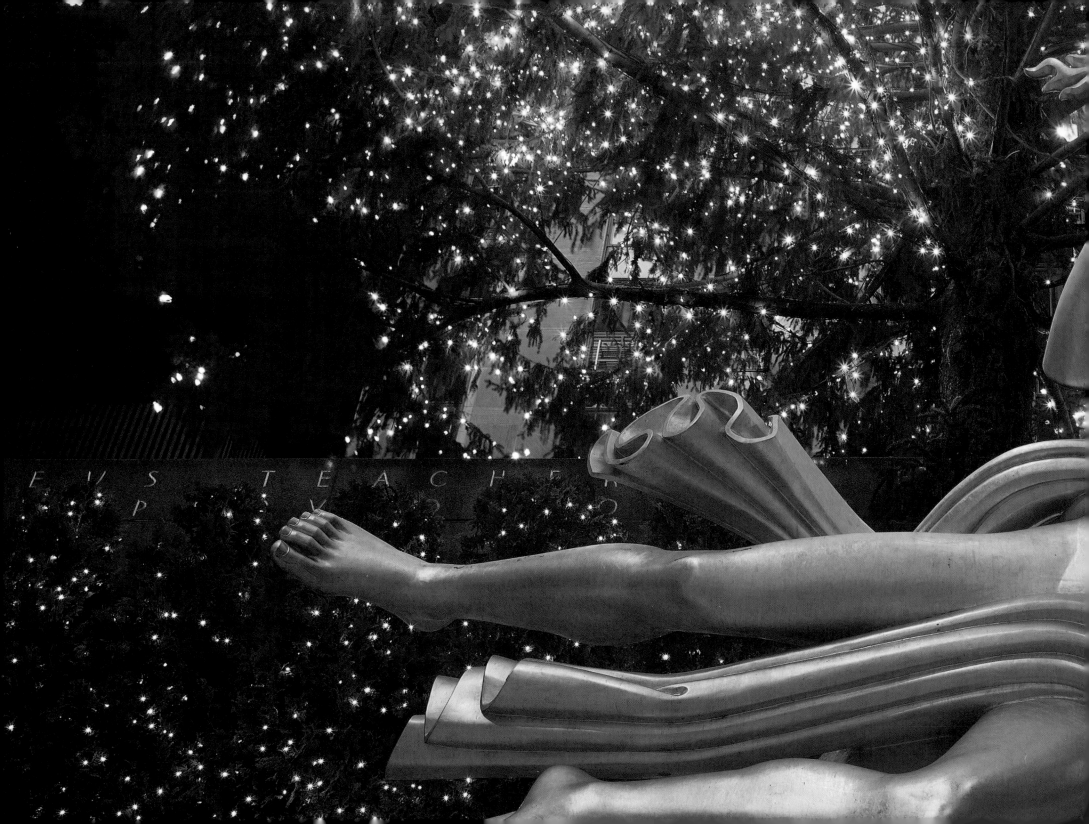

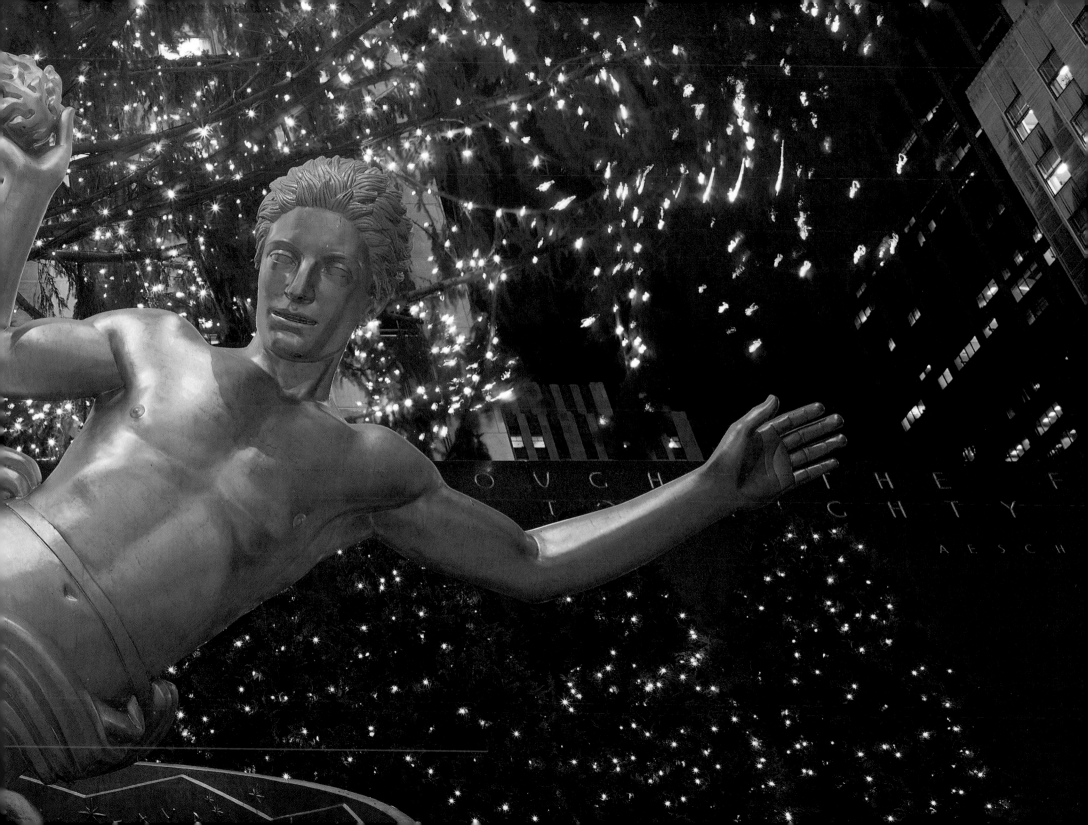

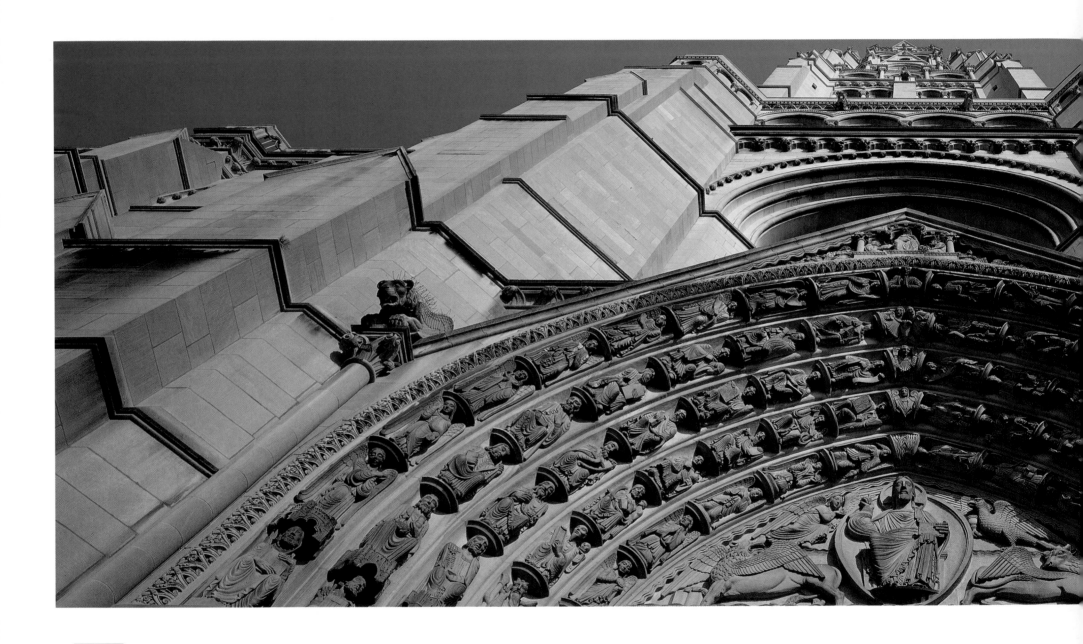

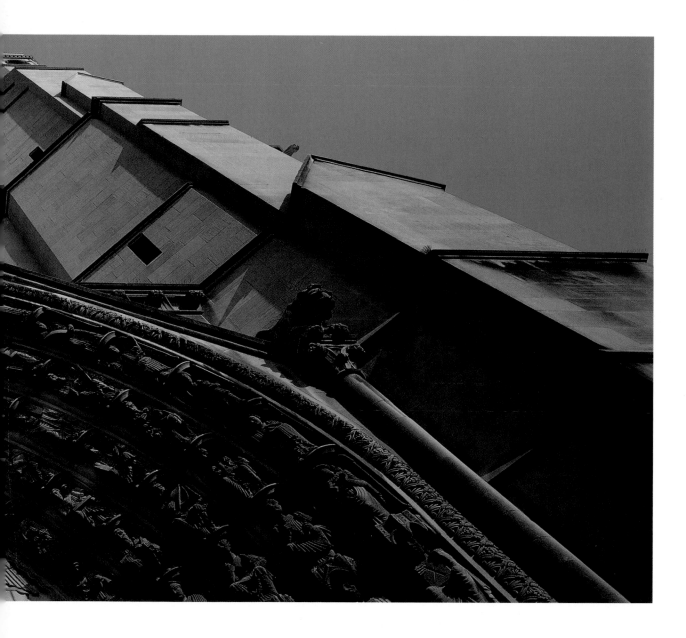

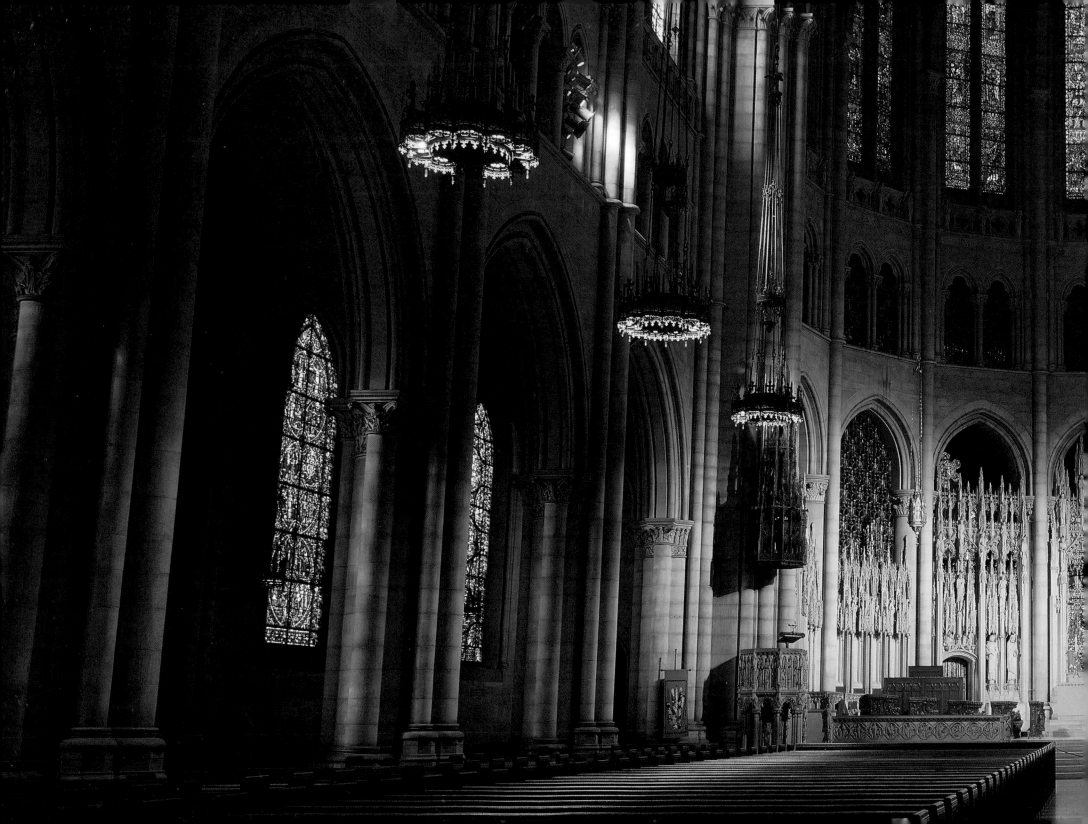

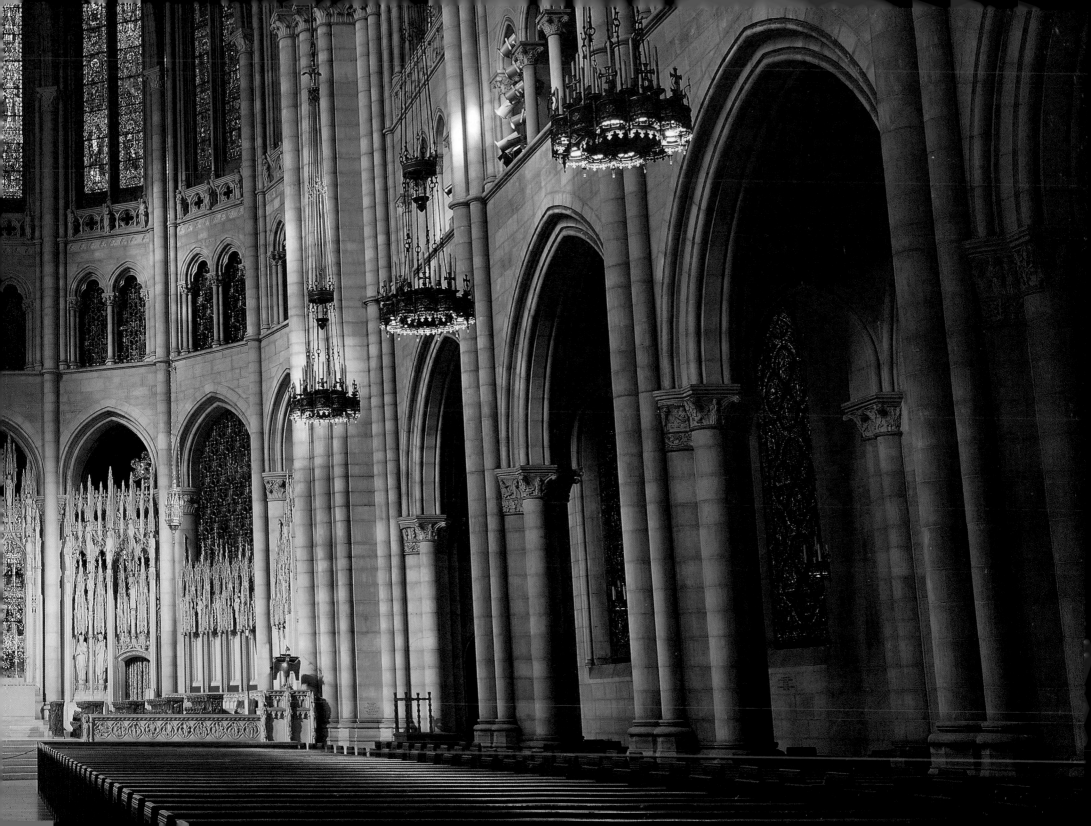

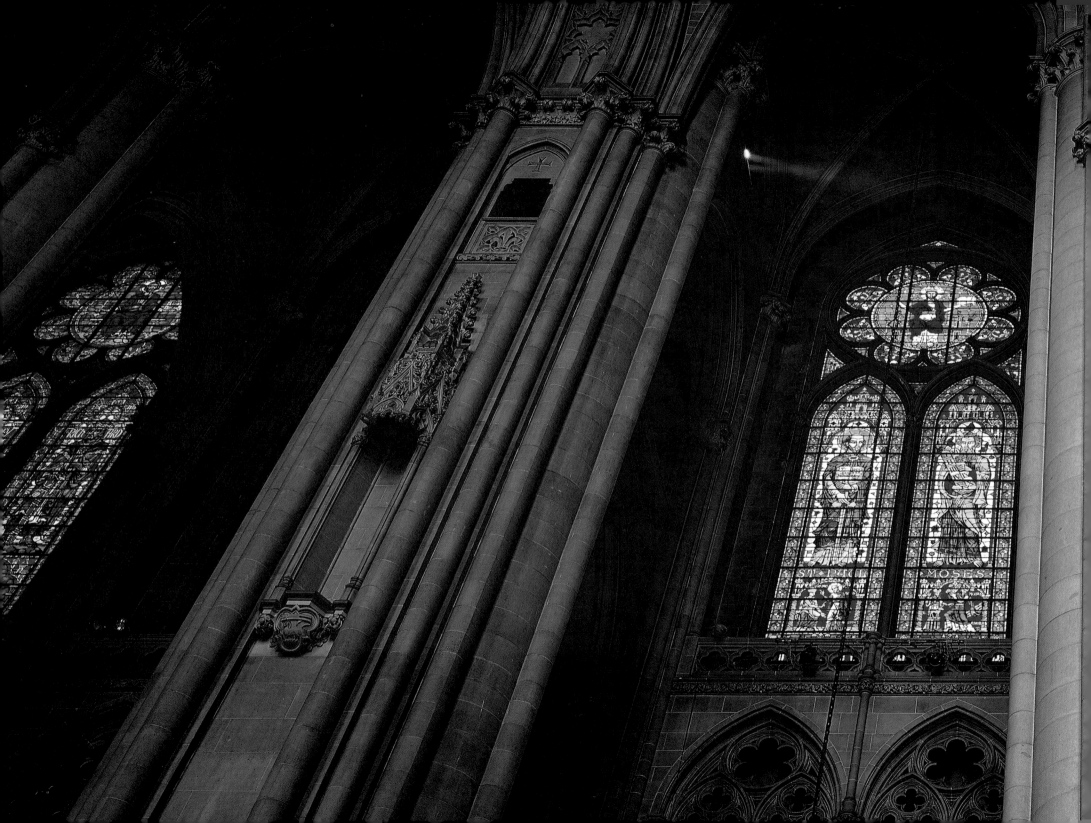

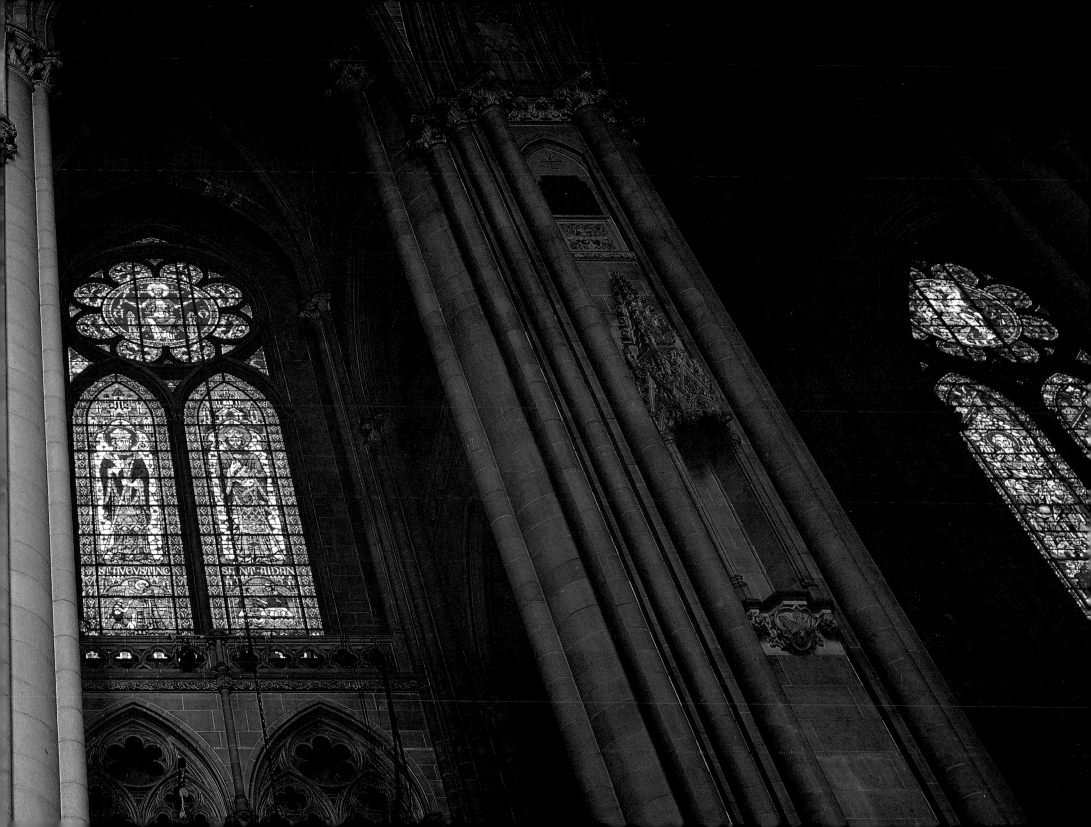

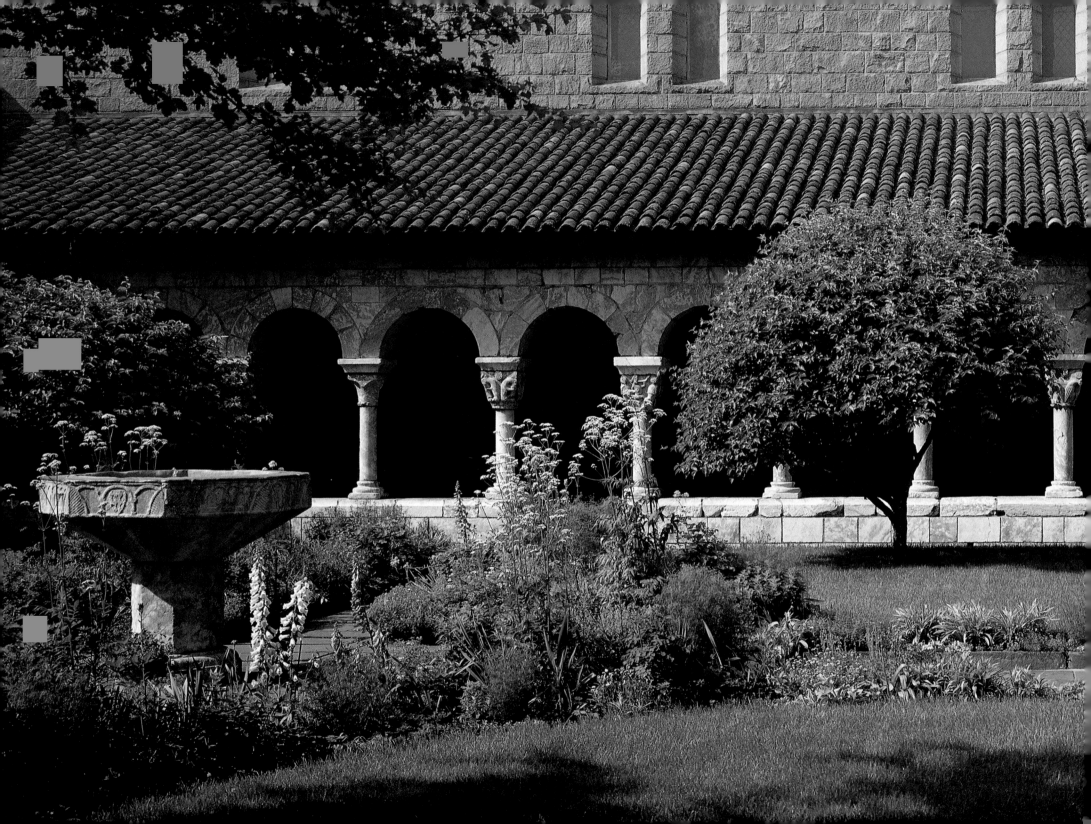

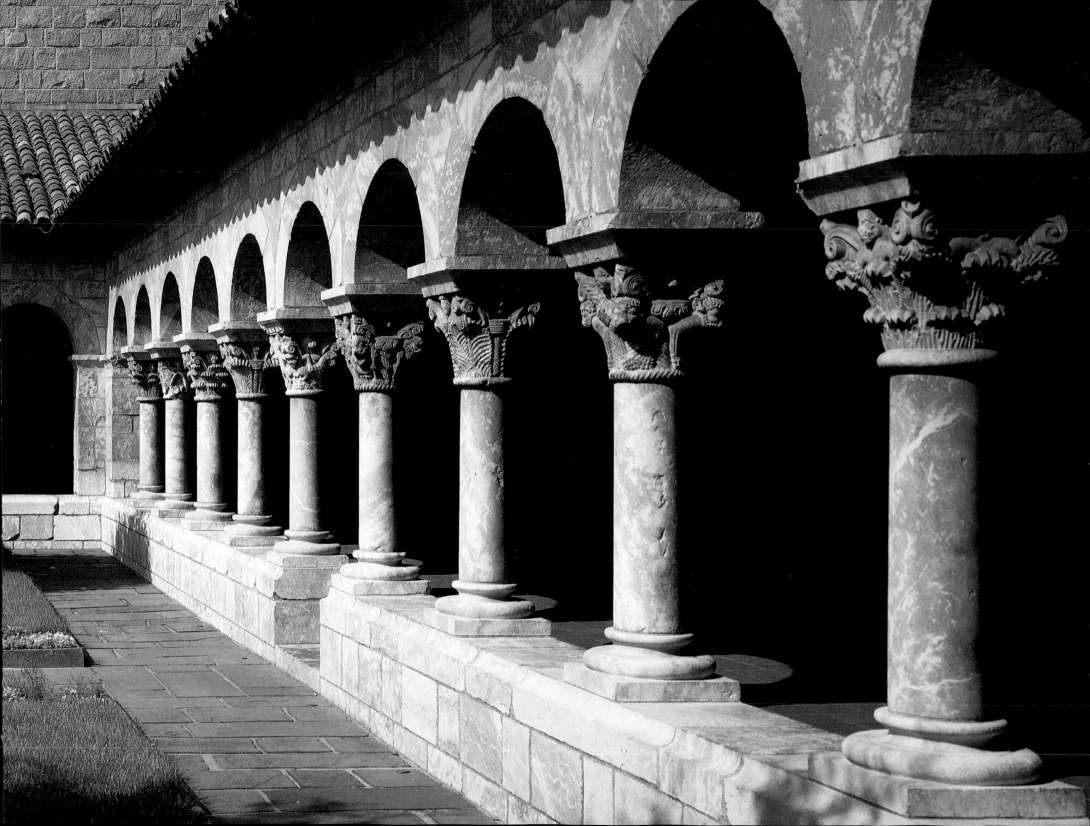

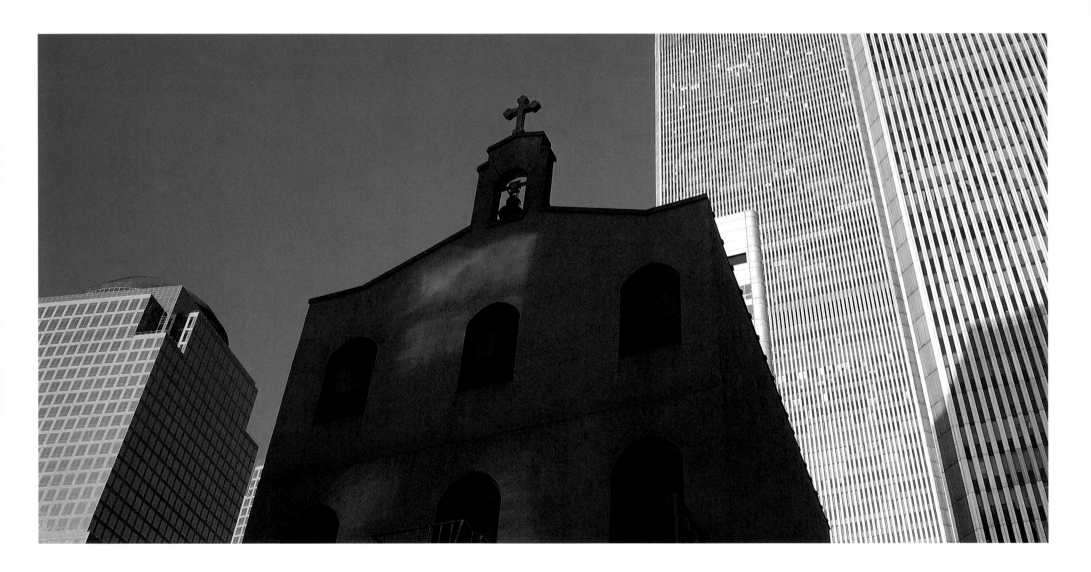

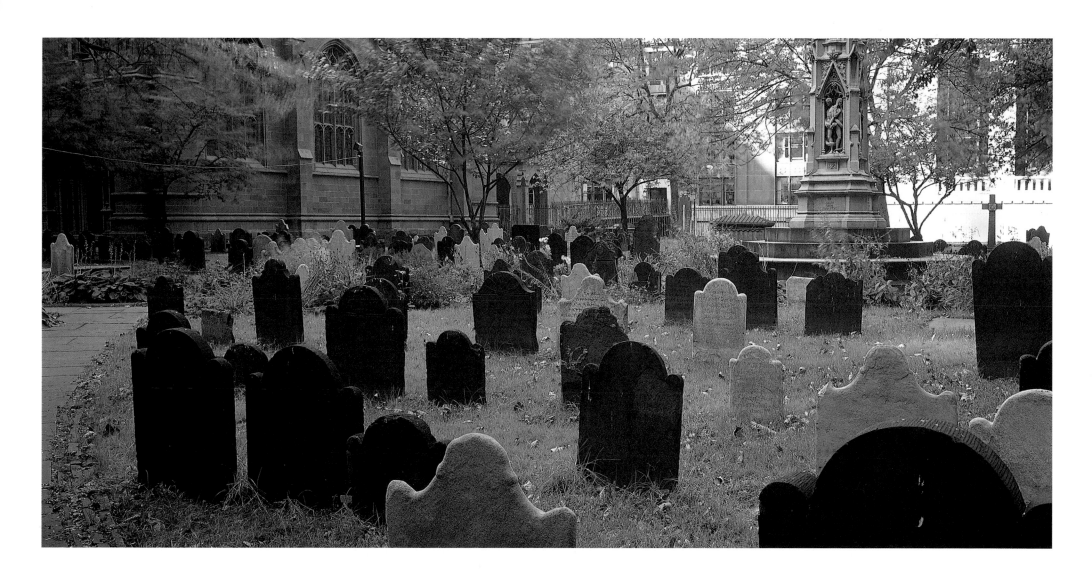

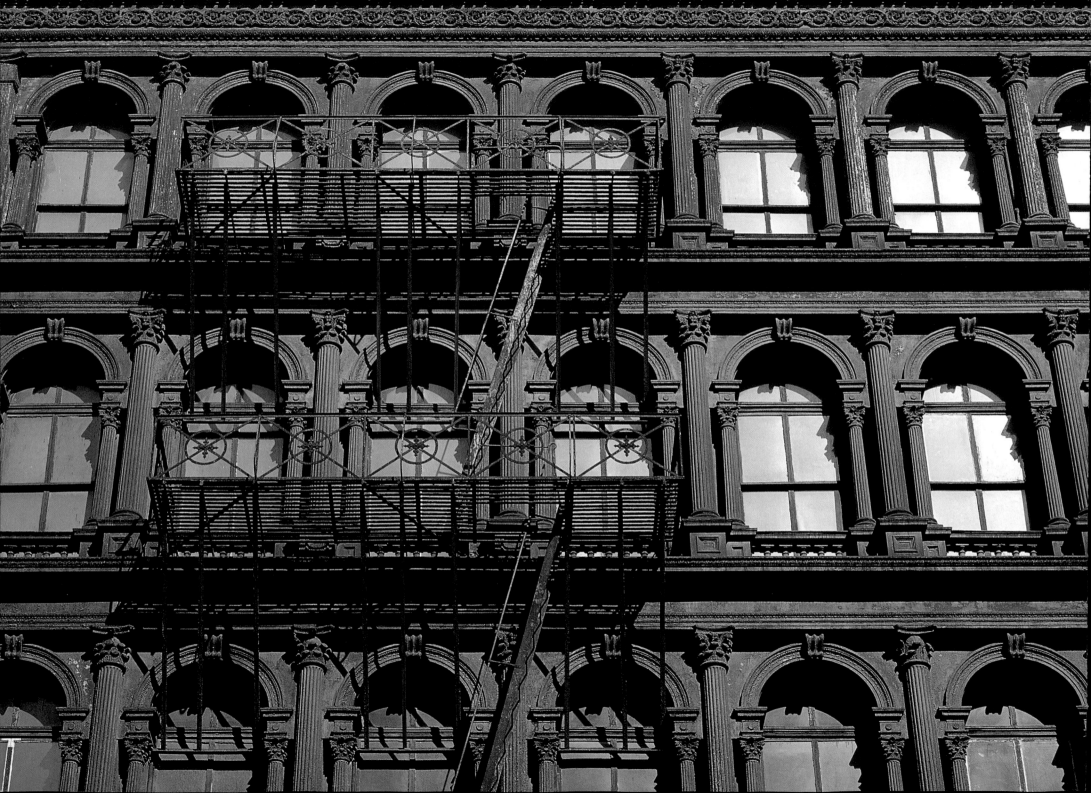

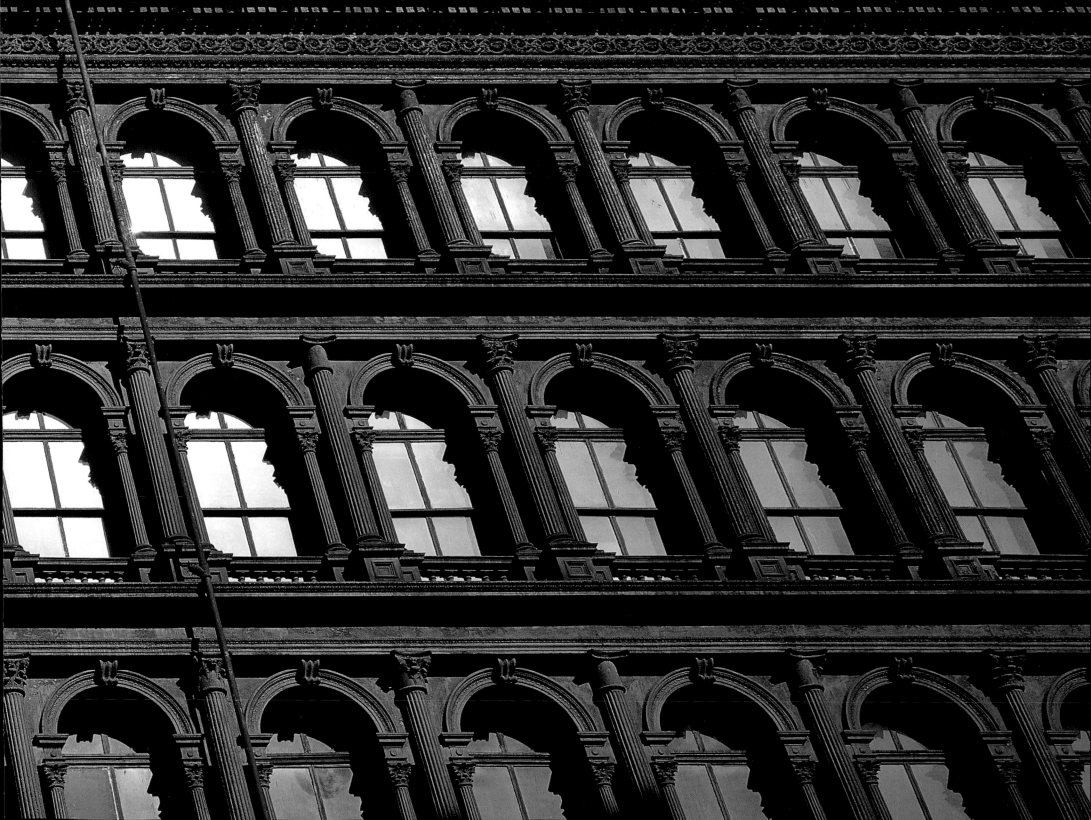

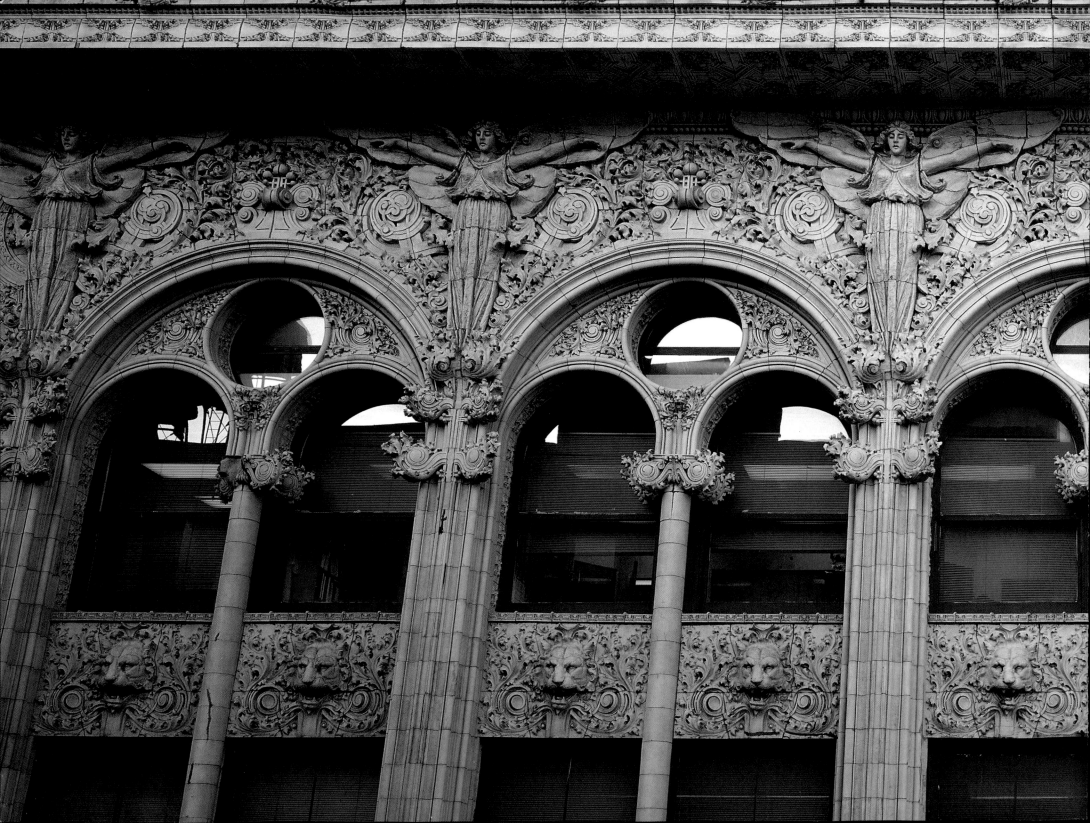

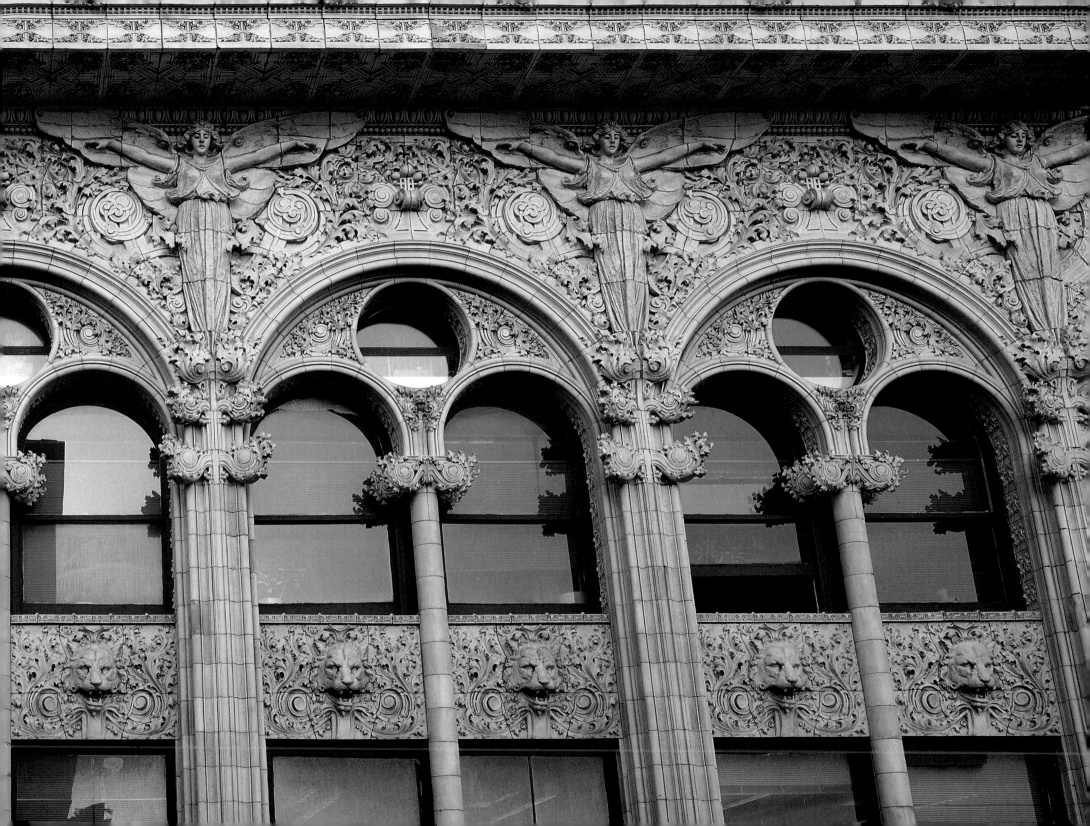

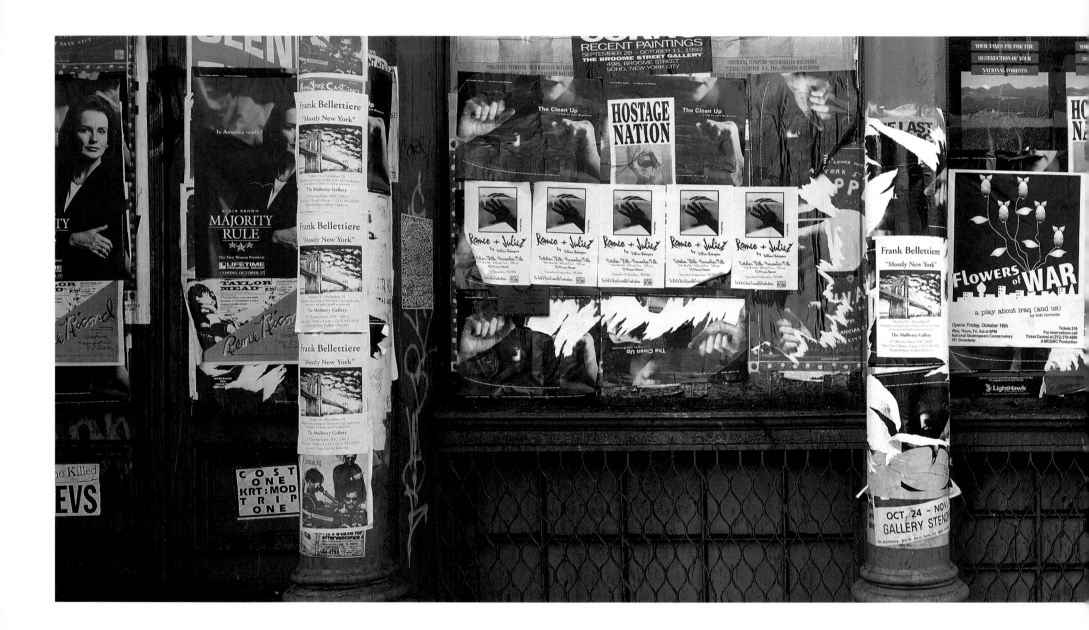

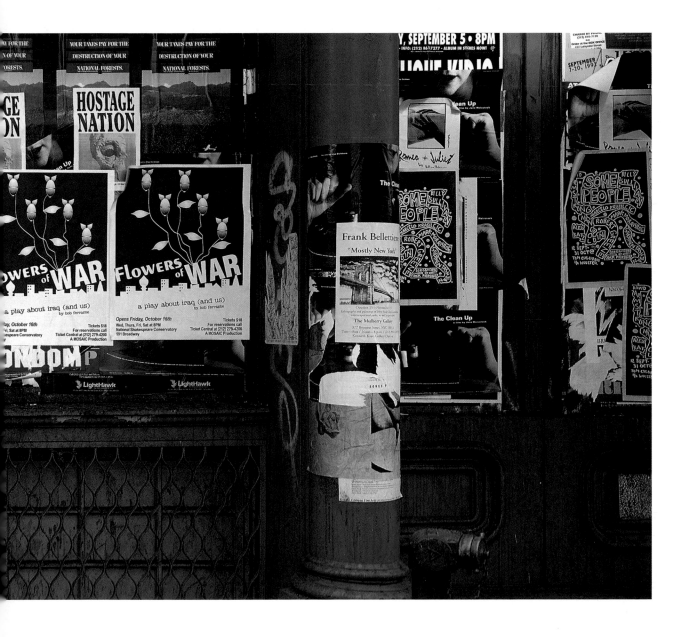

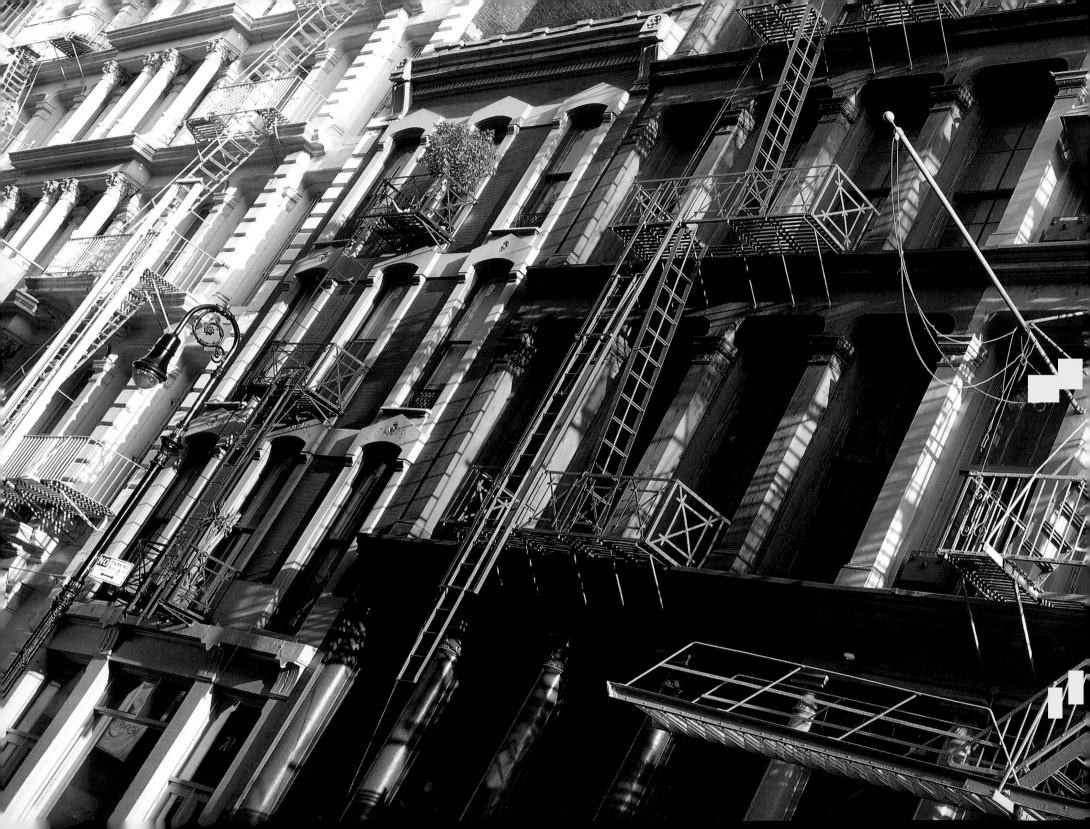

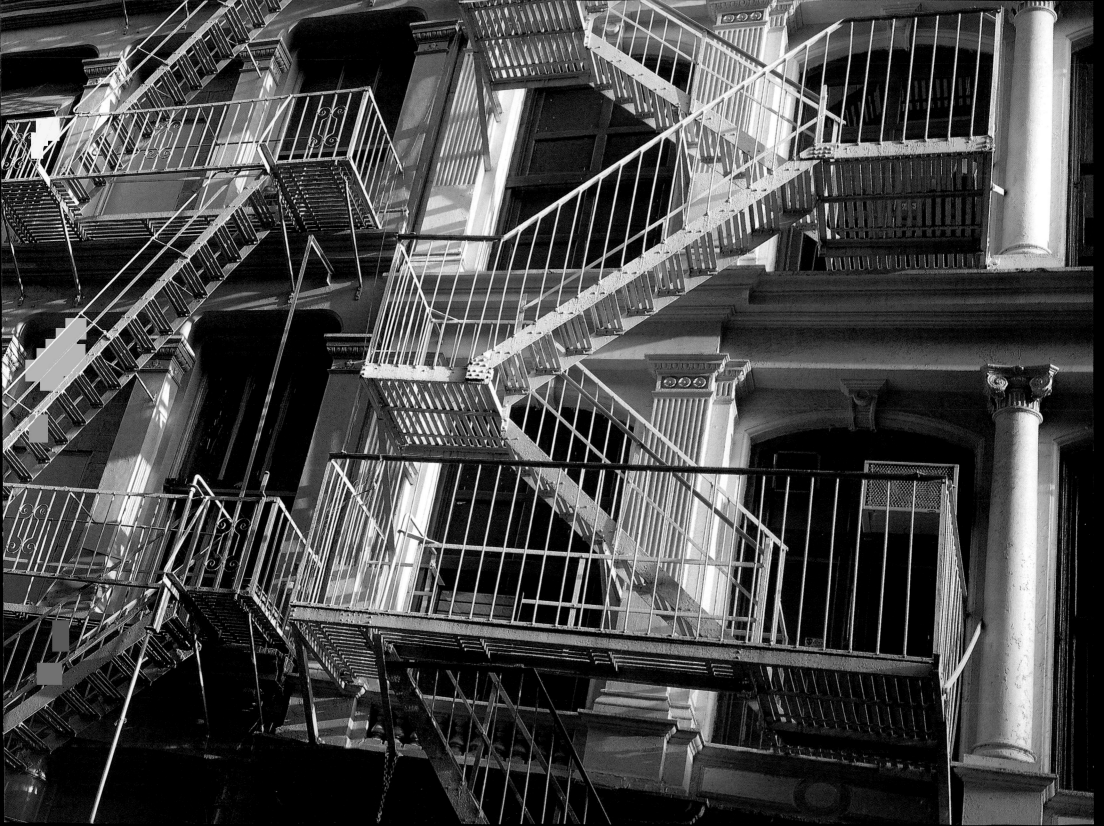

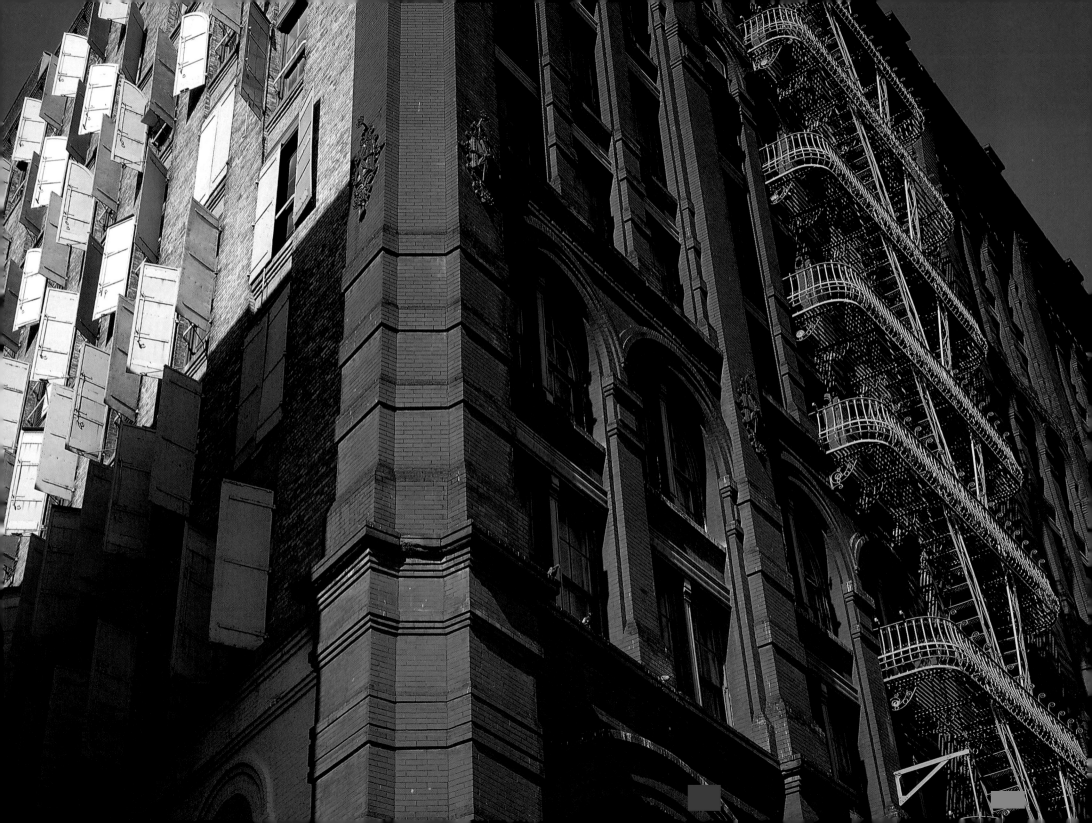

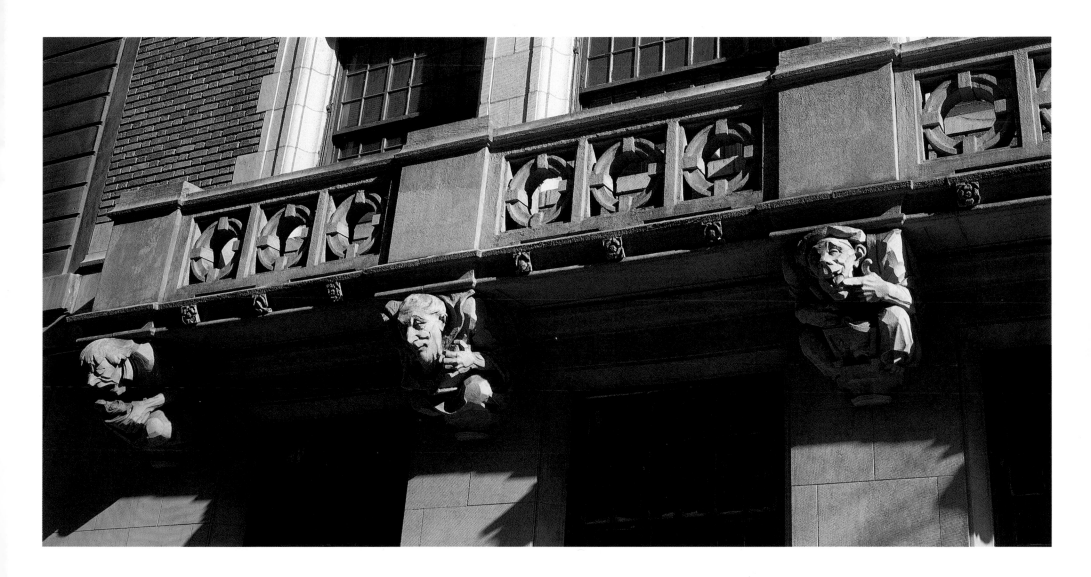

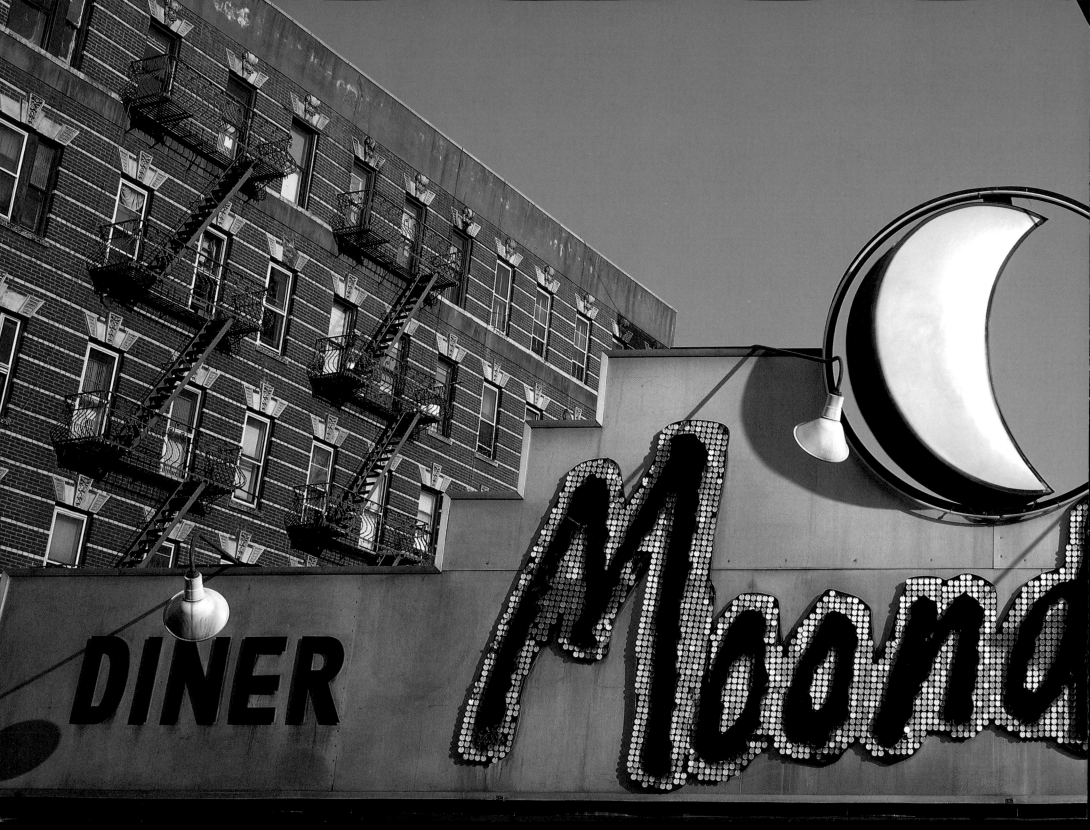

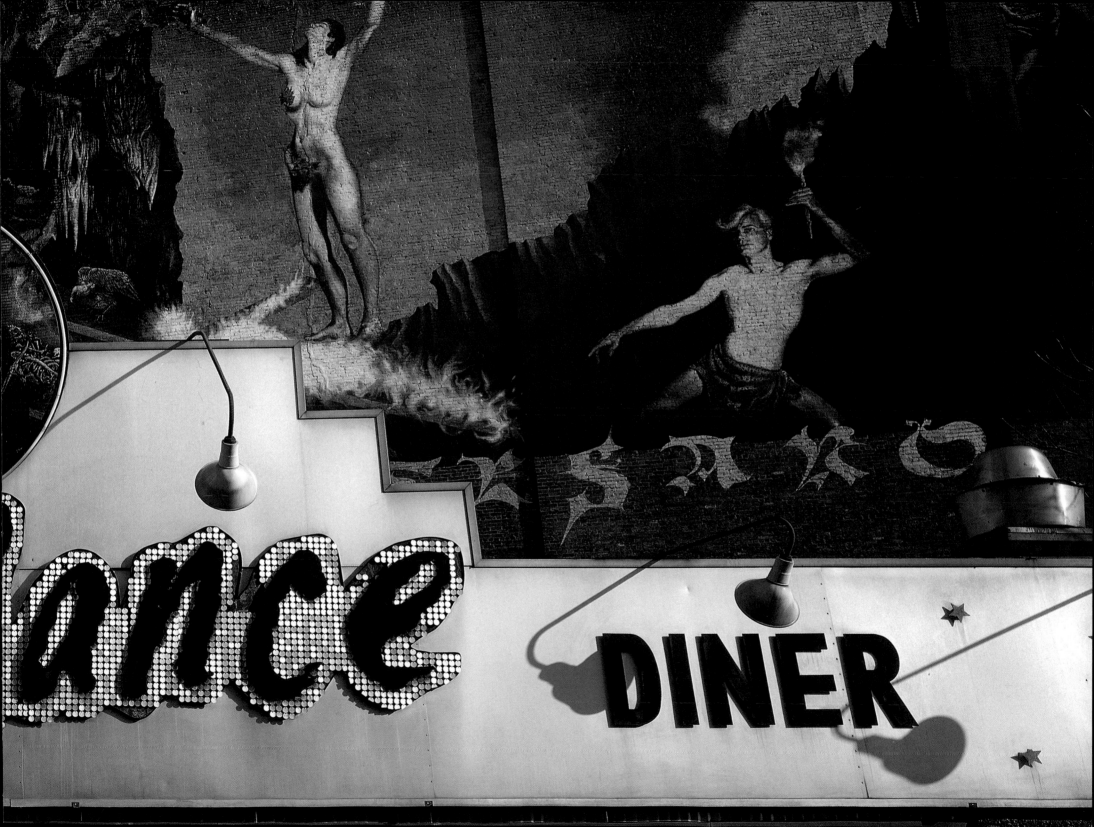

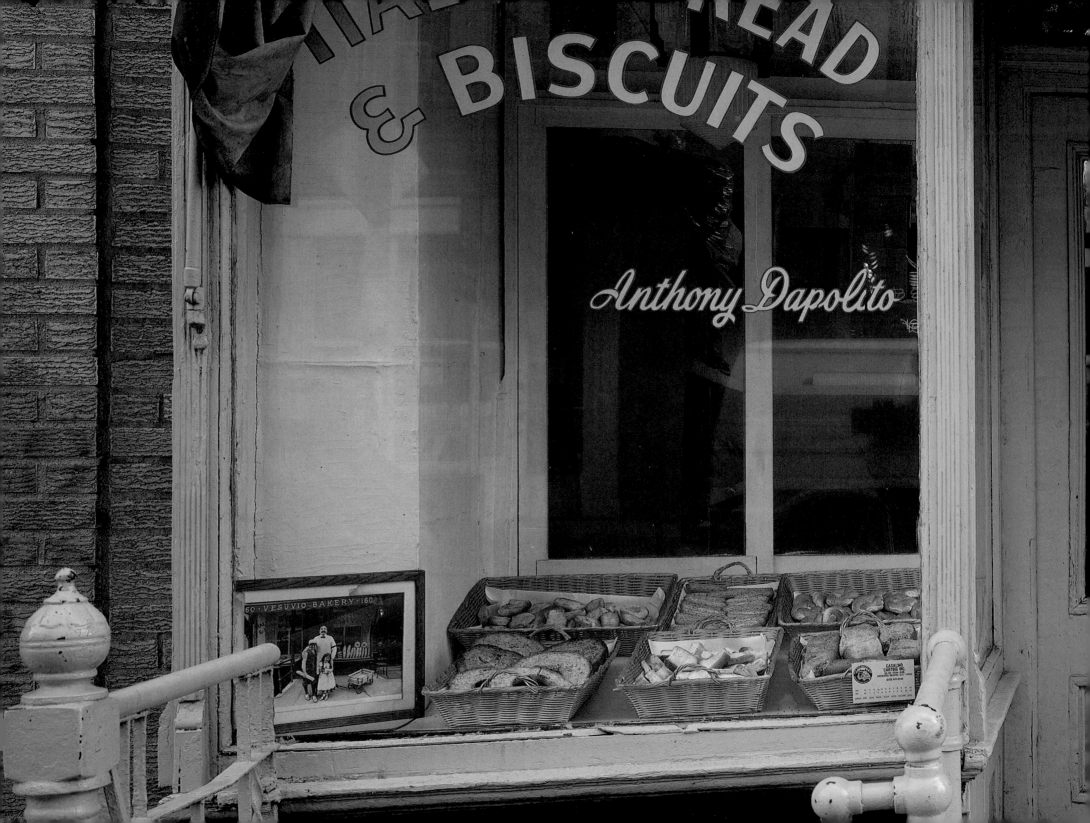

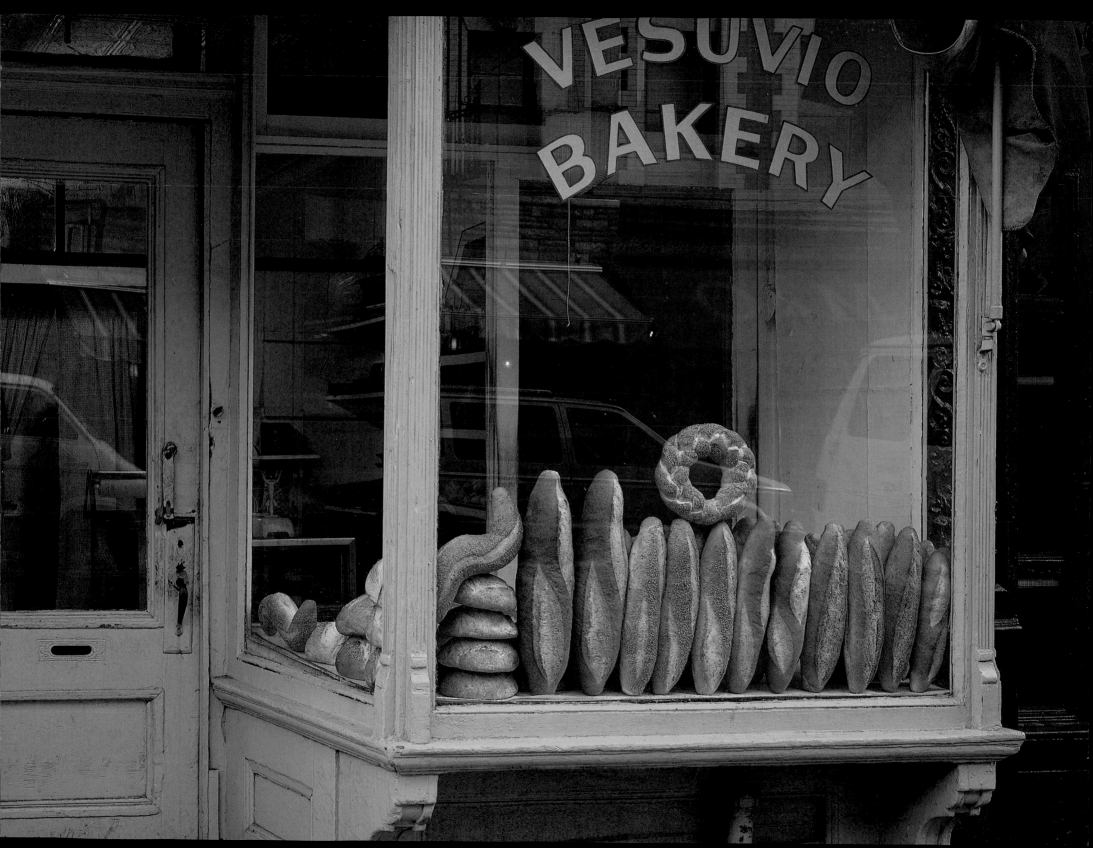

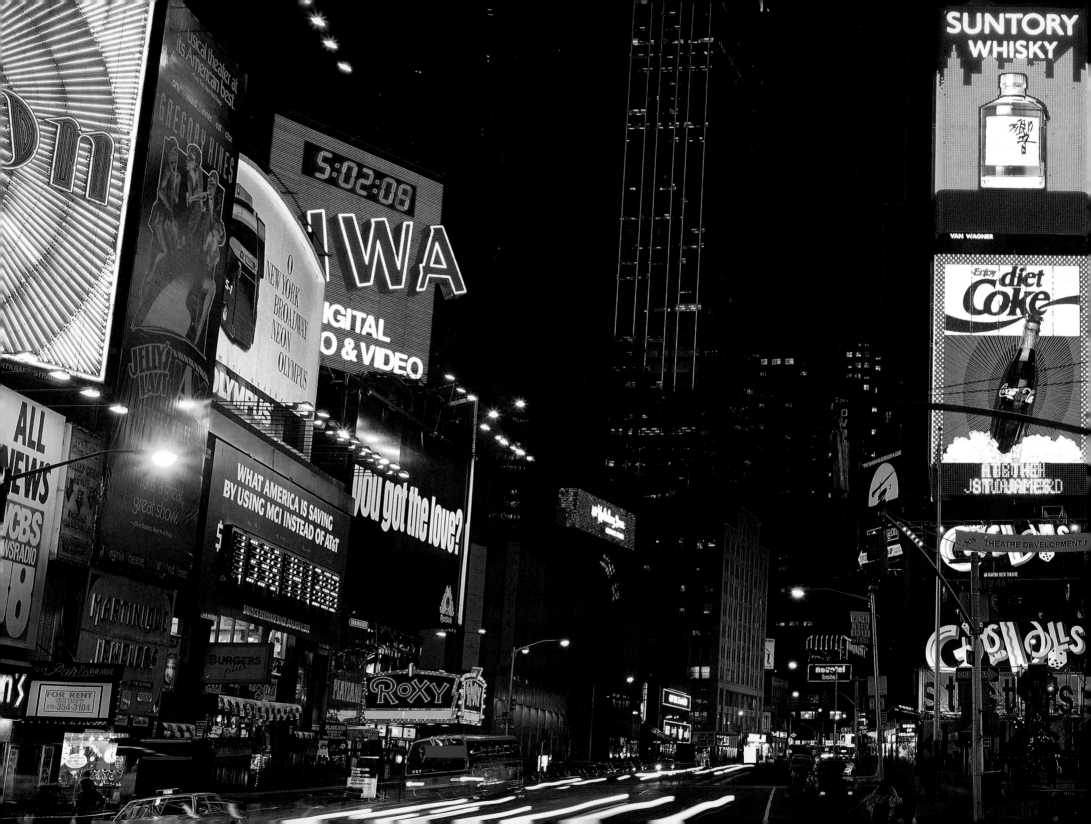

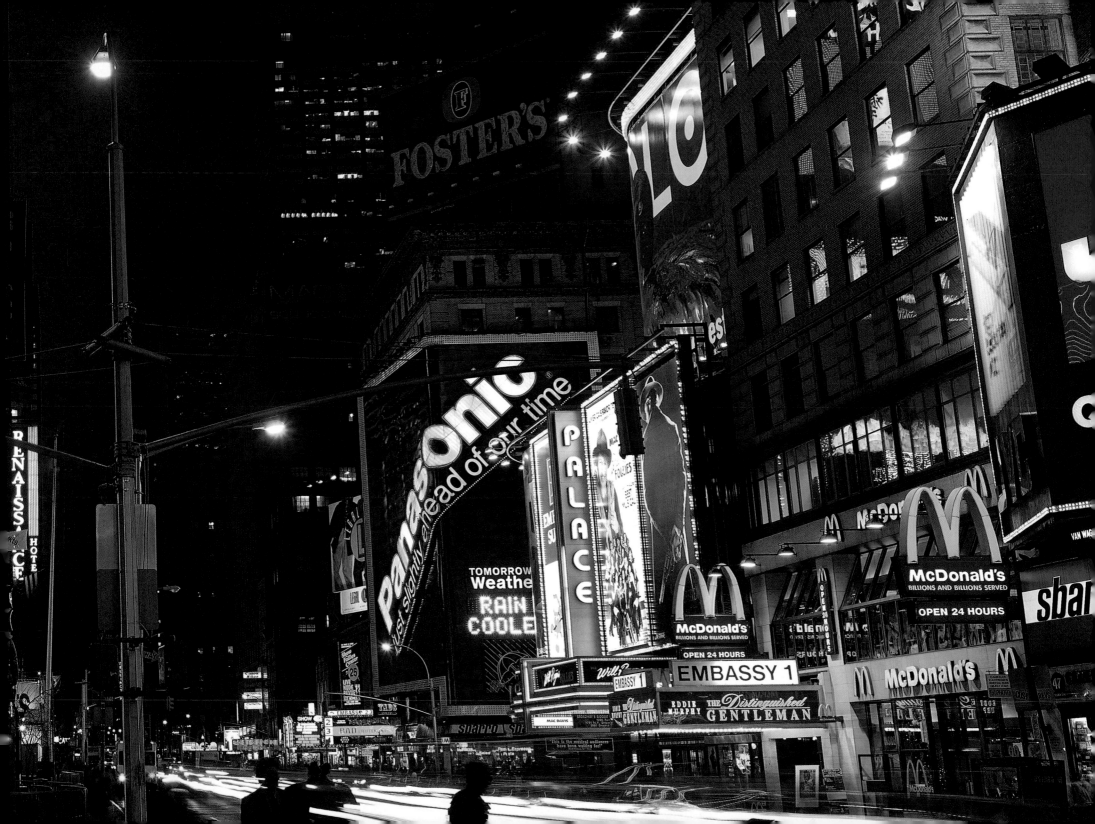

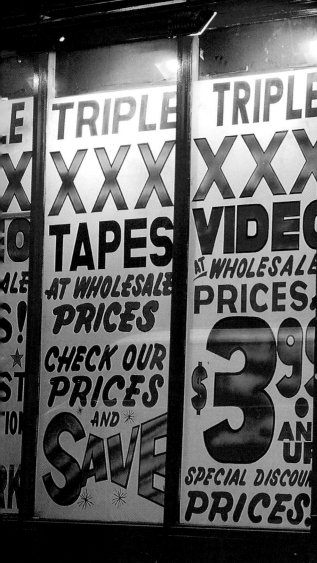

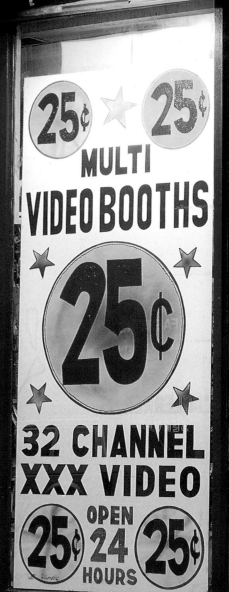

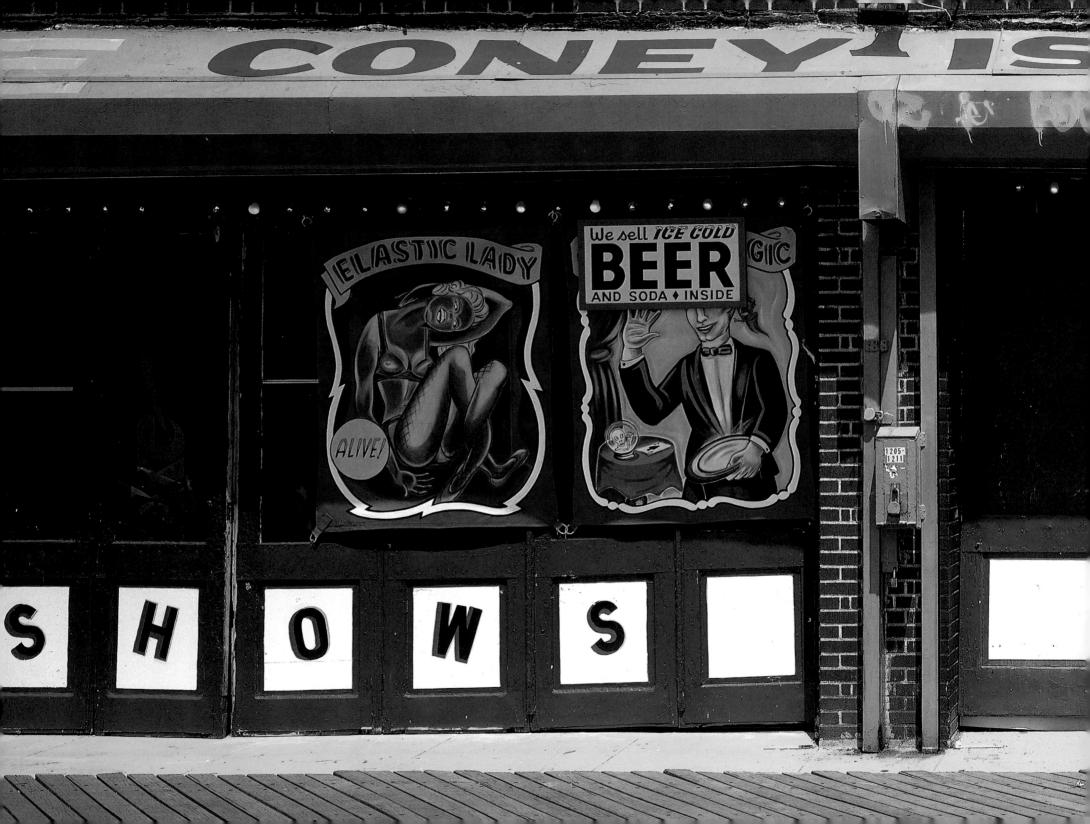

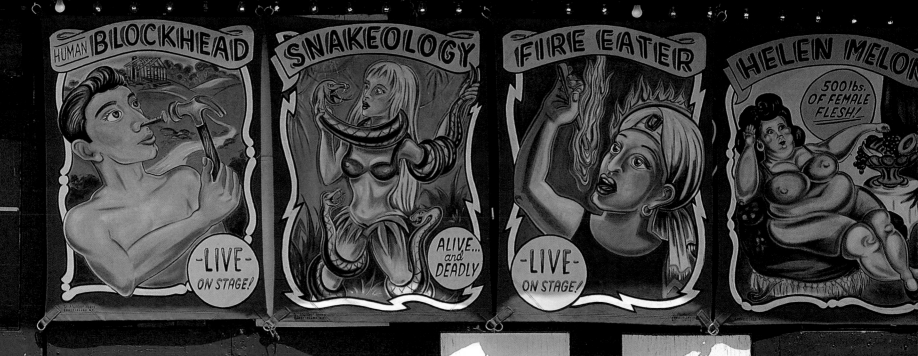

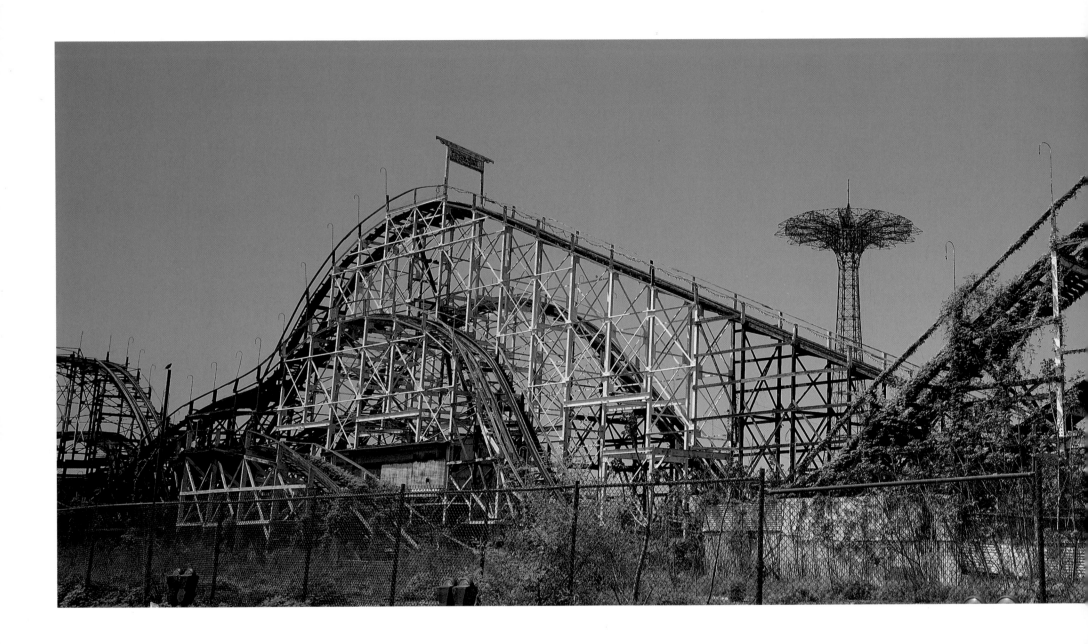

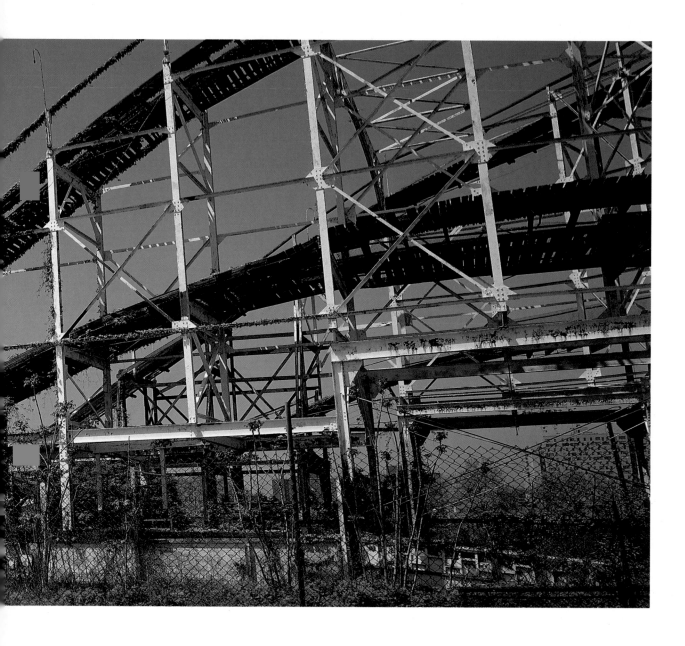

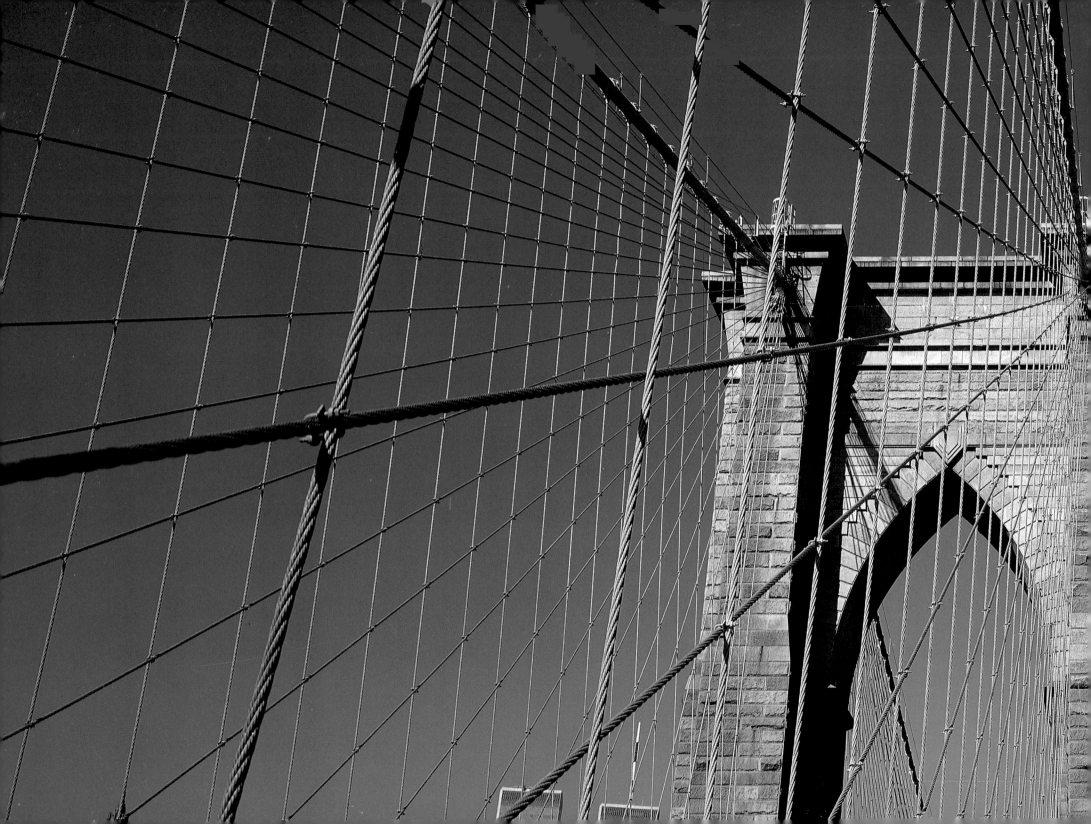

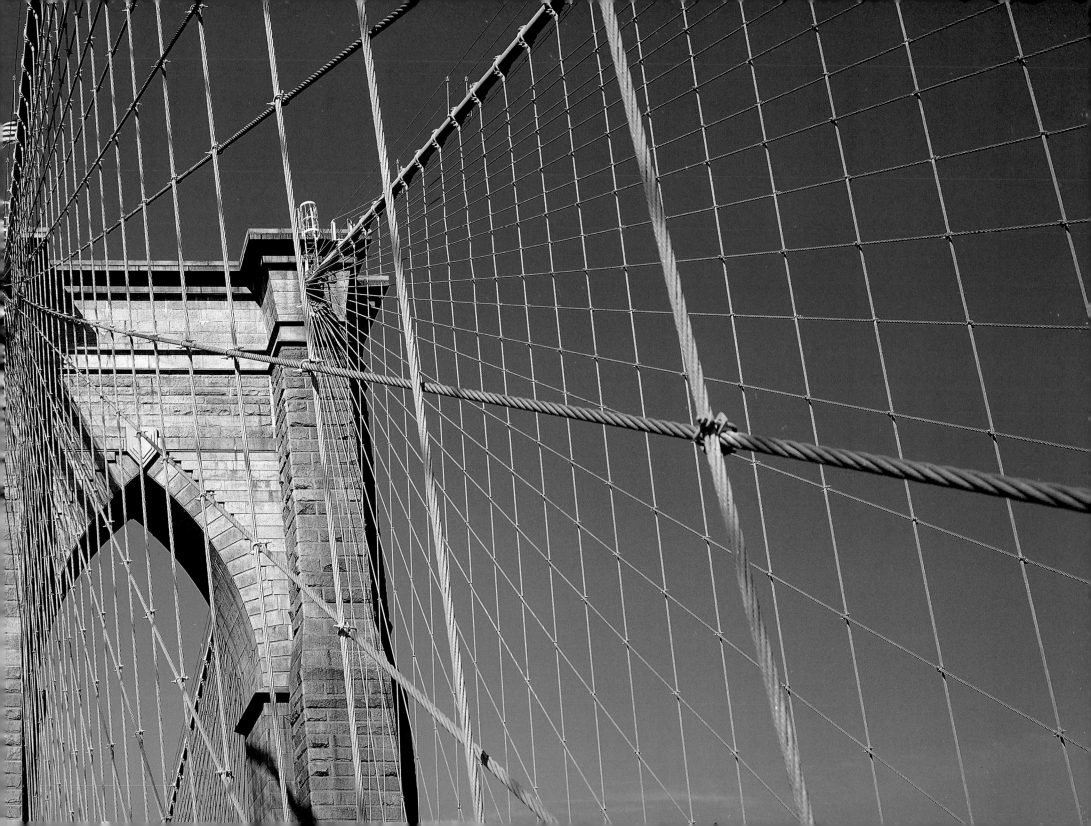

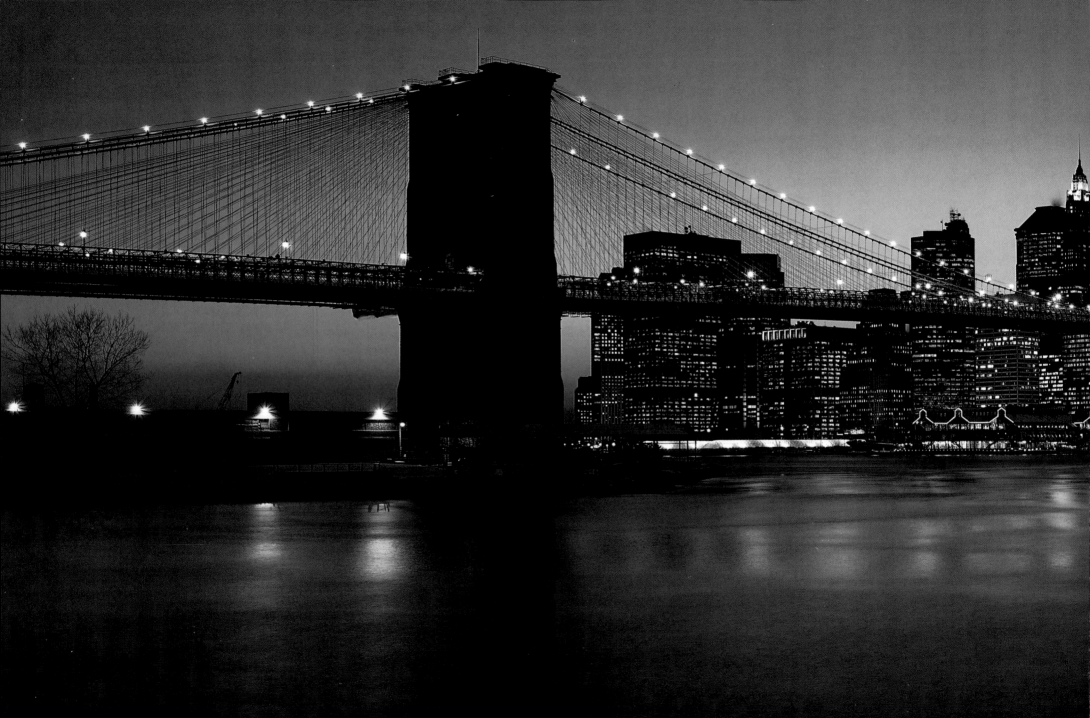

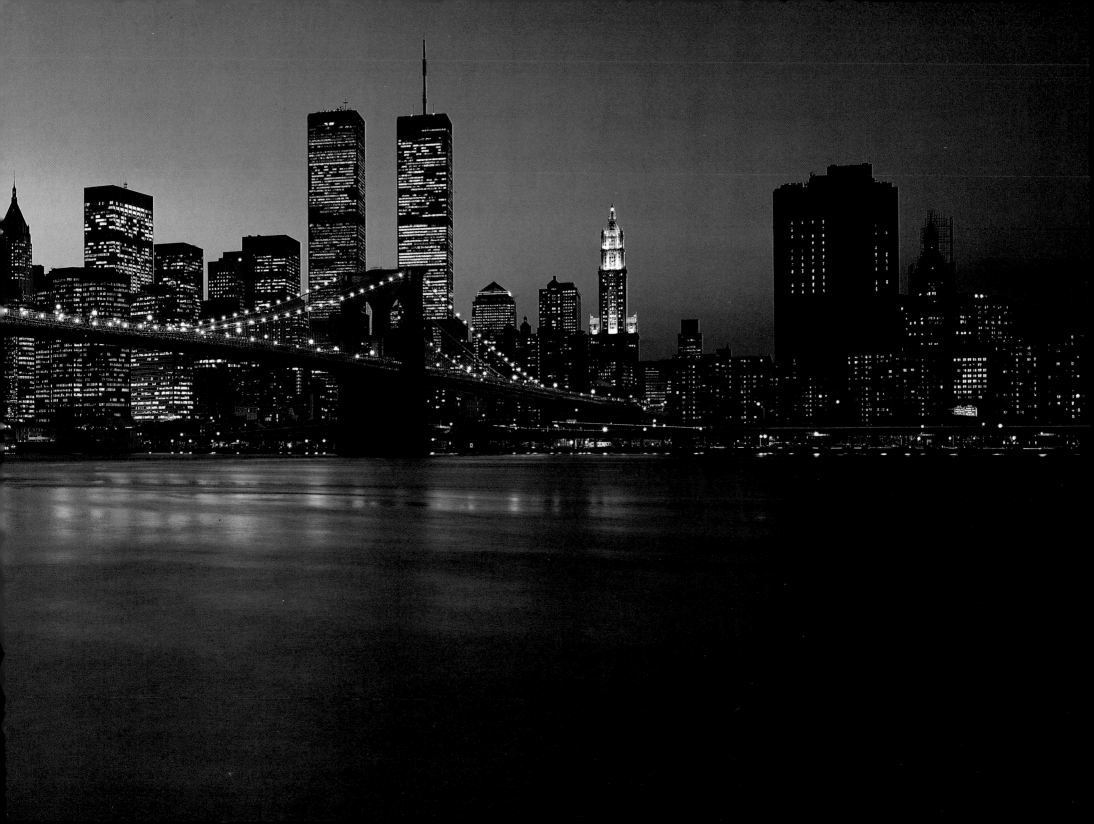

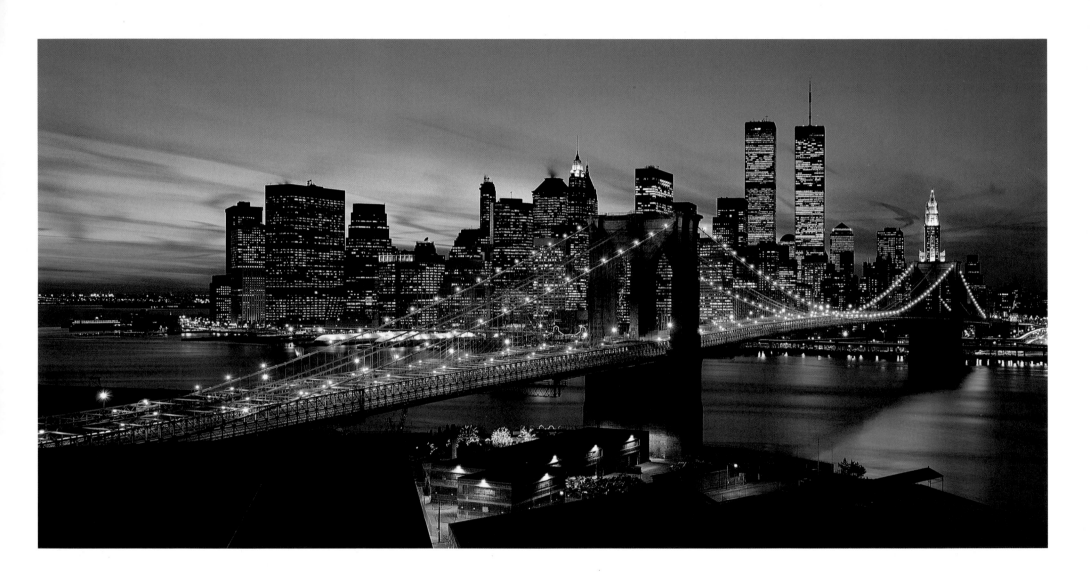

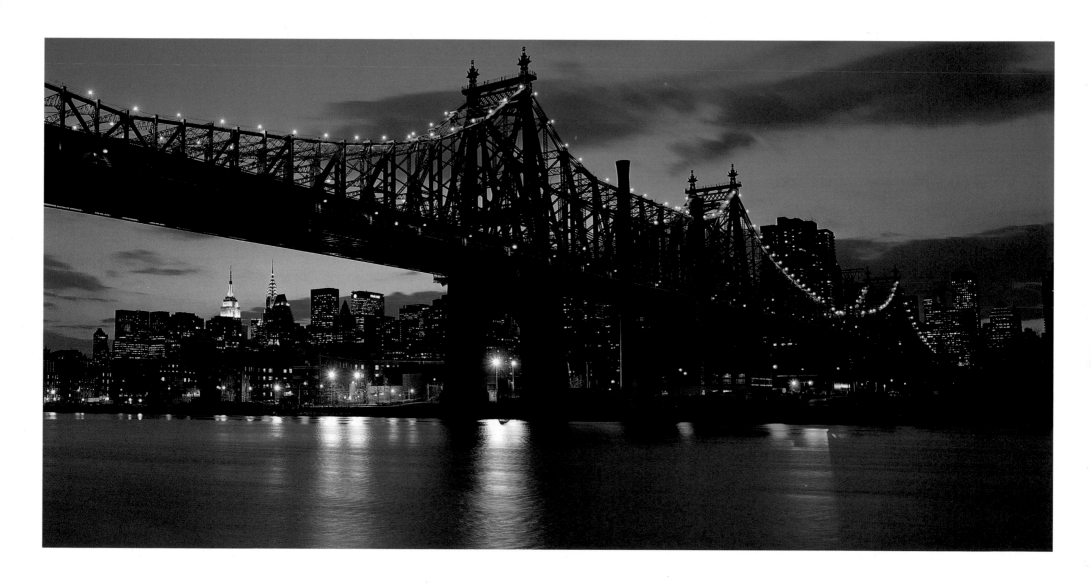

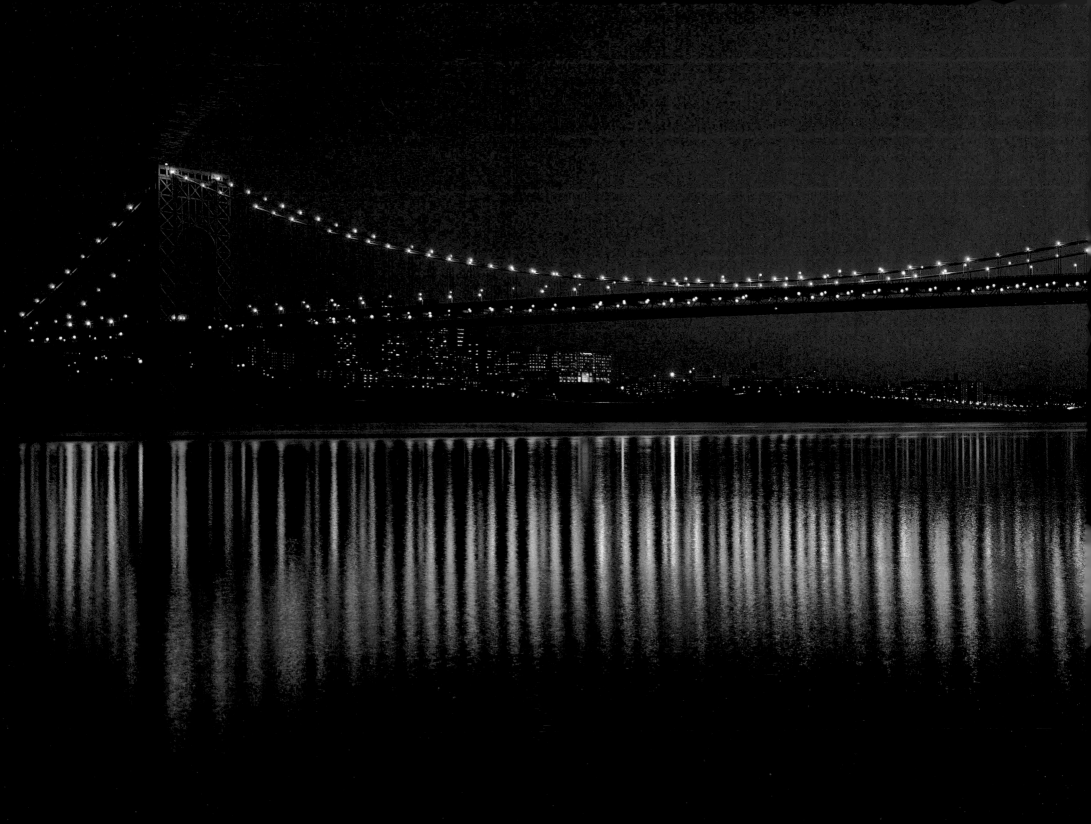

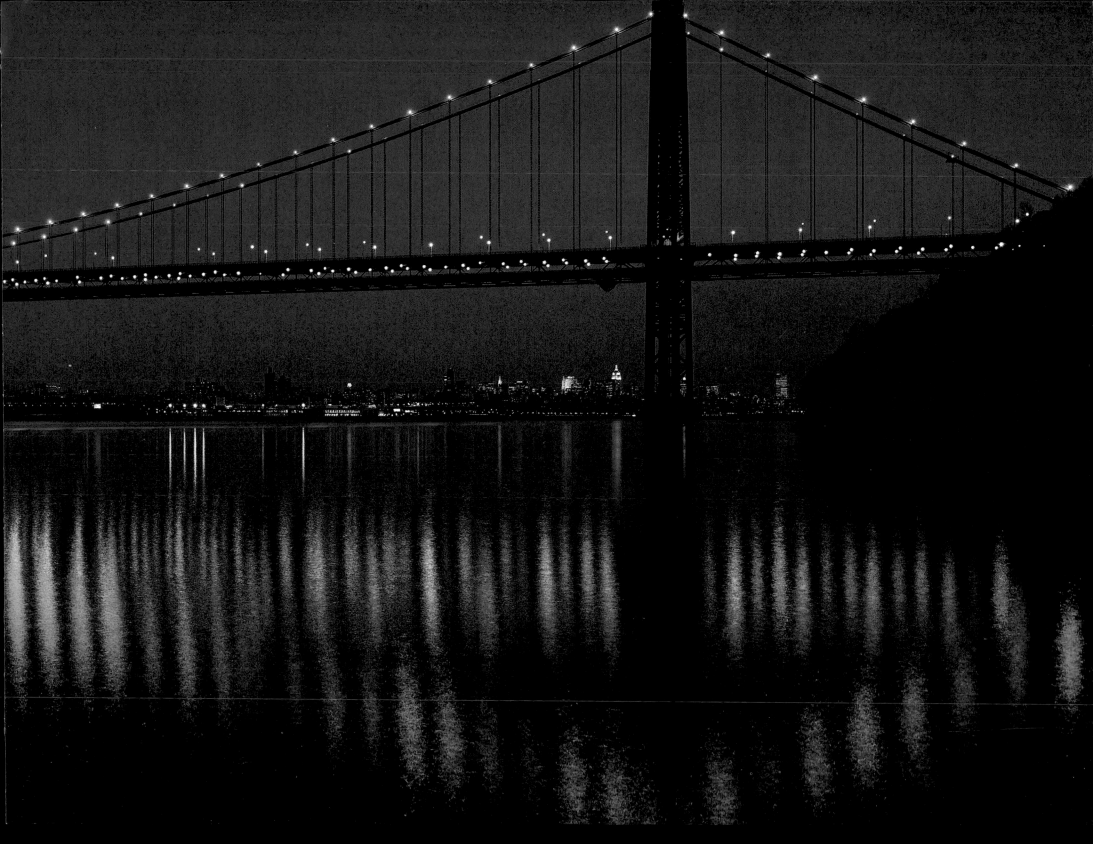

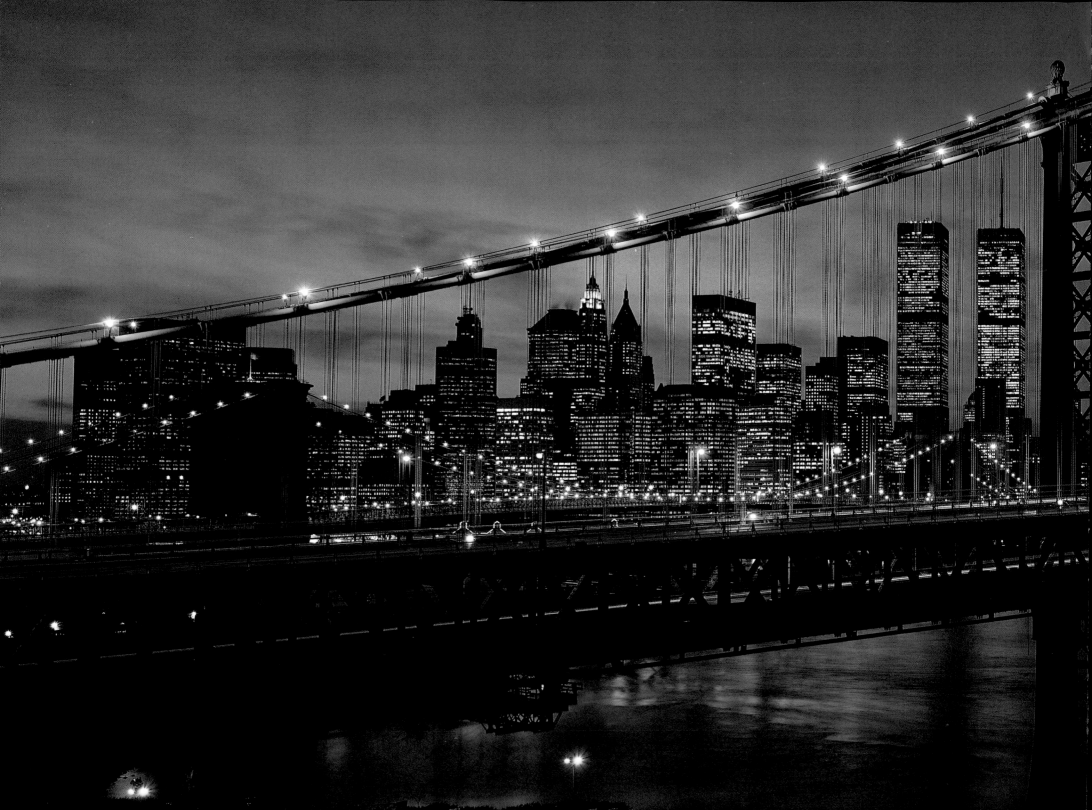

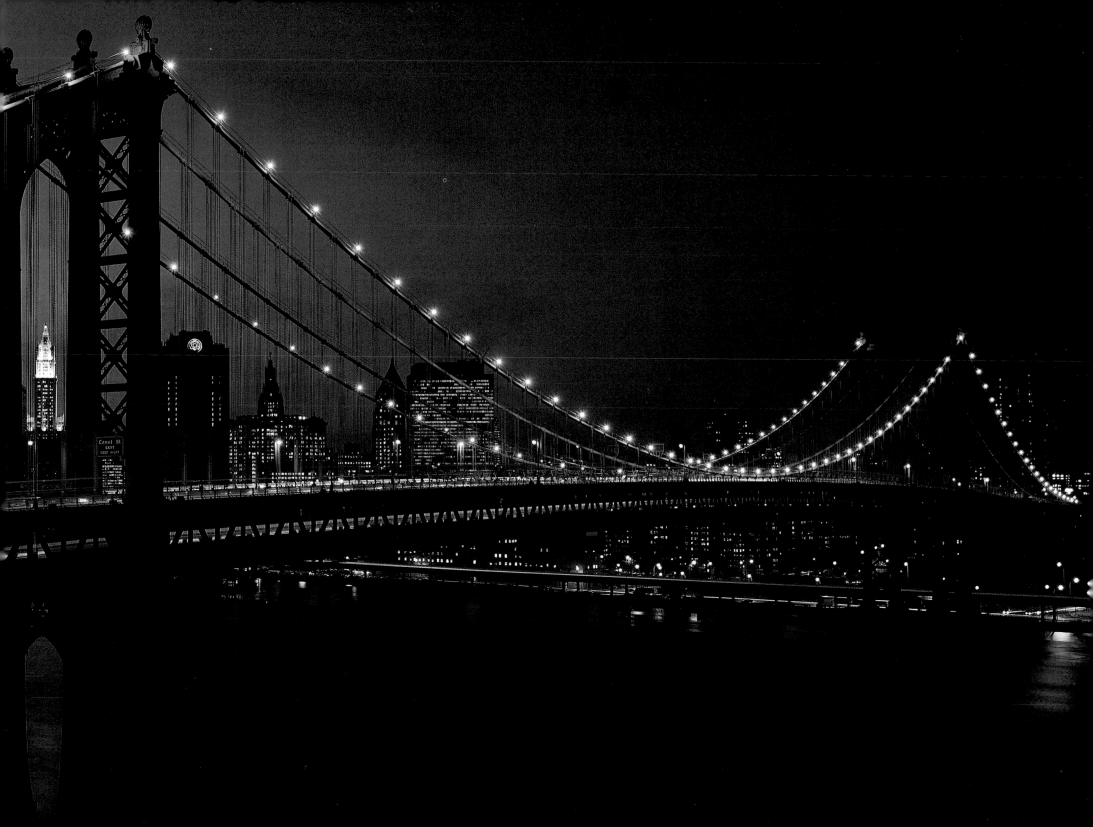

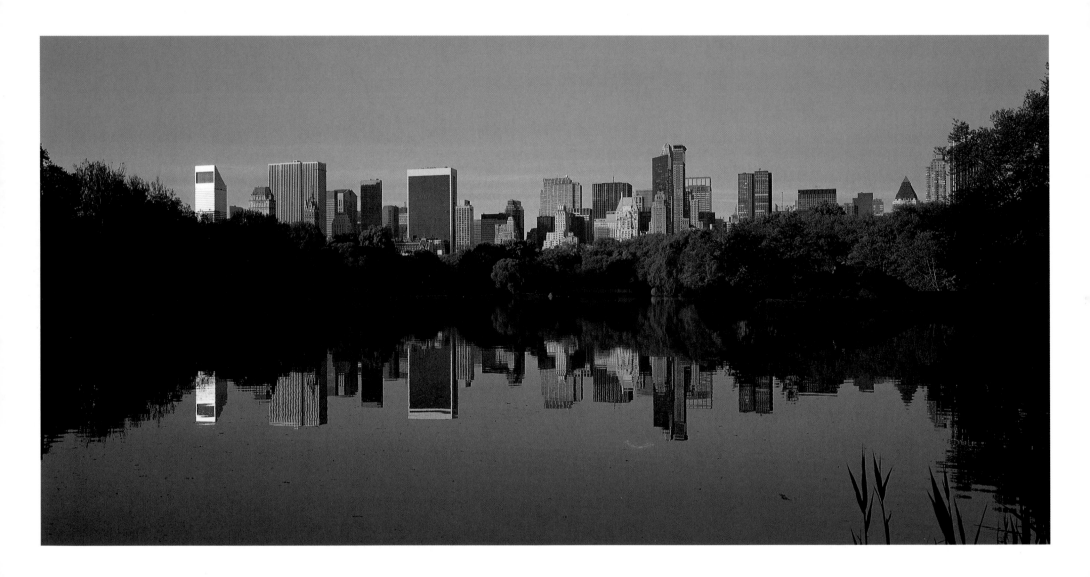

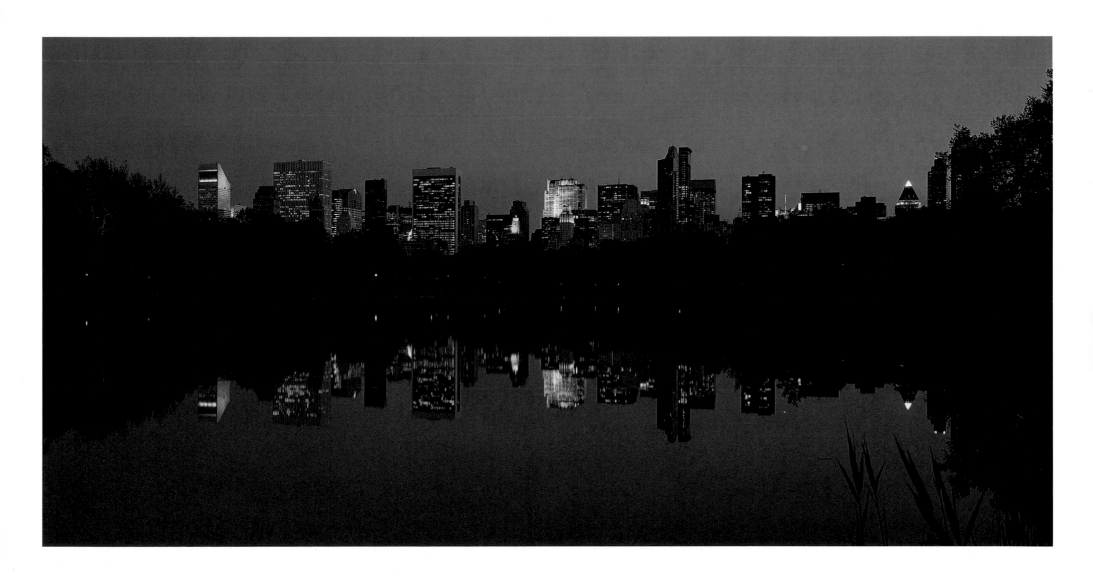

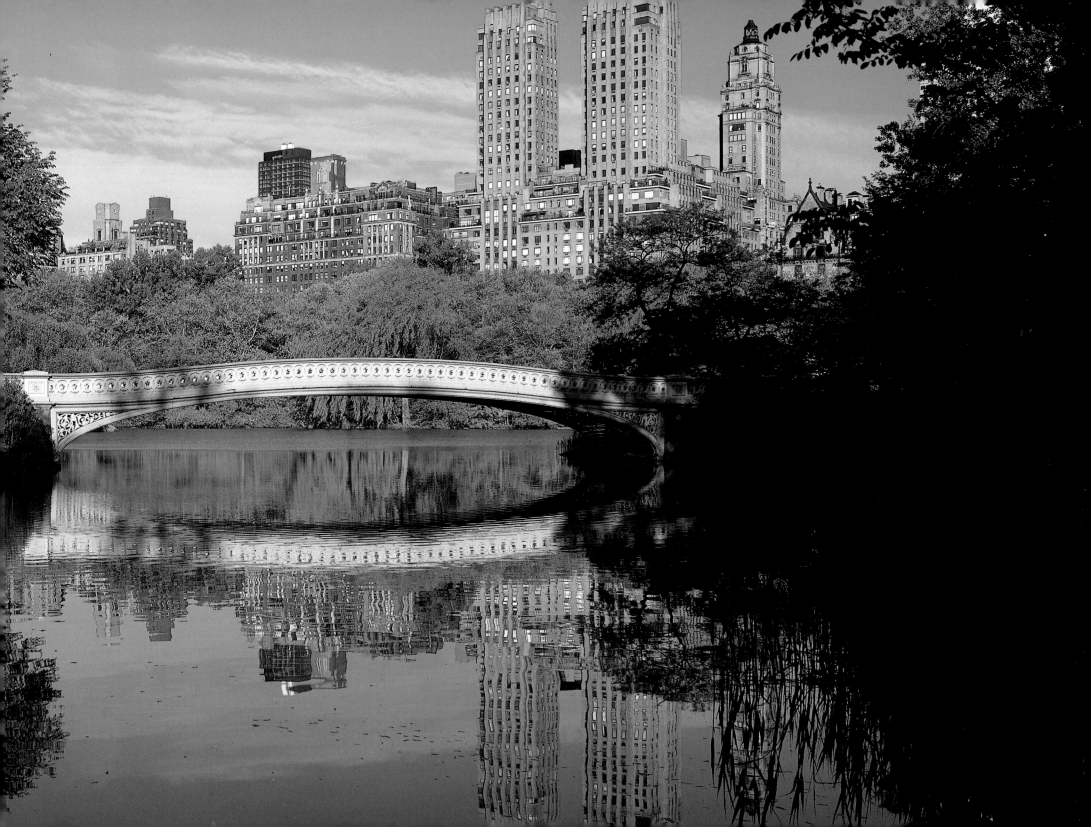

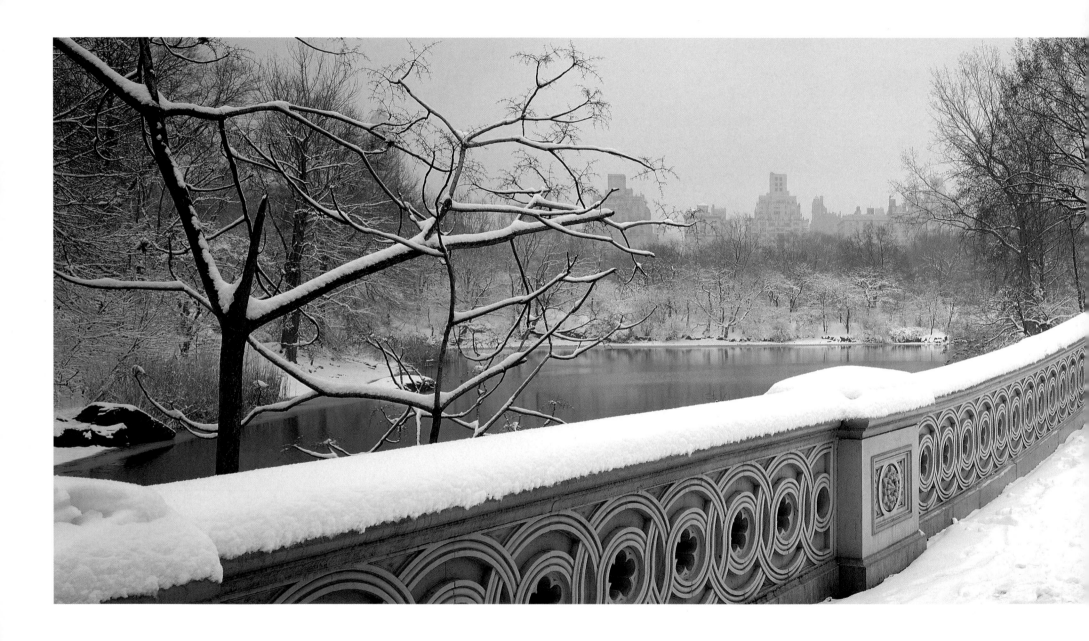

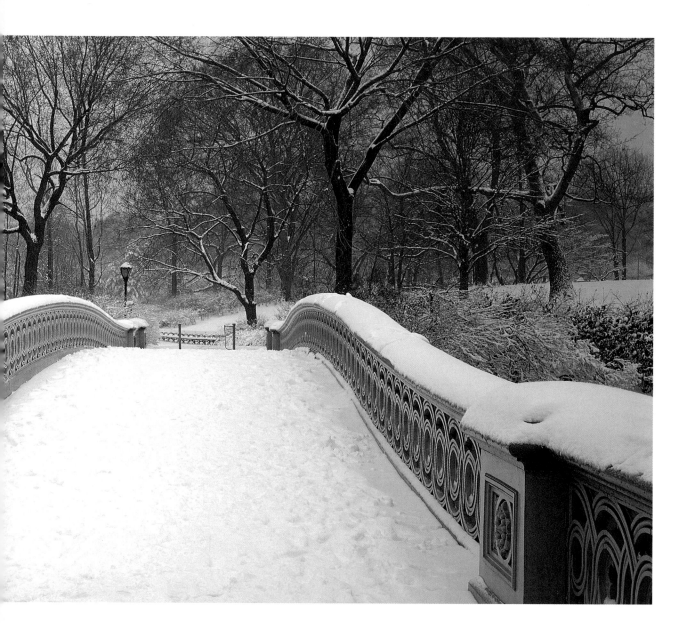

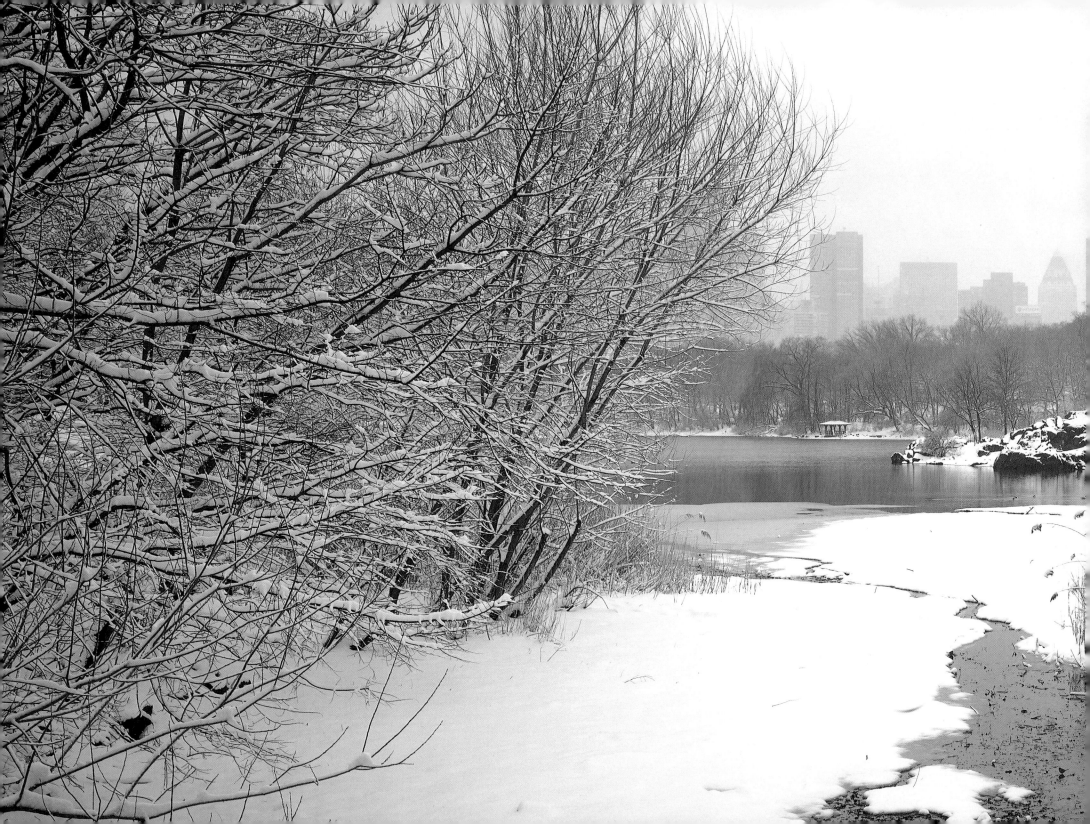

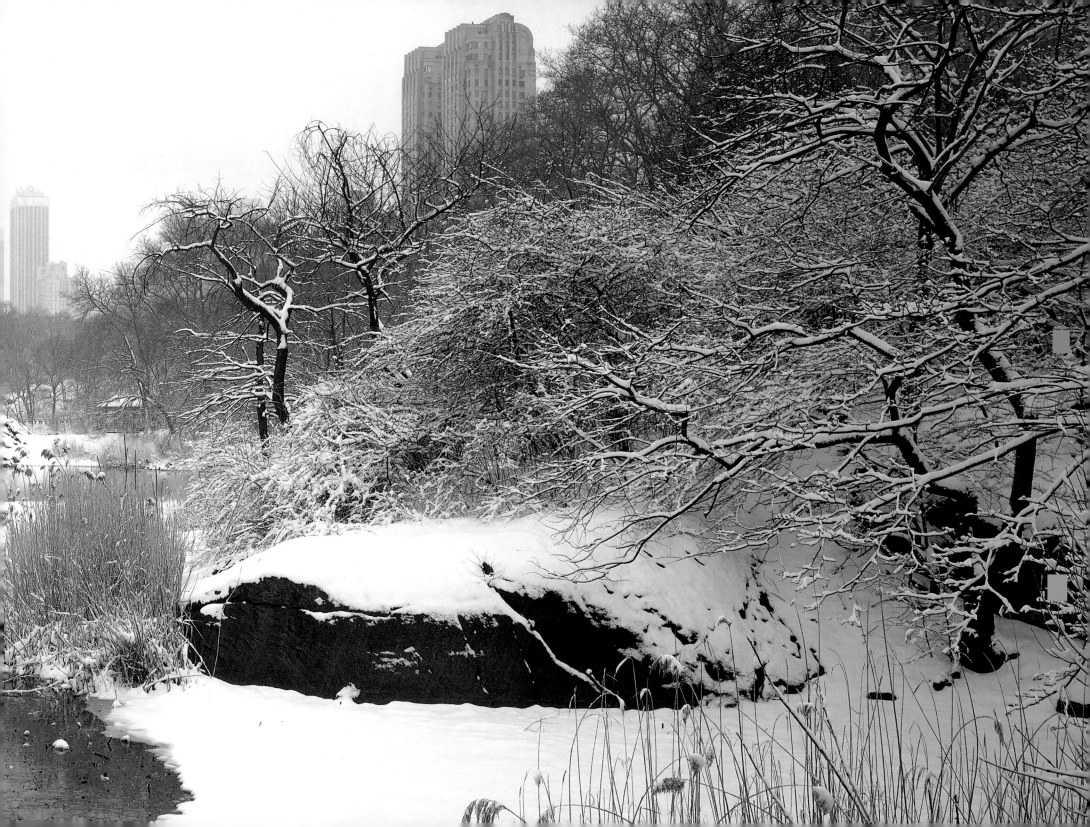

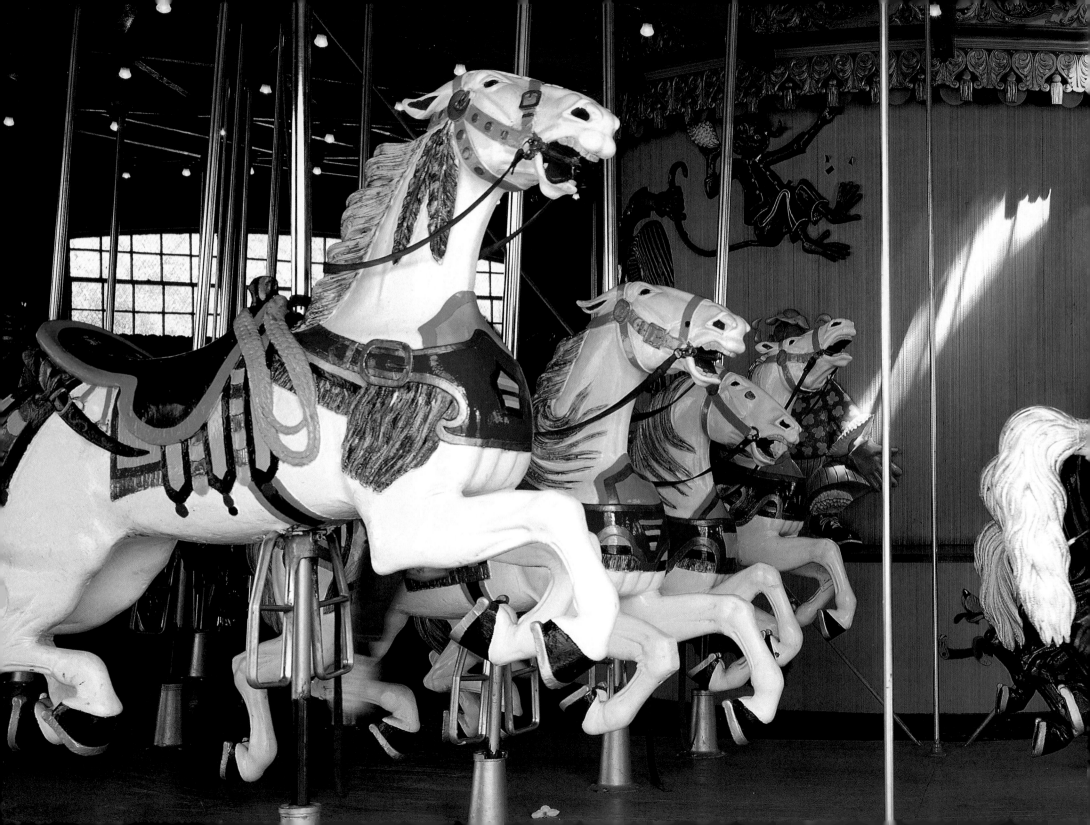

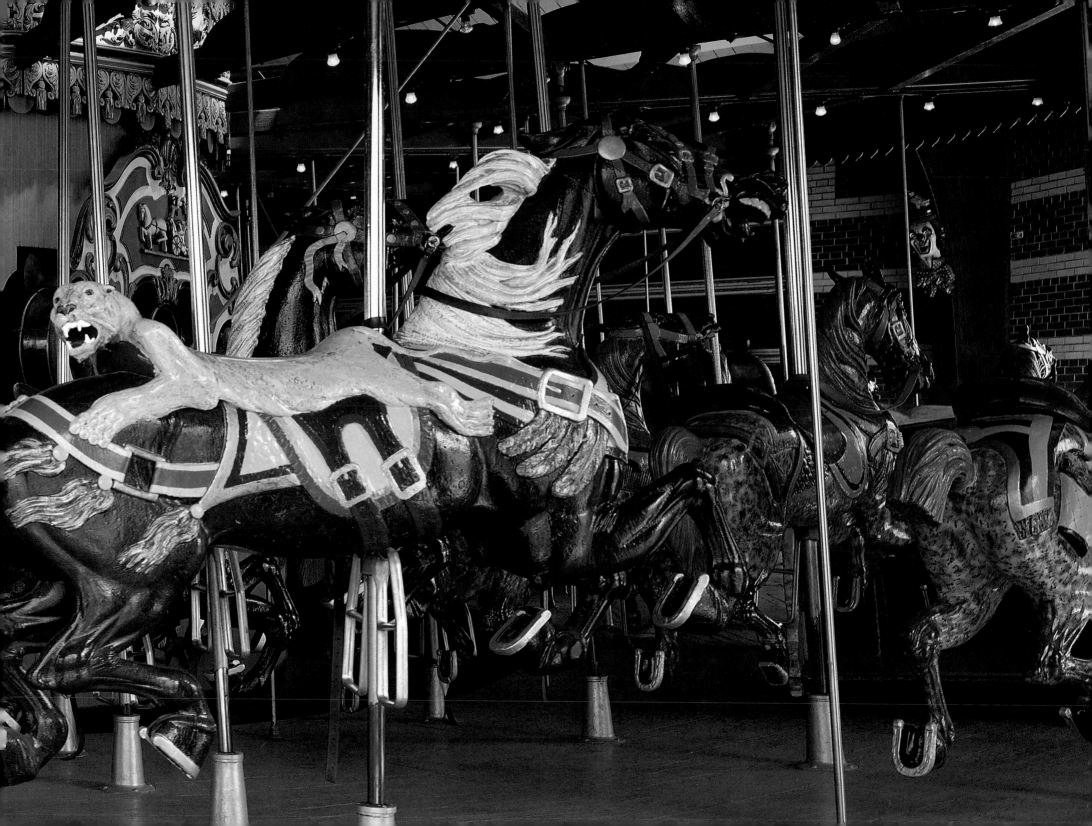

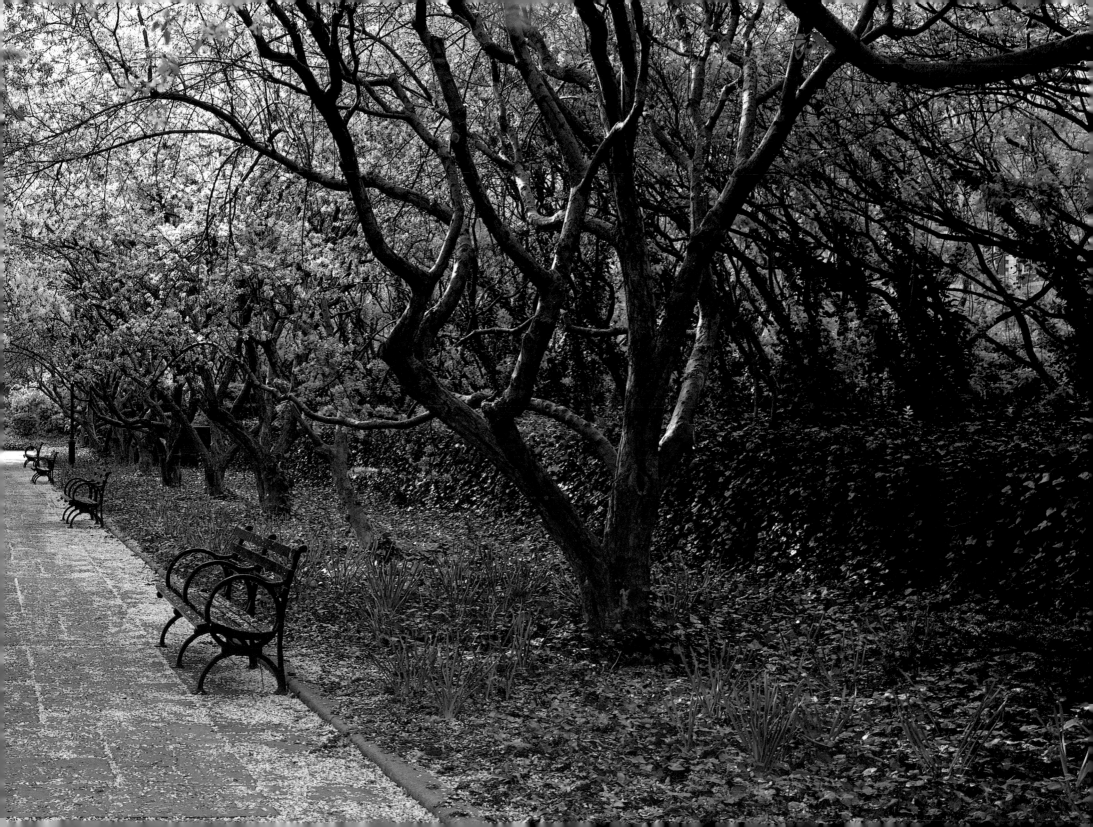

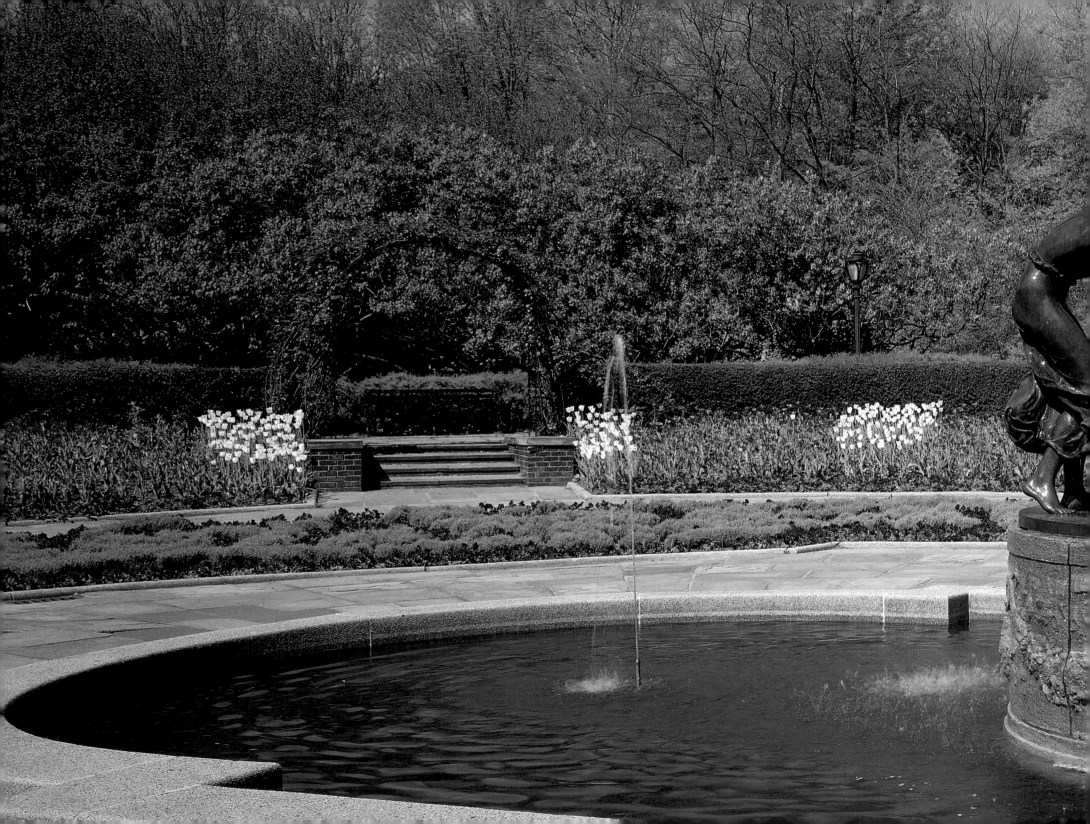

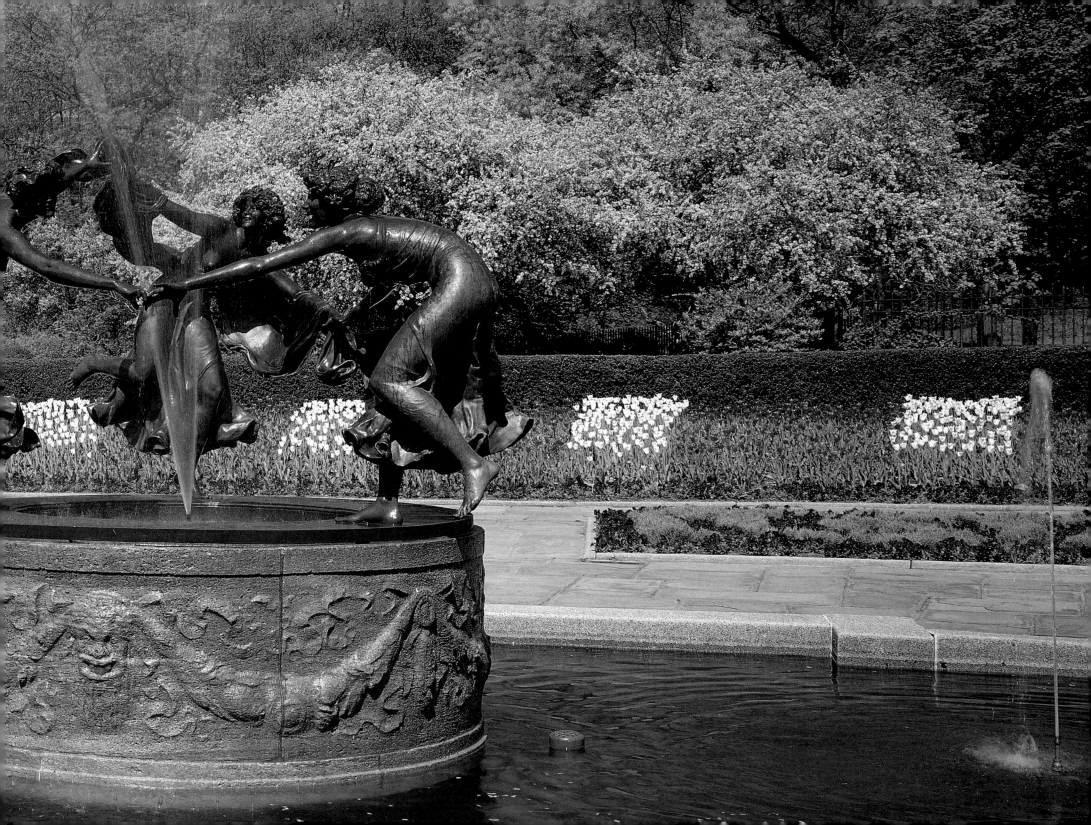

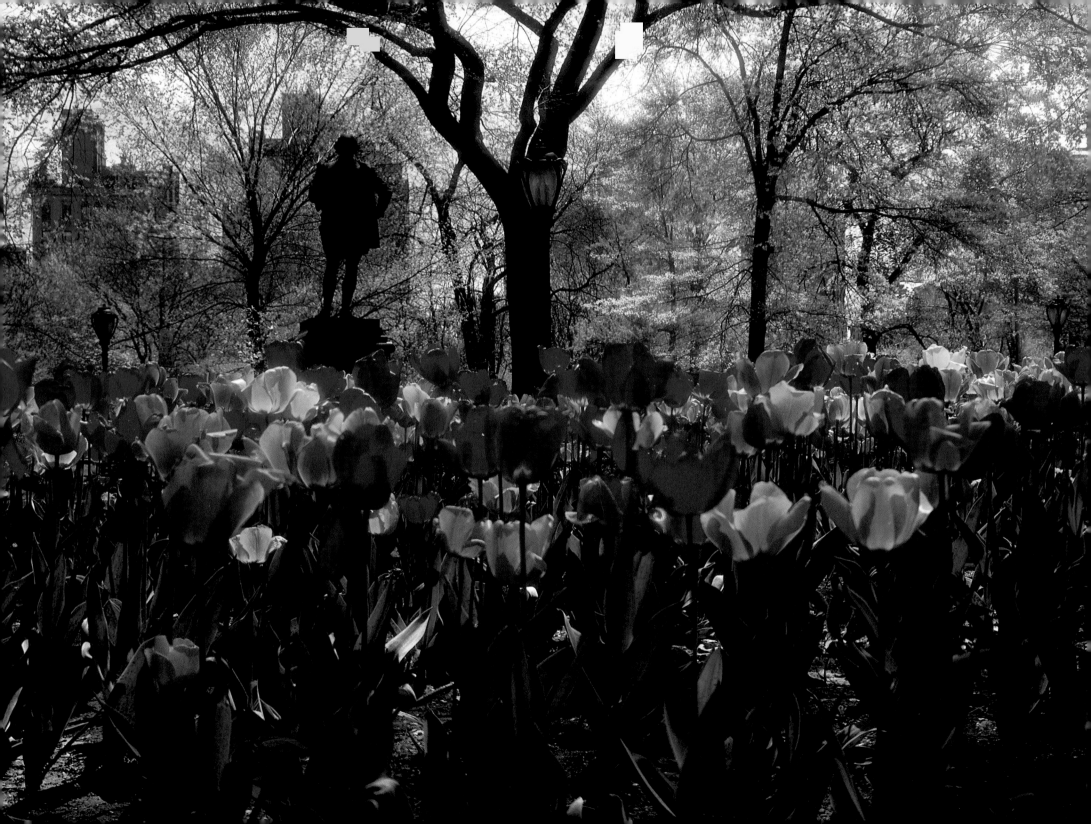

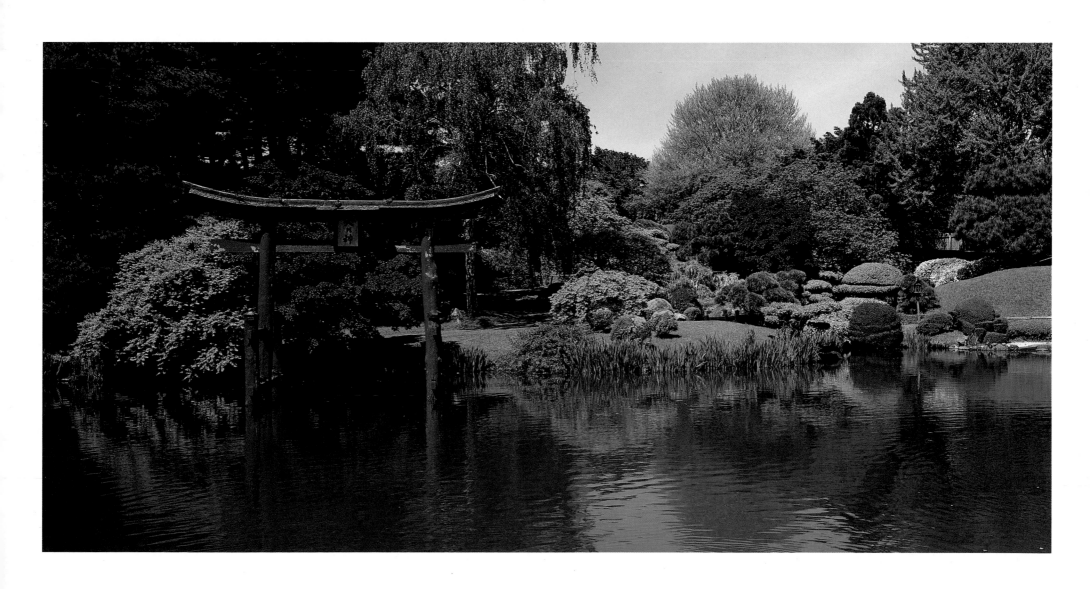

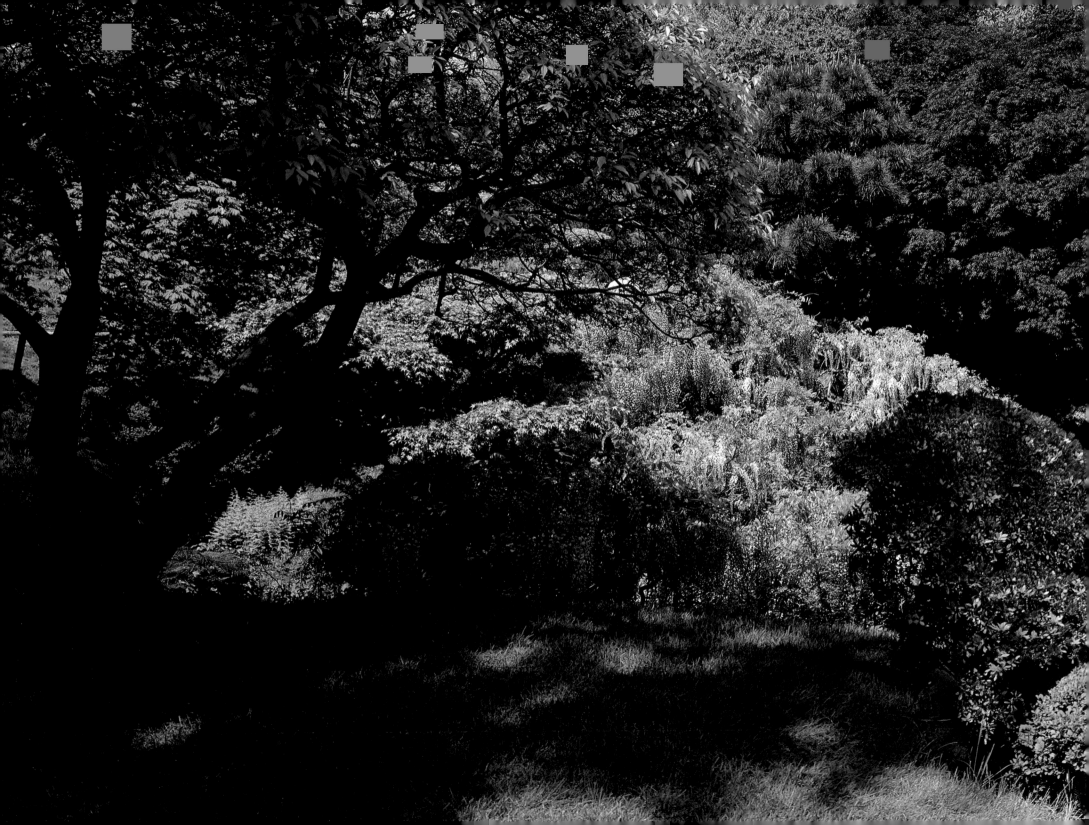

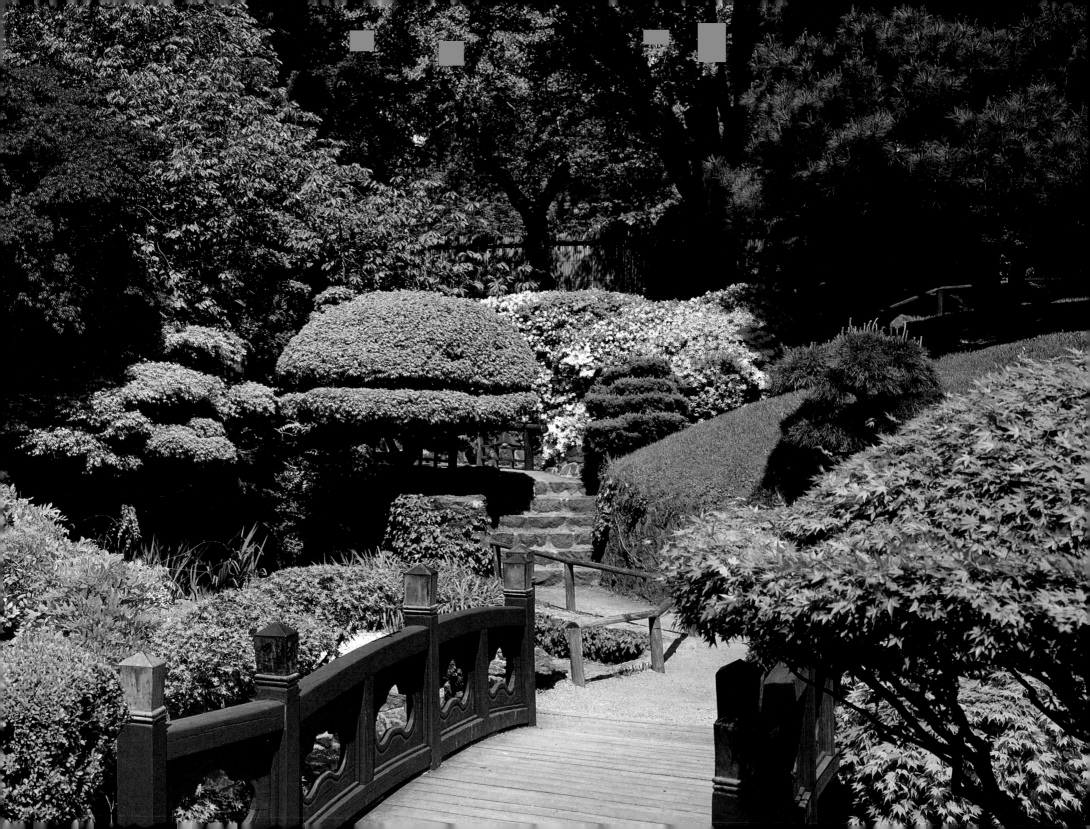

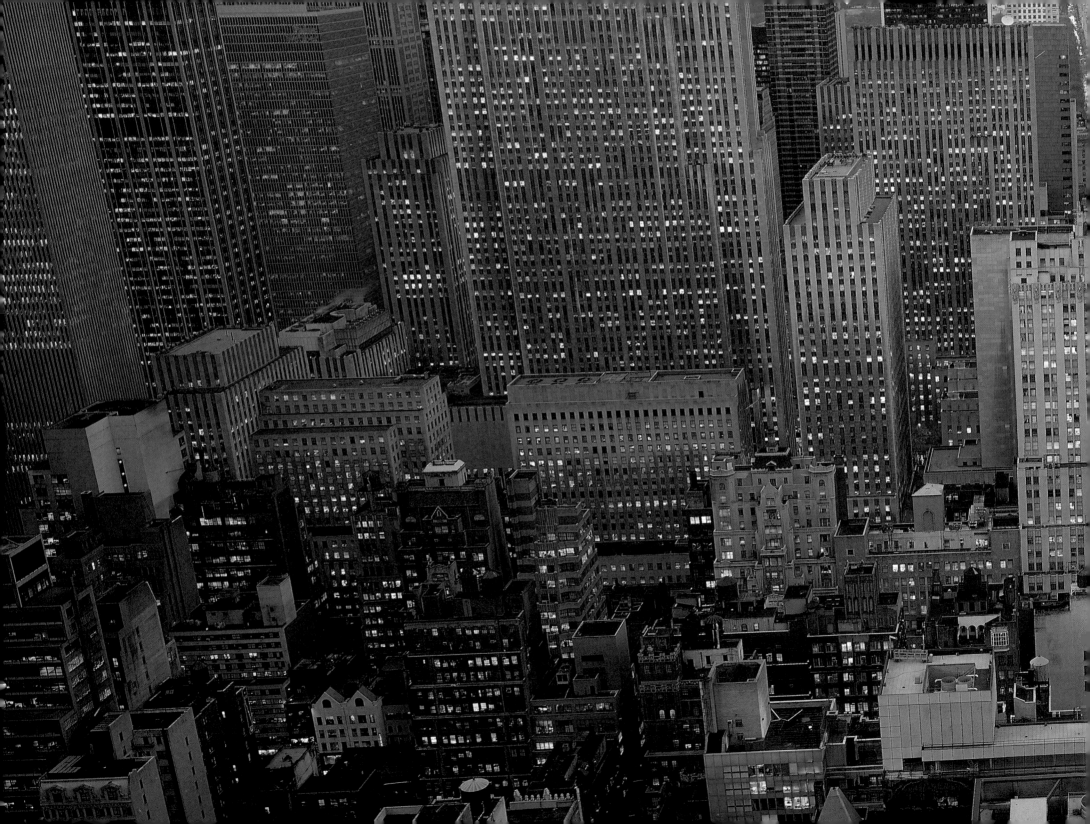

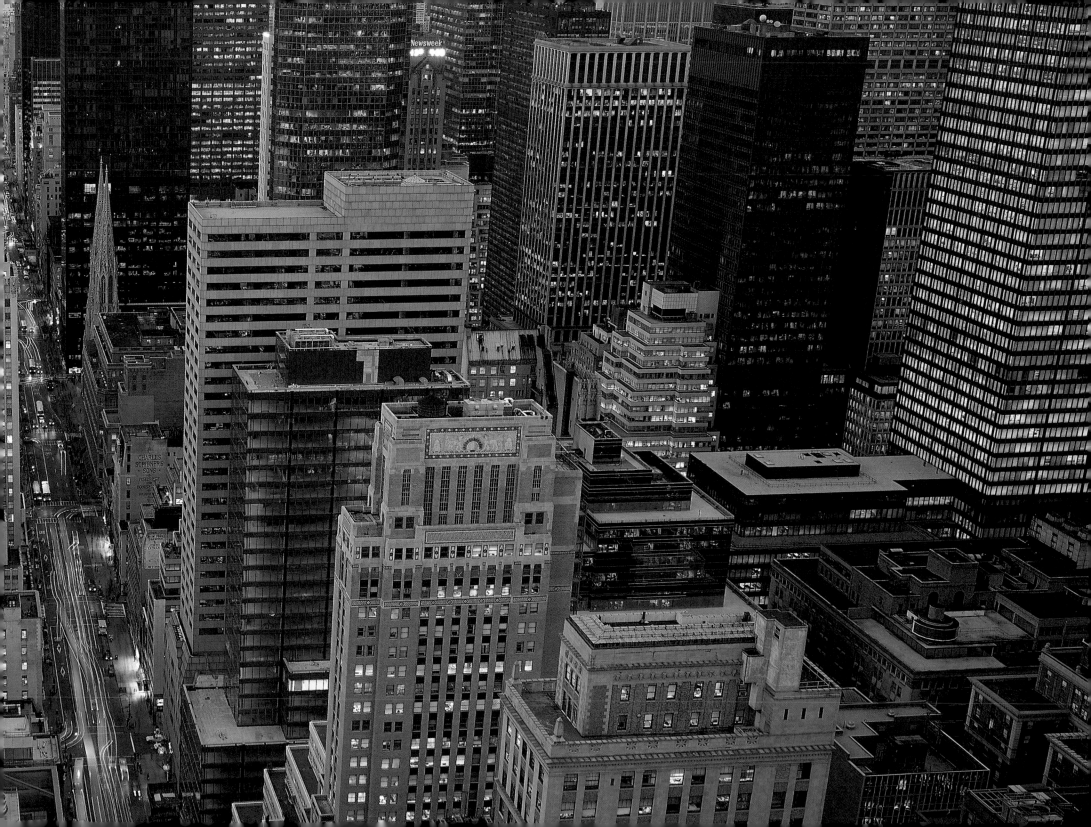

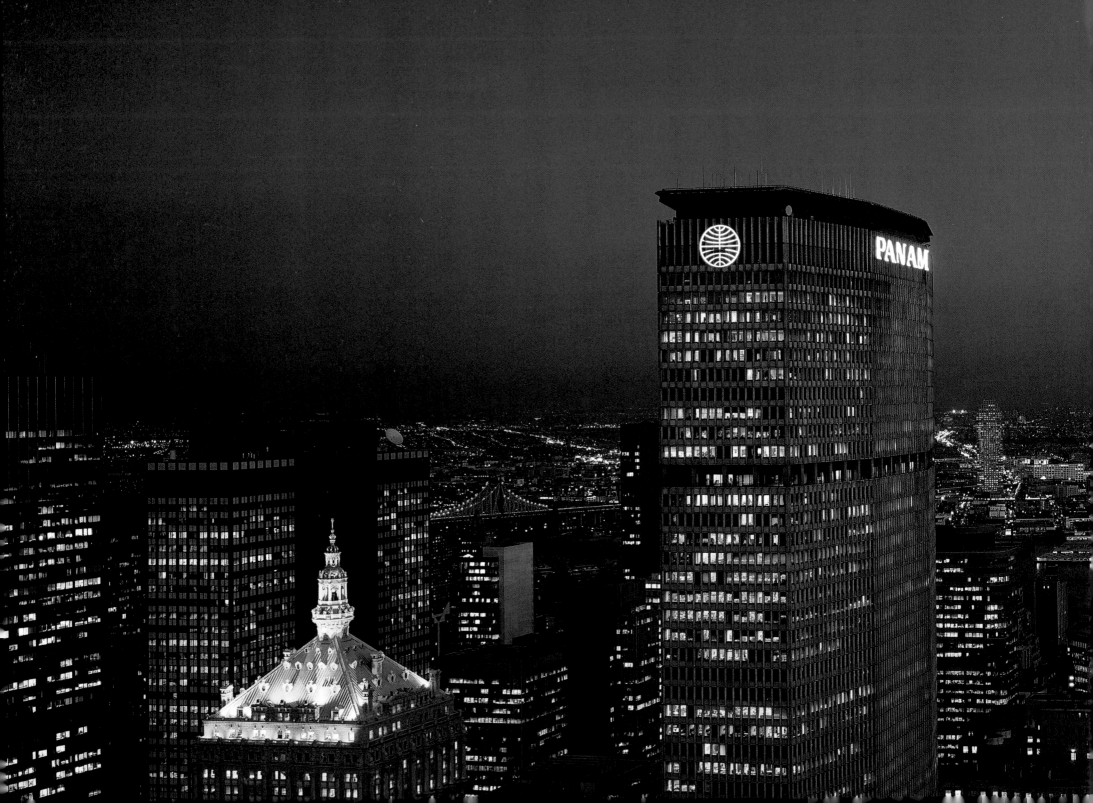

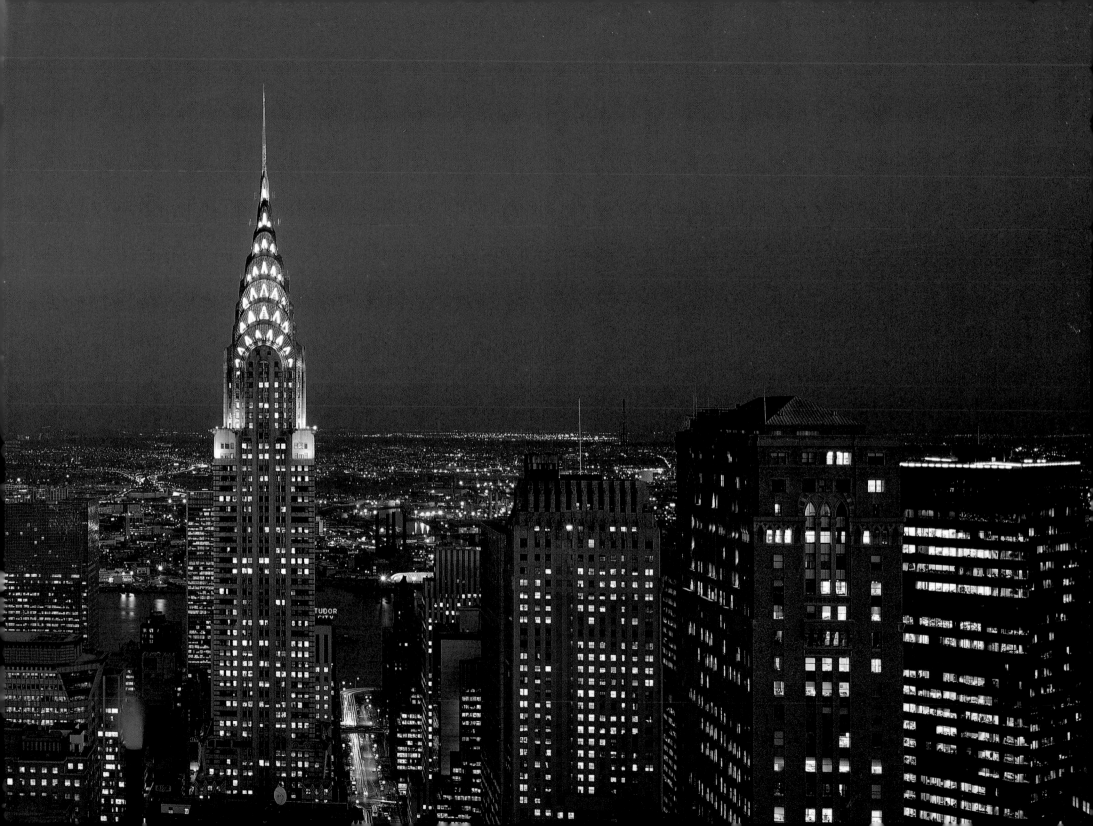

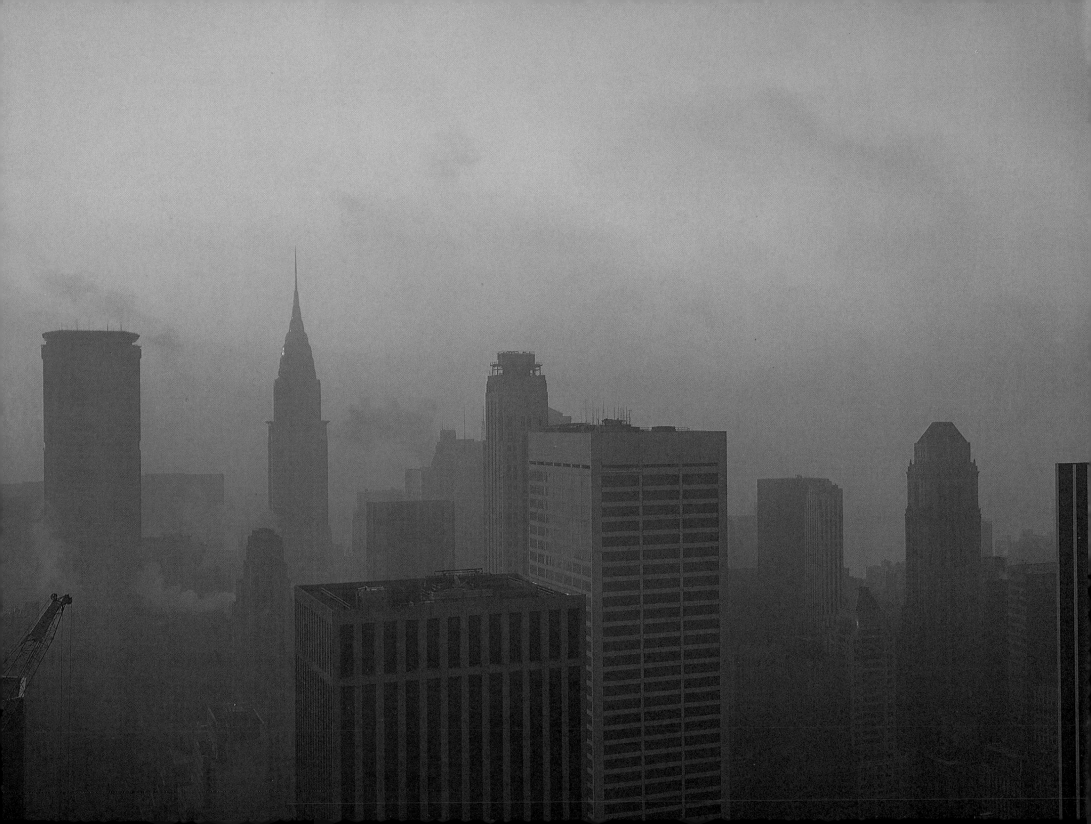

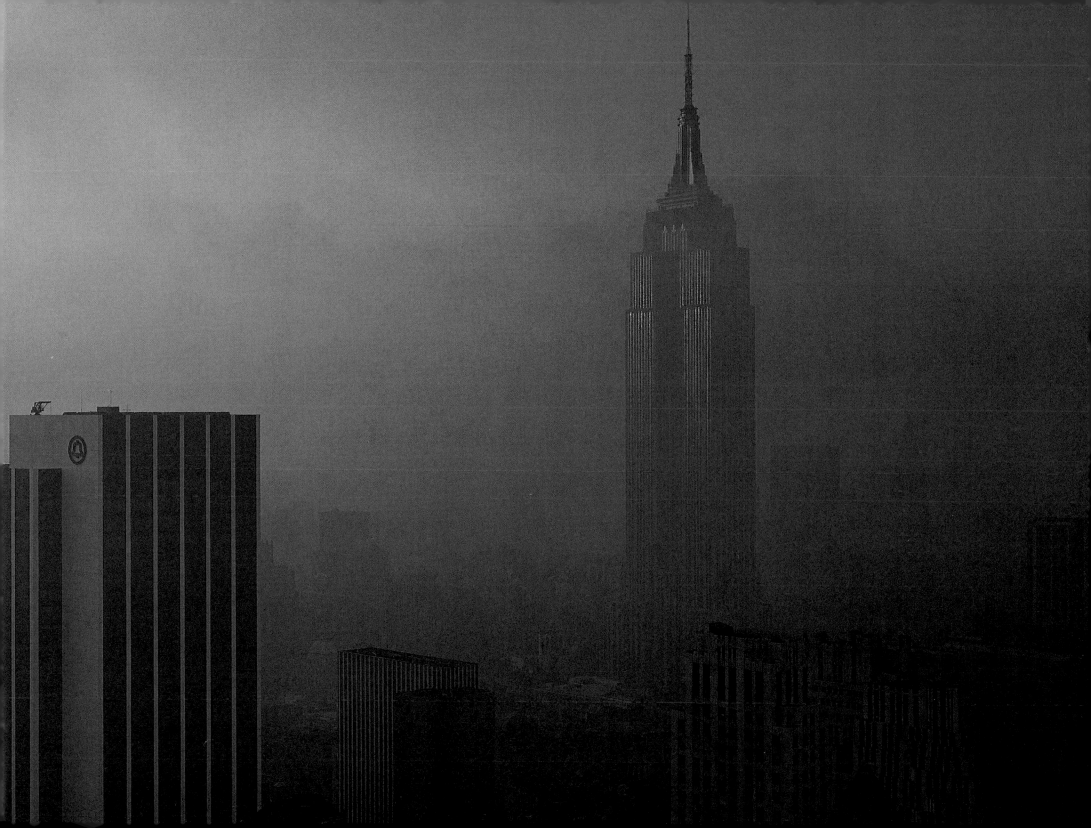

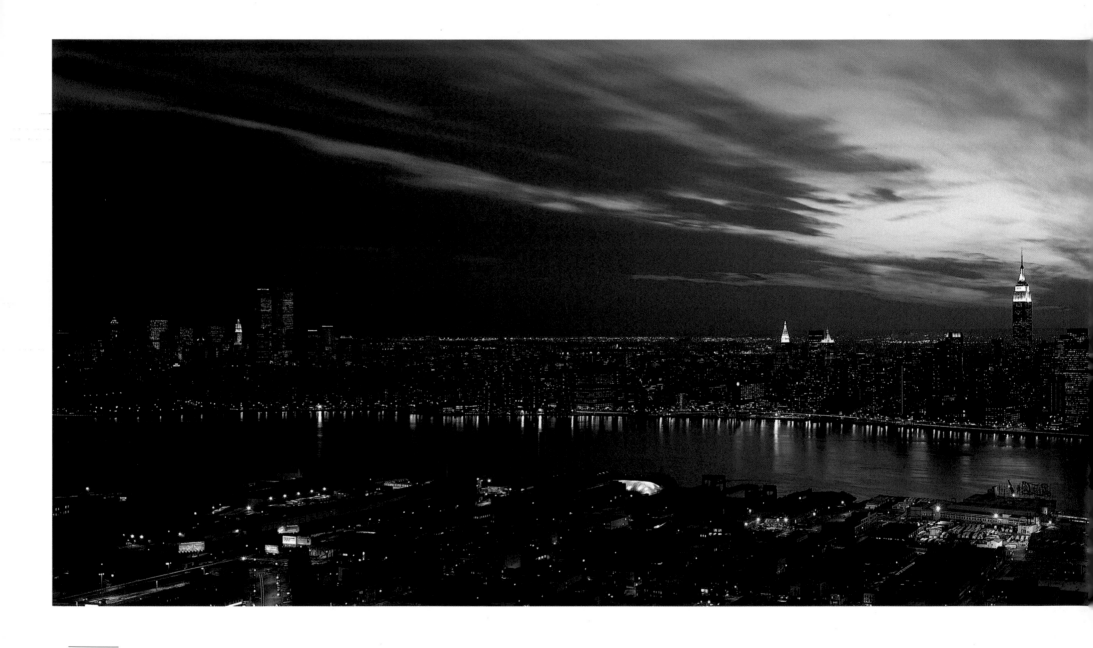

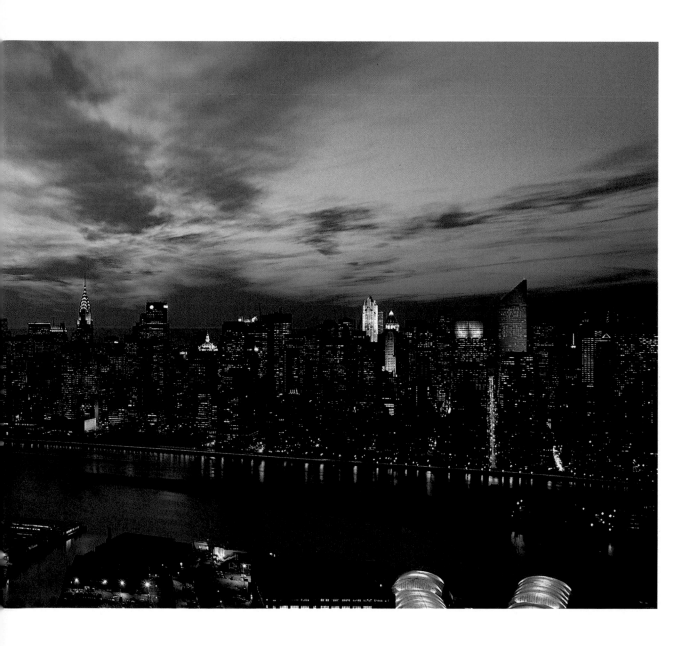

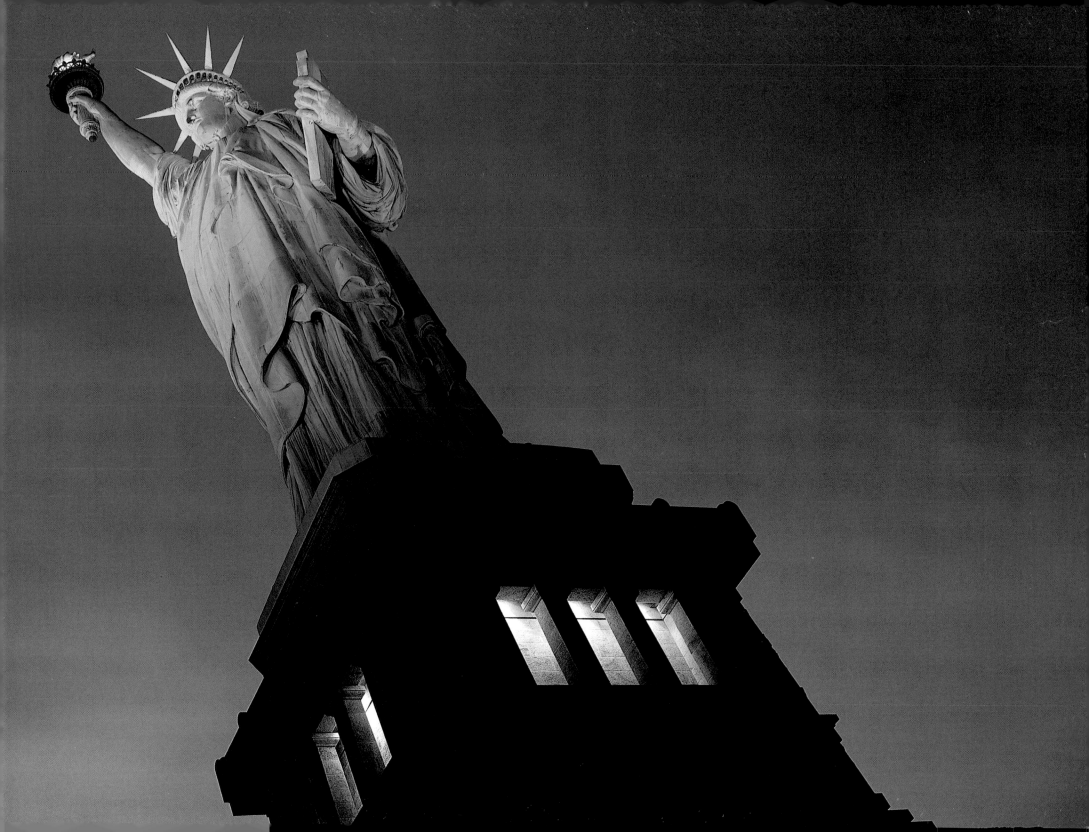

Picture Descriptions *for pages 24-127*

page 24

Midtown Manhattan photographed from New Jersey on a night when the moon was full. The lunar clarity of the nocturnal scene combines with the sheer breadth of the view to make the photograph something of an urban response to Ansel Adams's celebrated picture entitled Moonrise over Hernandez. But unlike the small New Mexican town, Manhattan never sleeps, as the glowing towers and harbor lights attest.

page 25

Lower Manhattan—New York's financial district—photographed from New Jersey across the Hudson River where it flows into New York Harbor. Although much altered from its pre-1960 state, this was the view—bristling thickets of towers rising sheer from the water's edge—that Europeans thrilled to in the days when they arrived mainly by transatlantic liners bound for piers along the Hudson River.

pages 26-27

Lower Manhattan, as seen from New Jersey in the deep purple of dusk, could be a realm under the spell of some great enchanter, perhaps in the guise of the radiant beetle—a glass-and-metal Winter Garden ablaze with white light—at the water's-edge heart of the World Financial Center. Thanks to time exposure, the wide, fast-flowing Hudson River looks as solid and lustrous as polished marble.

page 28

Midtown Manhattan viewed from Queens across the East River. Bronzed by the light of a new-risen sun, the scene is bracketed on the left by the slab-like United Nations building and on the right by the slant-topped Citicorp tower. A fascinating feature in the foreground is the sliver point of Roosevelt Island with its neo-Gothic ruins of an old hospital.

page 29

Midtown Manhattan viewed from Queens, this time by the silvery illumination of pre-dawn. With warmer lights all concentrated near the ground, the skyscrapers resemble rockets being heated up in preparation for space flight. The United Nations General Assembly building at the left and the knife-edged Citicorp tower glow as if they were storage batteries ready to charge up a new day in America's most populous city.

pages 30-31

In this dramatically foreshortened view, the twin towers of the World Trade Center look as if they had been extracted from one of the double bays of 90 West Street and then stripped of that building's French Renaissance embellishments before being recast into the colossal, cubic masses typical of late-modernist architecture.

pages 32-33

Isolated by the camera's selective eye, these tower tops soar aloft like an excerpt from the real-life architectural encyclopedia of Lower Manhattan, ranging from the copper-green Baroque cupolas of Park Row to the neo-Gothic spire of the Woolworth Building to the neo-Romanesque or Italian fortress style of the pyramid-capped building in between.

pages 34-35

Here, in close-up detail, is the glass-and-steel Winter Garden that burns so brightly across the water on pages 26-27. Now light radiates all about rather than from within, illuminating, on either side, the burnt-orange and blue grid of the World Financial Center and, in the background, one of the micro-ribbed shafts of the World Trade Center, whose twin towers are the tallest in New York City.

pages 36-37

As an idea, the New York Stock Exchange, here glowing red in the night, might seem remote from George Washington, whose bronze statue stands precisely where the first President of the United States took his first oath of office. Stylistically, however, the father of the nation would very likely feel right at home confronting the Exchange's Corinthian temple front, since Greco-Roman antiquity served as the ultimate symbol of the New Republic and its democratic ideals.

pages 38-39

Thus abstracted from the real, workaday world down below, the lines of the boxy modernist additions to Rockefeller Center, along the west side of the Avenue of the Americas, look as pure as the cloudless, cobalt sky they are seen against. Indeed, they could be giant versions of the radiant slab symbolic of divine mystery in the film 2001.

pages 40-41

In the gold and purple light of dusk, the crown of the Jacob K. Javits Convention Center could be a cut diamond the size of a mountain, or yet the eye of a great Spielberg monster. Indeed, it seems to be watching us as we observe it. Certainly, the place is often alive with throngs of people come to attend every kind of mass meeting or take in exhibitions of everything from new car models to fashion.

pages 42-43

From within the steel-and-glass cage of the Javits Convention Center, Midtown Manhattan becomes a flat, cubistic composition punctuated just to the right of center by the lance-like spire of the Empire State Building. Designed by I.M. Pei & Partners as a late-20th-century response to London's historic Crystal Palace—the 1851 site of the first "world's fair"—the Javits Convention Center stands like a gigantic sparkling jewel at the edge of Hell's Kitchen. It enthralls hundreds of thousands of visiting conventioneers not only with the view seen here but also, on the opposite side, with a long promenade overhanging the mighty Hudson River.

pages 44-45

For a half-century, until the mid-sixties, this magnificent Corinthian colonnade—the façade of the General Post Office—echoed the Classical front of the old Pennsylvania Station on the opposite side of Eighth Avenue. Both the postal building and the long-gone but much lamented station were designed by McKim, Mead & White, modern America's greatest architects before the arrival of Frank Lloyd Wright. Just above the colonnade seen here runs the famous frieze paraphrasing Herodotus: "Neither snow nor rain nor heat nor gloom of night stays these couriers from the swift completion of their appointed rounds."

pages 46-47

Here, under the curious half-light of dusk, the triumphant Beaux-Arts façade of Grand Central Station glows lemon yellow in its dialogue with an indigo environment penetrated by the glittering spire of the Art Deco Chrysler Building and a glassy curtain wall of the Grand Hyatt Hotel. Astride the pediment crowning the "gateway to the city" is Jules Félix Coutan's sculptural group entitled Transportation and composed of Mercury (Commerce) flanked by Hercules (Physical Energy) and Minerva (Intellectual Energy).

pages 48-49

Within Grand Central Station, the "main concourse" is a noble, truly exalted space comparable to those of Roman baths. Here, hard-pressed commuters can purchase tickets, meet friends, and await trains in a palatial setting of monumental simplicity enriched by marble, Caen stone, and a discreet use of Classical detailing. As this would suggest, Grand Central remains one of the most successful of all exercises in urbanistic design.

pages 50-51

From this vantage point, Rockefeller Center resembles the gardens of Versailles reinterpreted for an urban setting. Indeed, with its roof terraces, sunken plazas, promenades, and tree-lined streets, it could be an Art Deco version of the Hanging Gardens of Babylon. The centerpiece is Paul Manship's gilt-bronze sculpture of Prometheus, who "brought the fire that hath proved to mortals a means to mighty ends."

pages 52-53

Giddy with Christmas cheer, Radio City Music Hall has been New York's grandest theater, as well as the nation's largest, ever since it opened in 1932. By now, the Music Hall has entertained more than 250 million men, women, and children with its combined programs of films and live performances, especially those given by the famous precision dancers known as the Rockettes. The most elaborate and popular show of the year is the one staged for the Christmas season.

pages 54-55

At Christmastime the Promenade at Rockefeller Center becomes a fairyland of radiant horn-playing angels, star bursts, and lavishly decorated shop windows, all of which climax in the colossal fir tree imported for the occasion and illuminated with thousands of lights. Behind this magnificent display looms the 70-story General Electric Building, which is still best known by its original name, the RCA Building. At the center of the Promenade are René Chambellan's bronze fountainheads formed as dolphins ridden by tritons and nereids, which will remain in hibernation until spring allows water to flow again.

pages 56-57

Here, ablaze with light reflected from the great Christmas tree in Rockefeller Center, Prometheus truly looks like the Titan he was, seizing the gods' fire for the benefit of humankind. Even in summer, when the holiday tree is replaced by a 50-jet screen of fountain water, Paul Manship's gilt-bronze sculpture of 1934 retains the fiery presence of an immortal bent upon endowing frail humanity with "a means to mighty ends."

pages 58-59

Closely related to the Rockefeller family is Riverside Church, whose main entrance is here seen in steeply foreshortened perspective, racing away to the top of a 20-story bell tower. Quite consciously, the portal echoes that on the west façade of Chartres Cathedral, especially in the tympanum with its relief of Christ surrounded by emblems of the four Evangelists and its sequence of five archivolts. The carvings on the latter represent not only angels and religious figures but also philosophers and scientists, Classical and modern as well as Christian.

pages 60-61

Filling the ogival arcade surrounding the chancel of the interdenominational Riverside Church is a stone screen carved in the Gothic style with figures representing seven aspects of Christ's life, among them portrayals of Savonarola, Johann Sebastian Bach, Florence Nightingale, and Louis Pasteur. The stained-glass windows in the clerestory were not only inspired by those in Chartres Cathedral but also fashioned in a Chartres atelier. Yet, for all its Gothicism, Riverside Church, on which construction began in 1930, is structured upon a modern steel frame.

pages 62-63

The Cathedral of Saint John the Divine on Morningside Heights, although far from completed, is already the largest Gothic church in the world, the width of its vast nave being more than twice that of Westminster Abbey. Here, the alternating thick and thin piers of one bay have turned purple in light filtered through stained-glass windows representing a cast of saintly figures drawn from all over the world. Unlike Riverside Church, the Episcopal Cathedral is entirely masonry-built, with techniques scarcely altered from those employed by the great cathedral workshops of the 12th and 13th centuries.

pages 64-65

The Cuxa Cloister reconstructed, stone by stone, from a 12th-century Benedictine monastery in the Pyrenees. At the center of the Romanesque enclosure is a garden of fragrant plants known to have been grown in such a setting during the Middle Ages. The ensemble forms part of The Cloisters, a medieval division of the Metropolitan Museum located in Fort Tryon Park at the northern tip of Manhattan Island.

page 66

This Greek Orthodox church, dating from as early as the 1820s, survives in tiny, isolated splendor in a Lower Manhattan quarter now dominated by the behemoth structures of the World Financial Center on the left and the World Trade Center on the right. Until the 1930s, when construction of the Brooklyn-Battery Tunnel broke up the ethnic communities, the area had long been settled not only by Greeks but by Armenians and Turks as well.

page 67

The ancient cemetery surrounding Trinity Church in Lower Manhattan, where some of the tombstones date from the late 17th century. The grassy churchyard as a whole is cherished not only for its unpaved naturalness and simplicity but also for its constant reminder of something more transcendent than the "filthy lucre" so ardently pursued in nearby Wall Street.

page 68-69

The Haughwout Building, dating from 1857, has sometimes been called the "Parthenon of Cast-Iron Architecture," for its Classical elements of course but also for the harmony created by their endless repetition. The latter is a product of the cast-iron process employed for the building's construction, which permitted bay segments to be prefabricated and then assembled on the building site. This was the beginning of modern architecture, in which loads would be borne not by masonry walls but rather by a skeletal framework of strong metal.

pages 70-71

The Bayard-Condit Building on Bleeker Street in Greenwich Village is New York City's only edifice designed by Louis Sullivan, the great Chicago architect who pioneered skyscraper construction and coined the celebrated modernist dictum: "form follows function." Be that as it may, Sullivan loved to decorate his functional forms with lavish bursts of leafy Art Nouveau embellishment, here climaxing in angels sprung from the main piers with their wings spread wide as if to support the overhanging cornice.

pages 72-73

In SoHo (south of Houston Street), where cutting-edge artists and their galleries occupy loft spaces long held by factory-like enterprises, even public walls become aesthetic statements, plastered over as they are with palimpsest layers of posters announcing avant-garde exhibitions, plays, films, and political activities. This spread of "found" art, with its bright colors and jazzy patterns on a dark background, was shot on Broome Street.

pages 74-75

SoHo, with its 19th-century loft architecture of cast-iron façades and hanging fire escapes, becomes for Berenholtz's camera a diagrid pattern of overlaid geometry and color. Behind the formal regularity of this industrialized Classicism once thrived a whole world of light manufacturing, now largely replaced by a bohemian world of artists, galleries, yuppies, trendy bars, and popular restaurants.

page 76

The Puck Building (1885-93), on the corner of Lafayette and Houston streets, gives SoHo one of its most impressive as well as most charming structures—impressive in its Victorian/Romanesque solidity and rich color, charming in the pair of gilt-bronze figures of a top-hatted and cherubic Puck, posed above the entrance as well as on a corner of the edifice overlooking Houston Street. The building began as the home of the now-defunct humor magazine Puck, and it continues to serve various aspects of the graphic arts.

page 77

These gargoyles, discovered on an otherwise ordinary building on West 110th Street, may very well have been inspired by the sculptural program underway at the neighboring Cathedral of Saint John the Divine. Here, they serve as corbels supporting the stone balcony hung from the building's main façade. Clearly, the figures tell a story, but it has yet to be deciphered.

pages 78-79

At the Moondance Diner in SoHo the sign makes good on the title not only through the spinning half-moon but also through the grid of loosely hung "coins" that quake and shimmer in the wind rather like silvery Aspen leaves. Equally arresting is the Stefano mural in the background, evidently an exercise in pure fantasy carried out by SoHo's answer to the Douanier Rousseau, France's great "primitive" or "naïve" painter active in the Picasso circle just after the turn of the 20th century.

pages 80-81

The Vesuvio Bakery survives on Prince Street, at the heart of bohemian SoHo, from the pre-World War I days when the area served as an outer perimeter of the immigrant neighborhood known as Little Italy. With its colorful, old-fashioned store front and beautiful breads, the Vesuvio thrives as never before, in an area enamored of simple, authentic food of the highest quality.

pages 82-83

Times Square in Midtown Manhattan may no longer be the crossroads of the universe that it once appeared to be, but the visual cacophony of its electronic signboards—promoting everything from Broadway theater to state-of-the-art technology and hard-core pornography—still packs a terrific punch for those accustomed to less aggressive environments. Even in a still photograph, Berenholtz has managed to capture the staccato syncopations of the flashing, ever-active signboards.

pages 84-85

One of the numerous "porn shops" in Times Square is suitably painted red and equipped with a two-headed standpipe for the fire department in the event things get overheated inside. Evidently, supply exceeds demand in this industry, driving prices down to 25¢ for access to a "32 CHANNEL XXX VIDEO." As shown here, pornography looks rather quaint or perhaps even old-fashioned and a bit forlorn.

pages 86-87

Still more quaint and forlorn is the side show or "freak museum" at Coney Island, the fabled though now largely abandoned amusement park and beach on the Atlantic shore of Brooklyn. But hope springs eternal, and so the barker's platform remains in place ready to capture an audience for performances—"Live—On Stage!"—by the Elastic Lady, the Human Blockhead, and Helen Melon. In

Berenholtz's photograph, the scene could be a "combine painting" by one of the great Pop artists of the 1960s, such as Robert Rauschenberg, James Rosenquist, or Britain's Peter Blake. The poster-paintings seen here were actually executed by Valerie Haller.

pages 88-89

Coney Island's roller coaster and parachute jump look almost romantic in their dereliction, as nature takes over and endows rusting steel skeletons with the charm of oversized trellises and gazebos. The "world's largest playground" is today animated by little more than the nostalgic poetry of abandonment, in the wake of lower middle-class New York's move to the suburbs and the passive, vicarious pleasures of television.

pages 90-91

Brooklyn Bridge (1883), the world's first steel suspension bridge, may be the most photogenic structure ever built by human hands. Much of its beauty arises from the combination of massive granite towers pierced by ogival arches and the spiderweb of cables that stretch out and grasp the roadbed from above. Designed by John A. Roebling, an immigrant from Prussia, and built by immigrant labor for the immigration capital of an immigrant nation, the Brooklyn Bridge appropriately and proudly flies the American flag. "O harp and altar, of the fury fused/(How could mere toil align thy choiring strings!)."—Hart Crane (1930).

pages 92-93

In the crepuscular light of dusk, the Brooklyn Bridge spans the East River to Lower Manhattan with something like the élan of a dancer or the grace of a swan. However glittering the background, it cannot efface the delicate beauty of the cabled webbing, picked out as this is by lights strung along the catenary curves of the suspension system. Only after P.T. Barnum, the circus master, marched 21 elephants across it did the public gain confidence that such a fragile-looking structure might be reliably stable.

page 94

Here, again by dusk, the Brooklyn Bridge takes on the jeweled aspect of a great diamond necklace strung from tower to tower across the East River, optically greeted on the Manhattan side by the incandescent spire of the Woolworth Building. "Oh, what can ever be more stately and admirable to me than most-hemm'd Manhattan?/River and sunset and scallop edg'd waves of flood-tide?"—Walt Whitman (1856).

page 95

The Queensboro or 59th Street Bridge became the wonder of Manhattan's Upper East Side when it opened in 1909 to traffic from and to the Borough of Queens on Long Island. Although admired for its intricate mesh of steel beams, this span, unlike the Brooklyn, seems to have inspired few poets. Still, it played a key role in The Great Gatsby, where Scott Fitzgerald writes: "The city seen from the Queensboro Bridge is always the city seen for the first time, in its first wild promise of all the mystery and beauty in the world."

pages 96-97

The George Washington Bridge, the youngest of Manhattan's great river bridges and the only one spanning the Hudson to New Jersey, was twice as long as any previous suspension bridge when it opened in 1931. The Swiss architect Le Corbusier called it "the only seat of grace in the disordered city." The bridge's vast size and its distance from Midtown Manhattan can be judged by the toy-like scale of the illuminated Empire State Building just to the left of the structural tower on the right.

pages 98-99

The Manhattan Bridge (1909) towers over the older Brooklyn Bridge, in scale if not in aesthetic quality. It also carries a much heavier load, with subway trains crossing on the lower level and automobiles on the upper. The cables hang like a beaded curtain beyond which looms the celebrated skyline of Lower Manhattan. Again, Berenholtz has photographed the city at the hour of its greatest allure—dusk.

pages 100-101

Photographed at dawn and then at dusk from across the boating lake in Central Park, Midtown Manhattan could scarcely look more serene. Nothing here would cause one to suspect the hectic life actually pursued in the towers that crowd together and needle the sky beyond the sylvan calm of this bucolic setting.

pages 102-103

Calvert Vaux's Bow Bridge (1859) spanning the Lake in Central Park is so handsome that it has no bad angles. The uncanny elasticity of the form derives from its having been precast in iron. A foot bridge, it makes an unusually gracious foreground to the "Chinese wall" of Art Deco apartment blocks along Central Park West.

pages 104-105

Even under a blanket of snow, Bow Bridge in Central Park moves into depth with the same supple grace it displays in full profile on a bright summer day. After more than a century of exposure to alternating extremes of weather, Calvert Vaux's cast-iron span seems to have lost known of its crisp, ductile beauty.

pages 106-107

Snow brings a special enchantment to Central Park, a semipastoral world that already seems a miracle to most New Yorkers, accustomed as they are to the asphalt and stone jungle found everywhere else. For a brief moment, a good snowfall always leaves the heavily polluted city appearing as if it had been not only cleansed but also returned to an Edenic state of primary innocence.

pages 108-109

There is scarcely a native-born New Yorker who does not harbor fond memories of the Friedsam Carousel. The beautiful hand-carved horses—all 58 of them—originated in Coney Island, whence they were transferred in 1908 after those originally installed in Central Park succumbed to fire. As this picture suggests, the carousel, with its dashing steeds and ancient organ, is lovingly maintained in bright, mint condition.

pages 110-111

Spring flowering has transformed this allée of crab apples into a pink and green paradise. Part of the Conservatory Garden, the only formal garden within Central Park, the allée is one of two that flank the Center Garden, separating it from an English-style garden on the south and a French-style garden on the north. Quiet, secluded, and dappled with soft, filtered light, the two allées are ideal retreats for reading, chatting, or love-making, often at the same time on a good day.

pages 112-113

This circular fountain, with its carved granite base and ring of bronze dancing nymphs, is the centerpiece of the French-style North Garden within Central Park's Conservatory Garden. Beyond the surrounding beds of purple pansies, blue-green Dusty Miller, and tulips, are borders of yew and flowering quince. There is no more intimate, charming, or civilized area in all of New York City.

page 114

On a fine spring day, Berenholtz found the bronze effigy of William Shakespeare contemplating a brilliant bed of yellow and red tulips at the southern end of the Mall in Central Park. Created by John Quincy Adams Ward, the statue was installed in 1870 as part of New York City's observation of the tricentenary of the great playwright's birth.

page 115

This bit of Japan is found in the Brooklyn Botanic Garden, a 50-acre park created from wasteland, beginning in 1910, by the Brooklyn Institute of Arts and Sciences. Takeo Shiota designed the Japanese Garden, which includes a lake with a surround of dwarf trees and a vermilion torii or gateway signaling a Shinto shrine nearby. Claude Monet would very likely have been as much at home painting here as in his own water garden with its famous Japanese bridge.

pages 116-117

With its hanging wisteria and dwarf trees and shrubs, its wooden bridge, stone steps, and spreading pines, the Japanese Garden within the Brooklyn Botanic Garden lends exquisite diversity to a park noted for that very quality. The footbridge spans one of several small cascades with echo caverns beneath them. Few places in boisterous Brooklyn offer such meditative quietude as the Japanese Garden seen here.

pages 118-119

A high view over Midtown Manhattan at dusk. For some, this scene evokes nothing so much as a giant cemetery crowded with colossal tombstones. For others, it represents urbanism at its most dramatic and glamorous. Confronted with the 1920s version of this very quarter, Scott Fitzgerald wrote of "the enchanted metropolitan twilight" in which he imagined himself "hurrying towards gaiety and sharing [an] intimate experience."

pages 120-121

From atop a neighboring skyscraper, the flat-headed Pan Am Building (now Met Life) could be a monument to modernist banality, flanked as it is by two of Manhattan's most romantic towers—the illuminated Helmsley Crown, with its elaborate Beaux-Arts pinnacle, on the left and, straight ahead, the Chrysler Building, probably the most beautiful Art Deco monument in all of North America. Beyond the Chrysler's tapering bursts of light, culminating in a needle-like spire, lie the East River and the boroughs of Queens and Brooklyn.

pages 122-123

In the peach-colored mist of dawn, Manhattan—the city that never sleeps—looks thoroughly somnolent, with nary a candle burning anywhere in sight. The view is from the West Side around 40th Street, framed by the Empire State Building on the far right and the pointed crest of the Chrysler Building on the extreme left.

pages 124-125

*The Manhattan skyline from Queens opposite 53rd Street—
with the East River running along the foreground and the
sun going into spectacular decline beyond the Hudson River
on the West Side—could be an updated setting for Richard
Wagner's* Twilight of the Gods. *Anchored by the Empire
State Building just off center to the right, the great city
spreads before us all the way to the tip of Manhattan
Island, where the twin towers of the World Trade Center
loom above New York Harbor.*

pages 126-127

*What the World Trade Center looks out upon in New York
Harbor is the one monument in the city more famous than
either the Brooklyn Bridge or the Empire State Building—the
Statue of Liberty. A gift from France, dedicated in 1886 and
recently restored by the donor nation, Liberty stands taller
than ever, in the perfection of her verdigris tunic, radiant
crown, and lofty torch, its flame now solid, rather than
transparent, and set afire by powerful light beamed upon
the gilded skin. In a paean to Lady Liberty, the immigrant
poet Melech Ravitch wrote in 1893:*

> *Your torch is directed
> To New York, but your light burns
> To all the ends of the world.*

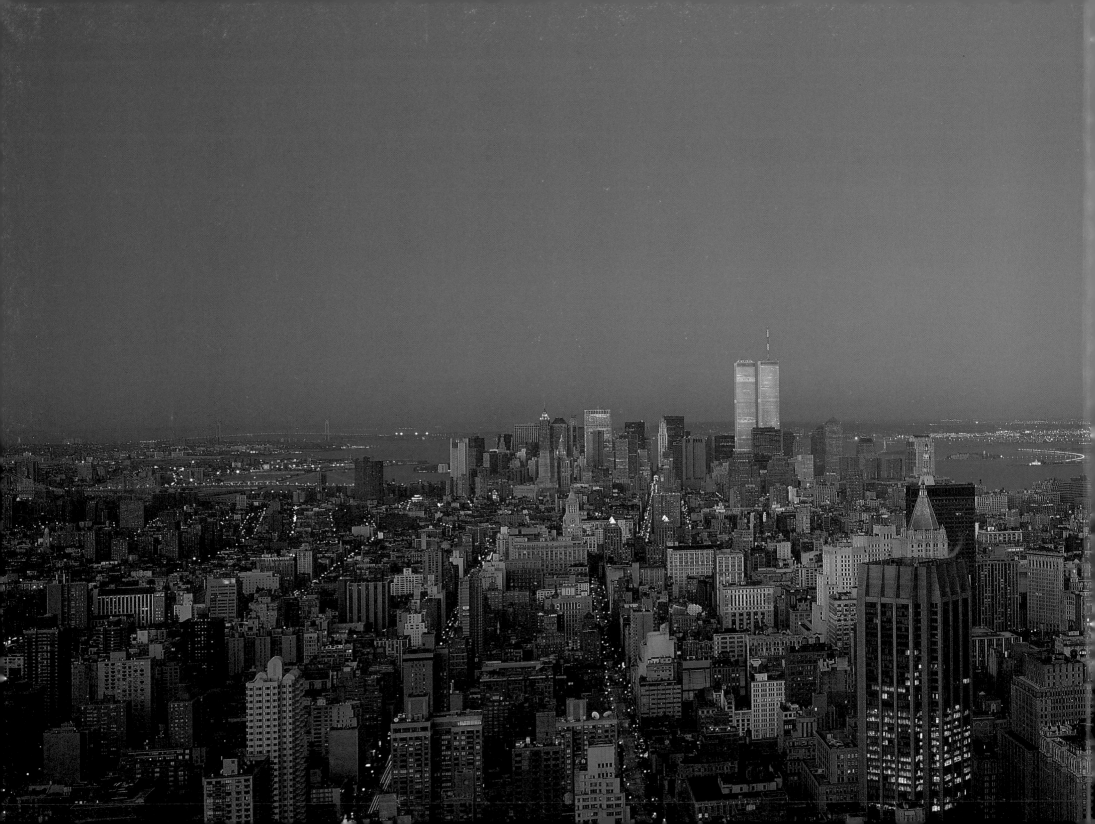